Léger gathers up what remains of the radicality and hurls it into a whirling "pervert's guide" to contemporary art, Brave New Avant Garde *reveals a multitude of interventionist practices and rapidly revolving dark particles that in light of recent events in Tunisia and Egypt no longer appear exotic, but instead vibrate prognostic, as if heralding the dawn of a sweeping phase change in twenty-first century art and politics.*

Gregory Sholette, author of *Dark Matter: Art and Politics in the Age of Enterprise Culture*

In this critical tour de force, Marc Léger successfully exposes the contradictions that animate contemporary art and that govern the actions of those who "participate in the game of culture" in the age of neoliberalism. And yet Léger is not content to simply critique, he also proposes alternatives through the medium of his concept of a sinthome-opathic cultural praxis, the product of a successful act of balancing on and moving along a pro-avant-gardist tightrope woven of recent politically and socially engaged art practices.

David Tomas, author of *Beyond the Image Machine: A History of Visual Technologies*

Marc James Léger's informed and thought-provoking analysis of critical art practices and related theories provides essential orientation for anyone looking for ways to resist and subvert what Peter McLaren has defined as the two thieves of capitalism and representative democracy.

Oliver Ressler, artist and filmmaker, author of *Alternative Economics, Alternative Societies*

Brave New Avant Garde

Essays on Contemporary Art
and Politics

Brave New Avant Garde

Essays on Contemporary Art
and Politics

Marc James Léger

Winchester, UK
Washington, USA

First published by Zero Books, 2012
Zero Books is an imprint of John Hunt Publishing Ltd., Laurel House, Station Approach,
Alresford, Hants, SO24 9JH, UK
office1@o-books.net
www.o-books.com

For distributor details and how to order please visit the 'Ordering' section on our website.

ISBN: 978 1 78099 050 7

A CIP catalogue record for this book is available from the British Library.

Design: Stuart Davies

Printed in the UK by CPI Antony Rowe
Printed in the USA by Offset Paperback Mfrs, Inc

We operate a distinctive and ethical publishing philosophy in all
areas of our business, from our global network of authors to
production and worldwide distribution.

Contents

Acknowledgements

This book would not have been possible without the encouragement of the colleagues and comrades I have worked with in the past few years. In 2006 I completed my doctoral dissertation in the program in Visual & Cultural Studies at the University of Rochester. Thanks go to my supervisor Joan Saab for her support of my research, which gave me the intellectual freedom I needed to make the move from radical democracy towards Žižekian ideology critique. My dissertation would never have been accomplished had it not been for the loving support of Rosika Desnoyers. Upon completion of my thesis I set out to consider the challenges to Marxism that have been posed by contemporary anarchist theory and post-operaism. During this time I have enjoyed a productive relationship with Bruce Barber, whose book *Performance, [Performance] and Performers* I had the pleasure and privilege to work on as editor. The chapter "In a Way We Are All Hokies" was first presented at a Universities Art Association of Canada panel chaired by Bruce in 2007. We also co-chaired a UAAC panel in 2010 on the subject of "the neoliberal undead."

Working on Bruce's [performance] books gave me the inspiration to produce a project of my own, which turned out to be the edited text *Culture and Contestation in the New Century*, published by Intellect in London. Many wonderful exchanges came from this project, including a collegial friendship with Aras Ozgun, with whom I co-chaired a panel on "Creative Labour and Creative Industries" at UAAC in 2008, and collaborations with Oliver Ressler, which includes an interview that was published in *Art Journal* as well as a North American presentation of his exhibition "A World Where Many Worlds Fit" at the Foreman Art Gallery in Sherbrooke, Québec, in 2010. During this time I have had the pleasure of meeting and working with, in person or through correspondence, Carole Condé and Karl Beveridge,

Lucia Sommer, Vitaly Komar, Brian Holmes, Gregory Sholette, Mathieu Beauséjour, Rosemary Heather, Izida Zorde, Gerald Raunig, John Jordan, Petra Gerschner, Jackie Sumell, Pierre Allard, Federico Zukerfeld, Yahya Madra, Isabelle Lelarge, Jelena Stanovik, Christina Ulke and Marc Herbst. All the while I also enjoyed the abiding support of my teacher Claude Lacroix, who gave me the opportunity to present new research to his students at Bishop's University.

Thanks go to the magazines and journals that supported my ideas during this time. In particular, I want to acknowledge the *Journal of Aesthetics and Protest*, where I first published a version of "A Brief Excursus on Avant Garde and Community Art" in the 2008 issue. A different version was also published in *C Magazine* #98 (Summer 2008). "Community Subjects" was first published in the Montreal art magazine *Etc* #81 (2008). The chapter "Welcome to the Cultural Goodwill Revolution" was published online by *Journal of Aesthetic and Protest* in 2009 and parts of it also appeared in "Avant Garde and Creative Industry," which was published in *Creative Industries Journal* in 2010. A shorter version of the interview with Brian Holmes was published in *Art Papers* (Summer 2010).

Thanks go to my family and especially my mother, Denise Léger, for never tiring of talking with me about religion and politics. And lastly, I want to thank Cayley Sorochan, who has lovingly worked alongside and supported me these past years and who lets me borrow her Badiou books.

The Avant Garde Hypothesis

In an essay on the critique of institutions and the desire of radicalized artists to work outside the limits of established disciplinary structures, Brian Holmes argues that the most productive areas of contemporary critical art practice – discourse-based context art and institutional critique – have undergone a significant phase change, a shift toward extradisciplinary, transversal assemblages that link actors from the art world to projects oriented toward political contestation.[1] The world in which networked artists and activists operate is one that is today characterized as "cognitive capitalism," where affect and creativity, immaterial and communicative labour are held to be key components of the biopolitical engineering of subjectivity, a voluntary mechanical enslavement within a bureaucratically regulated process of continuous evaluation that is increasingly oriented towards a service economy. Such forms of critical art practice, associated with social and political movements, autonomous collectives, and alternative media, bear a striking resemblance to what was once referred to as the avant garde, which Alain Badiou associates with a "subtractive tendency," the willingness to sacrifice art, in the artistic gesture itself, rather than to give up on the real.[2]

To pursue Badiou's thought a bit further, we could paraphrase his critique of contemporary conservatism with the notion of an "avant garde hypothesis" that would correspond to his idea of a communist hypothesis.[3] With this we could ask the question: must the avant garde hypothesis be abandoned? What does the idea of the avant garde have to offer us in the present moment? There is no doubt that it has become conventional for contem-

porary cultural workers to deny that what they do is or can be conceived of as avant-garde. Avant garde is associated with modernist notions of teleology and totality and with the Marxist view that capitalism creates its own obstacle and means of overcoming in the form of the industrial prolatariat. With the growth of the tertiary middle class in the postwar consumer age, and with the appearance of the new left and new social movements from the 1950s to the 1980s, the idea of the political avant garde has by and large been replaced by constituent forms of power that act autonomously and in solidarity with one another, without the directives of a centralized political party. Yet the bourgeois state remains and prevents the full realization of progressive responses to the mercenary assault of free market ideology. In a similar way, in the art world, the operations of the "institution art," or the field of cultural production, puts pressure on activist art practices through the normalizing effects of cultural administration and through creative industry reengineering of policy and institutions. Progressive cultural workers are thus obliged to develop forms of resistance that can allow them to act politically while still retaining in their work some legitimizing features that would allow this work to be read and understood as cultural intervention. Although the rhetoric of such artists often eschews the term avant garde, I would argue that the avant garde idea continues to operate as the repressed underside of the contemporary forms of extradisciplinary practice. And so, this book is concerned with the present form of the "avant garde hypothesis." As such, it stands in opposition to the pieties of "new times" cultural studies and the belief that progressivism can be absorbed into strategies of postmodern complicity, social constructionism and speculative indeterminacy. If a postmodern, rhizomatic avant garde could be said to represent the "precarious inscription of new hybrid and fluid identity positions," as Johanne Lamoureux has argued, then the avant garde hypothesis that I speak of here is one that in no way

2

conforms to the post-structuralist doxa of a "beyond left and right" micro-politics.[4] A contemporary avant garde is one that seeks a path beyond what Hal Foster has termed the "double aftermath" of modernism and postmodernism and responds to Mao's injunction: "Reject your illusions and prepare for struggle." In this, today's avant garde represents not so much the transnational class of civilized petty bourgeois culturati, but a counter-power that rejects the inevitability of capitalist integration.

The term that I have given to the concept of struggle that best corresponds to a contemporary avant garde is *sinthomeopathic practice*. Whereas the transversal activists who have been inspired by the "post-political politics" of Italian workerism and the schizo-anarchism of Gilles Deleuze and Félix Guattari have called for an "exodus" from the established institutions of cultural production, *sinthomeopathy* does not pretend to succeed Marxism and claims, as Jacques Rancière asserts, that the power of the proletariat is a power that declassifies and affirms the community of equals.[5] Sinthomeopathy does not propose an escape from institutions but works towards the egalitarian transformation of institutions, which includes the nebulous state of art discourse. As far as transversal activists are concerned, the problem of avant garde representation is cancelled by both the critique of party-based and state-oriented politics and by the current modes and relations of production, which, through their own contradictory movement and the weakening of public institutions, produce the multitude as a form of constituent power.[6] Sinthomeapathy, in contrast, does not so much propose a counter-cultural critique of institutions, but a transformation of its mediating functions through occupation and radicalization. Any kind of prefigurative politics must therefore take into consideration rather than ignore the alienating structures that condition radical social praxis. One such structure is that of leadership and organization. In cultural terms this can take the

forms of authorship and autonomy.

In its willingness to break with predecessors, today's avant garde finds itself in the paradoxical position of not defining itself as avant-garde. This is not only due to the postmodern prohibition on meta discourses, but to the very prohibition on the prohibition since so many who are today complicit with the Fukuyaman view that there is no imaginable alternative to liberal capitalism also consider themselves progressive democrats. As Slavoj Žižek asserts, emancipatory struggle should be defined today as the struggle against liberal democracy, the predominant ideological form that is often the background of the usual topics of progressive academia. Žižek writes: "What, today, prevents the radical questioning of capitalism itself is precisely this belief in the democratic form of the struggle against capitalism."[7] And so, it has been much easier for the artworld to absorb the plurality of practices that speak to democratic inclusiveness than it has for it to self-comprehend itself as the byproduct of surplus value, generated on a global scale.

One of the tactics used by extradisciplinary artists to resist capitalist integration has been the critique of various aspects of bourgeois art production, usually understood in terms of individual studio work designed for incorporation into the art market. We find instead the radical practices of art collectives who produce didactic and aesthetic interventions in the public sphere. We can list here, as examples, the work of REPOhistory, Group Material, Guerrilla Girls, WochenKlausur, ACT UP, Critical Art Ensemble, the Institute for Applied Autonomy, the Laboratory for Insurrectionary Imagination, Bureau d'Études, Ne Pas Plier, Temporary Services, HaHa, the Yes Men, Surveillance Camera Players, Ala Plastica, the Errorist International, Oda Projesi, PublixTheatreCaravan, ®TMark, Superflex, Yomango, Cultural Transmission Network, BüroBert, Hirsch Farm Project, Platform, Terra Cultural Research Society, ATSA, Collectivo Cambalache, Protoplast, The Art of Change, The Center for Land

Use Interpretation, Ultra Red, Radical Software Group, Park Fiction, Carbon Defense League, The Atlas Group, Infernal Noise Brigade, Visual Resistance, Toyshop Collective, N55, Instant Coffee, Raqs Media Collective, Paper Rad, Rude Mechanical Orchestra, It Can Change, Collective Jyrk, Chto Delat and Next Question, not to mention the countless progressive artists who work more or less individually. Brian Holmes argues that the pluralism of 60s and 70s art, and the discourse-based institutional critique of the 80s and 90s, has been superceded by a phase change wherein artists now circulate between disciplines and adopt the various counter-cultural positions of social movements, political associations and autonomous zones. He writes:

> The projects tend to be collective, even if they also tend to flee the difficulties that collectivity involves, by operating as networks. Their inventors, who came of age in the universe of cognitive capitalism, are drawn toward complex social functions which they seize upon in all their technical detail, and in full awareness that the second nature of the world is now shaped by technology and organizational form. In almost every case it is a political engagement that gives them the desire to pursue their exacting investigations beyond the limits of an artistic or academic discipline. But their analytic processes are at the same time expressive, and for them, every complex machine is awash in affect and subjectivity. It is when these subjective and analytic sides mesh closely together, in the new productive and political contexts of communicational labor (and not just in meta-reflections staged uniquely for the museum), that one can speak of a "third phase" of institutional critique – or better, of a "phase change" in what was formerly known as the public sphere, a change which has extensively transformed the contexts and modes of cultural and intellectual production in the twenty-

first century.[8]

The argument that I make in these pages is that such work typically does not escape the conditions of capitalist integration but responds rather to the existing hegemony of a new mode of cultural production in which biocapitalist networking rather than individualism is the norm, in which petty bourgeois allodoxia and the thesis of classlessness replace the politics of class struggle, and in which affinity and reformism replace avant-garde autonomy. Discourses regarding the multitude of struggles confirm the kinds of postmodern politics that are allowed by the system. A keystone in the shift away from class politics to the multitude of decentred struggles is the repudiation of universality and the inflation of culture wars and identity conflicts that are generated and championed by the liberal capitalist system. We should not of course disregard the progressive aspects of civil rights and the extension of the "democratic idea" to all social actors, but we should be aware that the idea of an equivalence between the different kinds of oppression – based on race, class, gender and sexuality – work to obfuscate the predominant features of class struggle. Not surprisingly, political correctness and identity politics, not to mention artistic *tendenzkunst*, can most readily be found on the reformist social democratic left.

It is not my purpose with this book to provide a catalogue of the various pre-existing conceptions of the avant garde. Art theory is replete with already existing models, including Peter Bürger's bohemian, historical and neo avant gardes, Hal Foster's neo-avant garde as "deferred action," Benjamin Buchloh's "post-neo-avant garde," and benign postmodern versions such as Sianne Ngai's cutting edge of "cuteness" or Norman Bryson's "post-ideological avant garde."[9] Needless to say, there is a long tradition of avant-garde engagement with the intersections of art and everyday life that is understood not only in terms of modernism but in terms of Marxist aesthetics. In his book on the

concept of totality, Martin Jay argues that "Western Marxism has been open and experimental in a way that is not comparable with anything in this [twentieth] century except perhaps aesthetic modernism, which also exploded in a whirl of movements and counter-movements."[10] Today's phase change, however, relates not so much to a break with a previous artistic tendency, but with a previous politico-philosophical tradition: namely, Hegelian Marxism and its various permutations in postwar existentialism, structuralism, and Frankfurt School Freudo-Marxism. It is my view that beyond the deadlock of the postmodern critique of meta-narratives, artists, theorists and activists have begun to revisit questions of radical praxis that were prematurely consigned to the dustbin of history. One can see this clearly in the case of the social revolutions taking place in Tunisia and Egypt and across the Arab world. While Facebook and the Internet are credited with providing social movements with important channels of communication, it is the radical praxis of trade unions and leftist social movements that paved the way for the spectacular broad-based social revolts that even produced echoes of resistance in the U.S. and Spain. It is apparent that if the peoples of these countries wish to find a way out of the kinds of dictatorial terror and underdevelopment that is promoted by transnational capitalism, they will need to rely on the guiding principles of socialism. What then, and in *this* world transformative context, is an adequate model of avant-garde cultural practice and what are its theoretical premises? Most will view the Leninist notion of the engaged artist as a communist party artist to be evidently out of step with an actuality in which there are no revolutionary organizations or even nation states that are powerful enough to lead the capitalist democracies to a new world situation. On this count, the socio-historical conditions that led to the emergence of the avant gardes in the nineteenth and twentieth centuries have shifted perceptibly toward the biocapitalist administration of culture, confirming rather than

denying Bürger's thesis on art's tendency towards autonomization, understood here in terms of capitalist reification. Autonomy in contemporary culture, however, finds itself enacted paradoxically through dispersed strategies of complicity, compliance, identification and relationality. These cool, affirmative strategies, pressured by the logic of networking and careerism, are often little more than survival strategies within conditions of biocapitalist governance. The following response by the American artist Andrea Fraser to the *Frieze* questionnaire "How has art changed?" describes this situation:

> We're in the midst of the total corporatization and marketization of the artistic field and the historic loss of autonomy won through more than a century of struggle. The field of art is now only nominally public and non-profit institutions have been transformed into a highly competitive global market. The specifically artistic values and criteria that marked the relative autonomy of the artistic field have been overtaken by quantitative criteria in museums, galleries and art discourse, where programmes are increasingly determined by sales – of art, at the box office and of advertising – and where a popular and rich artist is almost invariably considered a good artist, and vice versa. Art works are increasingly reduced to pure instruments of financial investment, as art-focused hedge funds sell shares of single paintings. The threat of instrumentalization by corporate interests has been met in the art world by a wholesale internalization of corporate values, methods and models, which can be seen everywhere from art schools to museums and galleries to the studios of artists who rely on big-money backers for large-scale – and often out-sourced – production. We are living through a historical tragedy: the extinguishing of the field of art as a site of resistance to the logic, values and power of the market.[11]

Fraser is enough of a close reader of the sociologist Pierre Bourdieu to know how the contradictions of the field of cultural production are, from the outset, tied to the social relations that produce surplus capital. What has perhaps been forgotten, or just plain abandoned, in contemporary art discourse is the fact that the critique of the "institution art" was developed as part of a critique of class society and is not perfectly synonymous with the critique of institutions.

Our thinking can thus benefit from a relative "disembedding" of art from society and politics to avoid what Lacanians refer to as premature historicization. Autonomy provides this very short-circuiting of a political perspective that is realist only to the extent that it insists on current conditions. Sinthomeopathy therefore insists, in dialectical fashion, that no pure synthesis is possible between the levels of art and politics, a claim that resists the post-structural reduction of art to a cultural politics of representation and a social constructionism that acts as little more than a new version of the thesis of false consciousness. Instead what we require is a concept of ideology that allows us to renew with the project of a critical realism in which art's awareness of its inconsequentiality as innocuous museum art leads not only back to life – cultural advocacy from within institutions and without – but back to a critical vision of the present: creative labour and cultural institutions in the service of a universal emancipatory project. As Badiou writes, "[a]ll those who abandon this hypothesis [of emancipation] immediately resign themselves to the market economy, to parliamentary democracy – the form of the state suited to capitalism – and to the withdrawal and 'natural' character of the most monstrous inequalities."[12]

The first chapter of this book discusses the work of Andrea Fraser. In 2006 I was asked to give a lecture on postmodern art at the University of Regina. The concerns of postmodern theory were at that time the furthest thing from my then current

research. It seemed to me that Fraser's work had provided an adequate answer the postmodern problem of "radical uncertainty."[13] Whereas Fraser's work, like most postmodern art, was certainly ironic, it distinguished itself from most other practices through its emphasis on determinacy rather than indeterminacy, critique rather than ambivalence, and decision rather than undecidability. Instead of postmodern double coding, her work confirmed the Lacanian truth that art always dies twice – the first time as formalist autonomy and the second as culture industry. The question remaining for me, and which runs like a red thread throughout this collection of essays, is how the subject lives in this state between two deaths.

The most immediate answer I could give to this problem when I first encountered it was Lacan's notion of the sinthome, the synthesis of symptom and fantasy and the political version of identification with the symptom.[14] The subject of postmodernism is split between the space of representation (experienced in terms of distance and detachment) and the space of identification (experienced as immersion and interestedness). Postmodernism brings into effect a nostalgia for modernism that it conceals from itself by gentrifying what it sees. The tendency of postmodern culture is to blind itself to present-day insecurities. It compensates for this state of insecurity by imagining the modernist past as quaint and outmoded. The postmodern notion of the end of meta-narratives thus acts like a symptom. It has the status for us of a meaningless bit of dogma that we adhere to as an alternative to class struggle. Psychoanalytically speaking, the temporality of meaningless doxa is that they seem to "come back from the future" in the form of a return of the repressed. They act in an unconscious way. Fraser's works from the 1980s and 90s announced a new kind of practice that was concerned with a working through of the meaninglessness and futile knavery of postmodern irony. In this her work gave meaning to meaninglessness, a para-doxa-logical activity in which ideology became

operative once again as a necessary illusion.

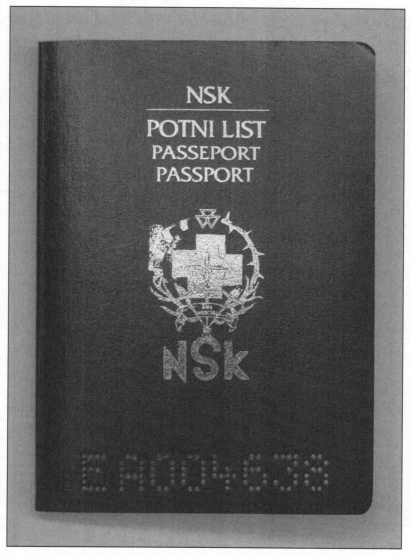

NSK, *NSK Passport*, 1993. Courtesy of IRWIN/NSK.

Many years later, one hardly needs to convince people that a certain kind of postmodernism is finished and that we have

become somewhat less contemptful of the sacrifices made in the past by those who struggled for a better world. Consider as an example of this, and also as an example of a kind of sithomeopathic practice, the recent glow-in-the-dark works of the Costa-Rican artist Juan Ortiz-Apuy. These works are based on pages taken from *The Freedom Fighter Manual,* a CIA document that was parachuted by airplains over Latin American countries in the 1980s. The images that Ortiz-Apuy exhibits appear to be blank in daylight but when the lights are out, their green luminescence allows a momentary glimpse of the pictograms, which teach civilian populations how to sabotage state socialist regimes. The same documents could of course serve insurgent forces fighting oligarchic regimes and this possibility I think is captured by the momentary flash, which is presented in the form of a "negative" image. The barbaric depravity of the texts is altered through a para-doxa-logical reading that brings to realization the constitution of subjectivity within ideological struggle. Another case is the work of Neue Slowenische Kunst, the Slovene collective that formed itself as a conceptual, virtual state after 1989, in the aftermath of the establishment of the new postsocialist states of the former Yugoslavia. According to Alexei Monroe, NSK State approaches the state as an abstract signifier of power and extracts from it utopian energies to provide a conceptual form of identification for individuals from various nationalities.[15] It issues passports that divert political energy into cultural form. Members of the musical group Laibach sometimes use these passports to travel from place to place, making the territory of the mind into a meta-construction that imposes everywhere it goes the alientated relation that people have to specific home nations, thereby rejecting the capitalist capture of identity through the pragmatism of security regimes and national differentiation. The responsibility for the use of the passports, once they have been issued, is left to the individual user. Through their verisimilitude with real passports, they appropriate mechanisms of state power.

According to Monroe, NSK State is a holding area for the repressed traumas of twentieth-century utopianism. It brings to light the falseness of the claims that are made by contemporary states to be concerned only with pragmatic political and economic reason and thereby reveals the absence in neoliberal governmentality of any meaningful expression of human hopes and desires.

If the field of cultural production, as Pierre Bourdieu defined it in *Distinction*, could be considered the effect of long-forgotten traumas, then the field itself can operate in this framework as symptom.[16] Transference, which operates as a fundamental misrecognition, allows us to think of the field of culture as precisely, postmodernism's historical necessity, a misrecognition of the orthodoxies of the theory of the end of ideology. Transference thus allows us to link fantasy with the artworld as symptom. In other words, when we operate in the field of art we are working in a space this is almost pathologically unable to incorporate the needed political awareness of its conditions of existence. As the avant-garde artist or critic begins to dissolve the state of transference, she becomes the subject responsible for her state of being, she begins to subjectivize the institutions that operate as mediating devices in the reproduction of social classes and the divisions of labour. Access to a critical understanding of the uses of the theory of the end of ideology is paid for with the loss of enjoyment. Having died twice, the artist is neither modern nor postmodern, yet caught in the order of time conditioned by her relation to the symptom, her relation to the artworld. Sinthomeopathy traverses the surplus enjoyment of end of ideology postmodernism and yet, in practice, identifies with the pathological particularity of culture in the age of late neoliberal capitalism. It was Andrea Fraser's work that first offered me this insight and it is to this subject that I turn to in the first chapter.

Andrea Fraser and the Subjectivization of Institutional Critique

Ever since the potentialities of aesthetic autonomy have been thought to have be negated by their disciplinary incorporation into the culture industries, artists working in mode of institutional critique, figures like Marcel Broodthaers, Hans Haacke, Michael Asher, and Daniel Buren, have sought to not only underscore the socioeconomic function of art, but to radically alter its place of production. As Peter Bürger surmised in his *Theory of the Avant Garde*, the social function of art does not depend on works, but on institutions. Avant-garde autonomy, if we can still speak of it today, continues not only to mine the contradictions of art's institutional incorporation but proposes an ethical engagement that seeks to expose and transform the social relations of domination that condition the very mode of critique. In her work from the late 1980s and 1990s, the American artist and critic Andrea Fraser offered some of the most complex performances of critical autonomy by subjugating herself to the manifest and unofficial mandates of various institutional contexts. Fraser's work has complicated the mode of institutional critique by amplifying the dimension of subjectivity through a feminist and a psychoanalytically informed performance of the way the "institution art" operates through fantasy, desire and identification. In particular, the institution-specific performance project, *Museum Highlights* (1989), and the less well-known collaborative work, *Services* (1994), enacted many of the insights that Fraser presented in theoretical terms in her published essays. By extending institutional critique to feminist grounds, and by remaining committed to sociological concerns with questions of economic and class

structure in relation to aesthetic autonomy, these works provided a powerful critique of the professionalization and corporatization of the artworld. They did so by betraying the manner in which the public mandates of art institutions allow them to ignore the socio-political presuppositions of contemporary art. What marks the specificity of Fraser's analysis of the relations between the field of cultural production and the field of power, however, is Fraser herself. Paradoxically, the siting of the specificity of Fraser's work, overtly privileged in terms of the unique figure of the artist, is provided by her close adherence to sociology. In the following I examine the shift in Fraser's work from the construct of the "split" figure Jane Castleton/Andrea Fraser in *Museum Highlights* to the collaborative figure Andrea Fraser/Helmut Draxler in *Services*. In both instances Fraser draws on feminist approaches to psychoanalysis as a means to explore the sociological determinants of what I argue is a distinctly petty-bourgeois and transnational mode of creative cultural production. "Working through" the desire of the "institution art" and its obscene demand for cultural consecration, Andrea Fraser's work supplies institutional critique with a curious instance of avant-garde contestation.

What Does Autonomy Want?

Fraser's presence as an art theorist was first noticed in an article she wrote for *Art in America* concerning the work of Louise Lawler.[1] In Fraser's essay, Lawler's critical analysis of the postmodern museum is appreciated for bringing feminist issues to bear on institutional critique. The lucidity of Fraser's critique of cultural institutions was further established through the publication of the transcript of *Museum Highlights* in a 1989 issue of the journal *October*, a piece that occasioned the critical reception of her artwork.[2] The *October* transcript was followed in the 1990s by a series of essays that provided a fairly gender-blind analysis of the working conditions of artists who produce

context-specific project work.[3] While a number of theoretical approaches have been used by Fraser to describe her practice and her concerns, she has consistently made reference to the influence of the Marxist sociologist Pierre Bourdieu and in particular his book *Distinction*, a work which argues that taste functions as a marker of social class.[4] There is no doubt that Bourdieu has allowed Fraser to complicate the grammar of feminist-based body art and performance and simultaneously – through the performance of embodied social position – to address the limitations of the male-dominated tradition of institutional critique, where the names of Broodthaers and company have predominated. Throughout this short period, however, Fraser's writing became increasingly focused on a class-oriented sociological analysis. If second wave feminism could be thought to have refused the prioritization of class politics along with house cleaning, Fraser's work from the 1990s could be said to have challenged the mythologization of feminism in its art institutional setting.

Fraser's work invites viewers to decipher the complex relations that support and sustain the functioning of art institutions and the subject positions that are constructed in relation to them. She credits Bourdieu for having developed a reflexive sociology that acknowledges the ambivalence of artists and intellectuals who are positioned disadvantageously in a field of practice that works to sustain forms of social and symbolic domination through the force of cultural judgement.[5] Through the maintenance of the autonomy of artistic practice, artists and intellectuals reproduce structures of social inequality. Because of this, she argues, the artist must develop a reflexive practice that first uses aesthetic autonomy as a weapon against oneself, a kind of self-instrumentalization of resistance.[6] Inasmuch as there is no critique of the field of artistic production that does not involve a relation of desire, a fluctuating and intermittent motivation, there is no pure object of institutional art discourse, but rather a subject

of art discourse caught in the fantasy of appearances, an objectively subjective relation to the autonomy of the field.

By attempting to embody culture's impossible reduction to its material and economic supports, the purpose of Fraser's work has been, defiantly, to postpone and deter the reification of radical autonomy by exploring the ways that the field of art appears to her.[7] The subjectivization of the space of art institutions is noticed in the following statement by Fraser: "It's not a question of being against the institution: We are the institution. It's a question of what kind of institution we are, what kind of values we institutionalize, what forms of practice we reward, and what kinds of rewards we aspire to."[8] The reflexive secret to this action of subjectivization is effectively discerned in the emphasis on questions of taste and manner, which Bourdieu described in his theory of *habitus*, an account of the subjective predispositions towards culture, taste and conduct that are affected by objective social conditions, including education, social origin, and upbringing. The habitus is, according to Bourdieu, a structured structure (a synchronic complex) and a structuring structure (a process of social formation), a diachronic practical logic that continually reflects on and departs from its previous premises and, as such, is open to modification. The value of the concept of habitus, then, is that it de-idealizes the social conditions that produce individual actors as well as social classes and proposes some determining conditions and limits that are operative "below" the level of conscious decision-making. Bourdieu writes:

The schemes of the habitus, the primary forms of classification, owe their specific efficacy to the fact that they function below the level of consciousness and language, beyond the reach of introspective scrutiny or control of the will. Orienting practices practically, they embed what some would mistakenly call *values* in the most automatic gestures or the

apparently most insignificant techniques of the body... and engage the most fundamental principles of construction and evaluation of the social world, those which most directly express the division of labour (between the classes, the age groups and the sexes) or the division of the work of domination, in divisions between bodies and between relations to the body which borrow more features than one, as if to give them the appearance of naturalness, from the sexual division of labour and the division of sexual labour.[9]

For Bourdieu, all culture and cultural knowledge has the structural dimension of a fundamental misrecognition that is based in sociological difference. In his words again:

The dialectic of conditions and habitus is the basis of an alchemy which transforms the distribution of capital, the balance-sheet of a power relation, into a system of perceived differences, distinctive properties, that is, a distribution of symbolic capital, legitimate capital, whose objective truth is misrecognized.[10]

Fraser's defense of the sovereignty of the artist mimics the "unconscious" discourse of the museum as a secret language whose meanings are unknown, or misrecognized by its most adept adherents. We always play the game of culture, Bourdieu argues, but without ever knowing what the game is and without a clear understanding of the rules and who makes them. As such, one's personal disposition towards culture always entails the achievement of a certain level of competence related to these official and unofficial rules, beliefs and codes of performance.

Fraser's work, I would argue, is largely based on the mimicry of socio-cultural positions and dispositions that directly or indirectly support and challenge the unstated and unwritten rules of interaction, at times performing them effectively and at

other times making statements and "slips" that would not likely be part of the habitus of one and the same performer. Mistakes and discontinuities are disclosed through defamiliarization techniques like quotation, juxtaposition, assemblage, collision and conflation. Once the codes of a structure are exposed, what may at first have appeared as a necessary causality is put into question. Among the forms of inconsistency that are evident in Fraser's performances are discursive fluctuations, transdisciplinary confusions, role reversals, modulations of affect, self-reflexivity, the gratuitous rendering of normally unstated and unconscious motives, and a sometimes casual, sometimes aggressive, attitude toward her audience. Her scripts incorporate what is normally not the province of the artist, but rather what is associated with the "more impersonal" and "less creative" aspects of administrative procedures, marketing, maintenance and fundraising.[11] Fraser brings to light the ways in which the mechanisms of managerial competence form the unstated basis of all cultural production, including careers in institutional critique.

Following her 1986 gallery talk/performance, *Damaged Goods Gallery Talk Starts Here*, and her 1988 collaboration with Louise Lawler (called *The Public Life of Art: The Museum*), *Museum Highlights* (1989) initiated an unprecedented mode of site-specific performance. Presented as a docent tour of the Philadelphia Museum of Art, the work introduced a character called Jane Castleton, a figure that Fraser defines as a site of identification. Subjective identification with Castleton, performed by the artist herself, allowed Fraser to elaborate the objective social position of the contemporary artist. *Museum Highlights*, we could say, contracts in the figure of Fraser/Castleton the stages that someone like Fraser goes through in order to become an artist. Sociologically speaking, and to paraphrase Simone de Beauvoir, one is not born an artist, one becomes one. To become a critically recognized artist requires a high volume of cultural accultur-

ation. According to Bourdieu, cultural capital is most often acquired through education, and it is in the field of education that different cultural competencies among agents with unequal social capital encounter the limits of the schools' objective mechanisms of elimination and channeling. Beyond the highest levels of educational capital, it is the effects of the field of power, defined narrowly in terms of social and economic capital, that can reestablish what magically appears to be the miracle of inequality.

Adrea Fraser, *Museum Highlights: A Gallery Talk*, 1989. Courtesy of Friedrich Petzel Gallery, New York.

In *Museum Highlights*, Fraser takes on the guise of both Andrea Fraser (embodied) and Jane Castleton (performed). The institutional role played by Jane Castleton is that of a museum docent. This position, as it is traditionally embodied, is linked to someone who is associated with a high volume of social and

economic capital, and who aspires not to a high level of scholastic and cultural competence, but to a varied composition of all of these in order to achieve and maintain a high level of social power, displayed on the institutional site as a friendly, competent disposition towards legitimate culture. The docent, who is most often female, and who is typically unpaid for her services, functions as a vehicle of cultural transference, understood both in a psychoanalytic sense and a sociological sense, a mediator of different dispositions toward the museum.[12]

Fraser mentions the significance of Bourdieu's work in coming to an understanding of her personal investments in art as a system of cultural authority and domination. *Distinction*, she writes,

> exposed the paralyzing experience of illegitimacy with liberating clarity: the muting and mutilating violence of cultural judgments, the crushing authority of consecrated competence, the anguish that filled the gap between knowledge and recognition, the sense of imposture, the distinguishing force of aspirations structured according to socially and materially foreclosed possibilities.[13]

Playing herself, Fraser acknowledges her own investment in a process of cultural legitimation and domination. As Castleton, she dissimulates these investitures, and also fails to do so, with the manners of an ambitious and shrill socialite. Castleton is aware of the unequal social relations that structure her activity but disowns them by associating herself with the official letter of high culture as a space of formal equality. Her function as a docent allows her to imagine high culture to also be a reflection of her personal culture, a free relation that is seemingly unconstrained by necessity. Bourdieu's reflexive sociology thus becomes a model for both a subject-specific institutional critique and site-specific critique of the subject.

Through the collage construct of Fraser/Castleton, the artist presents and interrupts her own desire for critical consecration. Castleton mixes sociologically distinct dispositions – disenchantment, passionate investment, didacticism, resentment, reverence – not only towards legitimate culture, but also towards different museum functions: gallery spaces, lobbies, giftshops, washrooms and cafeterias. We could easily understand her confusion of cultural dispositions as consistent with what Bourdieu defined as the allodoxia of middle-brow culture, the "mistaken identifications" and "undifferentiated reverence" that transform artistic experiment into accessible versions and educational entertainments.[14] The attitude of "cultural goodwill" defines the indeterminacy of the petty-bourgeois social position as the tendency to accept extortion by the dominant class through the acceptance of ready-made judgements and the reproduction of the "origins of capitalism" through privations aimed at future recompense. The indeterminate position of the petty bourgeois culture industries, trapped between cultural conservatism, on the one hand, and the administration of a mass-mediated museum culture on the other, has undergone a structural transformation from the time of Bourdieu's studies. As the farm owning and manufacturing middle classes of the nineteenth century became the "classless class" of a now global consumer culture, and as the gap between the extremely wealthy and white collar employees increases, the contradictions of class polarization exert their influence on the social coordinates of cultural production. Today, even if one is economically middle-class, one's cultural disposition has a tendency to be petty bourgeois. Bourdieu's model of class distinction from the late 1960s is therefore not so much out of date as it is out of joint.

In her essay on Louise Lawler, Fraser associates art practice itself with the maintenance of a system of beliefs and social values, a "profession of social fantasy" based in ideologies of autonomy that deny the material interests of producers.[15] The

structures of aesthetic discourse are supported by fantasies of artistic competence, revamped in terms of avant-garde trans-gression and political contestation. Psychoanalytically speaking, the desire for cultural consecration in the form of a recognizable signature is associated with the form of a castration that inscribes subjectivity in a system of imaginary identifications with symbolic authority. For Fraser, the significance of Lawler's work was that it did not deny this relation.[16] It is an open question, however, the extent to which this admission merely operates a form of capitulation.

In *Museum Highlights*, Fraser's identification with Castleton is conditioned by her association with the museum as an exchange station for various kinds of capital: cultural, social, economic and intellectual. How is it that Fraser can consider Jane Castleton to be "the museum's exemplary viewer" when docents like her have remained marginal to the more scholastic, curatorial functions of cultural institutions?[17] Fraser writes,

> Jane is determined above all by the status of the docent as a nonexpert volunteer. As a volunteer, she expresses the possession of a quantity of the leisure and the economic and cultural capital that defines a museum's patron class. It is only a small quantity – indicating rather than bridging the class gap that compels her to volunteer her services in the absence of capital; to give, perhaps, her body in the absence of art objects.[18]

Fraser can consider Castleton to be the "the museum's exemplary viewer" because, in the form of Fraser/Castleton, Castleton marks the internal difference that links Fraser to the field of art and the field of institutional critique, providing her with a readymade insider status. Castleton, who offers her body, affect and services in the absence of a recognized cultural contribution, functions as a moment of seduction, a turning in on oneself that

Jean Laplanche defines as *"auto* time."[19] The paradigm of seduction facilitates Fraser's regression to the ideological fantasy space of the museum as the cause of desire. Rather than produce a sublimated or fetishized cultural product, Fraser enters into a transferential relation with the museum through Castleton as a surrogate. The result of this assymetry, of an impossible transformation and passage from one site (institution) to another (subject) is equivalent to the conversion of anxiety into libido. As the situation is libidinized, cultural production overlaps with sociological investigation; aesthetic autonomy now operates directly in terms of the production of subjectivity.

The psychoanalytic concept of transference allows us to perceive how it is that Fraser understands the museum in relation to processes of social formation, incorporation and intersubjectivity.[20] In a psychoanalytic situation, the subject enters into a relation of transference and resistance with the analyst. Only the subject can articulate their subjective relation to the unconscious, though this knowledge is perpetually deferred. In transference, the subject presumes that the analyst is the one who knows. This is not only a concession to what Lacan called the big Other, but also a kind of imminent demand imposed on the subject from without. Transference implies a form of resistance, an attempt to preserve one's desire, to preserve ego, as a defense against the analyst's gaze and the obscene demands of the unconscious.[21] In the psychoanalytic process, the analyst must resist the subject's displacement of subjectivity; the analyst must simultaneously support and deny the subject's cathected affect.

While Fraser argues that museum visitors impose on the docent the demand to know, the reality of a heterogeneous public imposes on Castleton, who embodies the specific class interests of the museum's patron class, the demand to know what she does not know, or what she chooses to ignore, that is, "different, conflicting interests."[22] The subjective is therefore a crucial moment of institutional critique. Fraser writes,

In the context of paradigms of site-specificity, defined by its physical, urban, architectural, geographical, or geological spaces and places, the constitutive sites of feminist practice were above all the body and the political, social, sexual, and intersubjective relations in which that body exists: a kind of "relational specificity" that I see as fundamentally feminist.[23]

However, and while the body makes its demands in terms of habitus – a durable and transposable complex of tastes and dispositions – the body's relation to the psyche makes such demands a matter of repression and fantasmatic projection. The body that supports legitimate culture and good taste is, according to Bourdieu, a member of the dominant group whose criteria of selection remain tacit because considered absolute, thereby masking the psychic processes that produce identity and identification. As Castleton says many times during the performance, she wants to be graceful. In order to be graceful, she couches her judgements in the rhetoric of legitimate culture and in the ethos of elective affinity, all the while attempting to regulate these concepts through physical presence, gestural flair and tailored clothing. Fraser has stated that she has long felt a personal sense of illegitimacy with regard to cultural institutions. Despite this, she says she understands "how Jane feels." She shares with her a subjective relation to desire that simultaneously crosses and consecrates social divisions. Castleton's bodily hysteresis, occasioned by the mere thought of working-class visitors, or what she calls "lower lowers," displays how she wishes she could desire her own self, an idiomorphic identification with a self that is misrecognized through the lens of legitimate culture. In the unfolding of the performance, we become aware of the impossibility of an ideal museum visitor as well as an ideal self. Fraser makes an important observation that we could take to be the authorial intention that structures Castleton's hysteresis: "I don't ask people what they want.

Despite all the references that I've made to what people who go to museums want, I'm finally not dealing with what could only ever be my fantasy of a public."[24]

The Field of Immaterial Labour

Contemporary approaches to cultural production in the age of cognitive capitalism look to the immaterial aspects of cultural goods within what is sometimes considered an affective economy. This extension of the field of marketing and promotion into the structure of the cultural commodity is carried to the point of excess in *Museum Highlights* as audience members do not know if they should identify with Fraser/Castleton out of horror, fascination or collusion. This short-circuiting of identification was later questioned by Fraser as she sought means to allow audiences to participate more directly in the critique of the institutional production of subjectivity. Perhaps the most complex example of this is the project *Services*, a collaborative performance that proposes professional self-examination as artwork.

Given that the self-criticism of art cannot occur within the current conditions of the capitalist depoliticization of autonomy, or even that such a self-criticism is now essentially pointless, Fraser's work provides an exceptional analysis of the conditions for a critical contextual art, a kind of psychotherapy where the positions of artist and institution, analyst and analysand interweave. Because Fraser adopts a reflexive mode that addresses the conditions of artistic production and the social relationships that artists must acknowledge if they are to participate in the game of culture, her emphasis on symbolic production and affect as part of the global flows of capitalism challenges legitimate culture's pretense to the maintenance of existing asset structures. Fraser can objectify the game of culture, however, only inasmuch as she engages with the pretensions of artists and art professionals who are witness to the transformation of the legitimacy of bourgeois high culture into the legitimacy of an international class that

refuses all specificity of identity and class determination. As a sociologist and an art theorist, and in order to underscore the institutional administration of culture, Fraser works to reconstruct the objectivity of the lower-middle class, or what was once referred to as "white collar" salaried professionals.[25] The hegemony of this class formation does not imply a domination of the entire social field, especially as culture industries continue to exploit, rather than impose, the fragments of the decaying dominant culture.[26] As a dynamic field, the field of culture gives rise to levels of subjectivation that are mediated by belief in the game and levels of affective engagement marked by social difference. The conditions for a critical contextual art are defined by *Services* as the possible transformation of institutional critique on the basis of political decision and collective action, a *passage à l'acte* that marks the limits of the homology between culture and economy.[27] Since she has begun to receive critical exposure as a vanguard figure within institutional critique, Fraser has concerned herself with the relation between her own practice and the institutions that choose to endorse her critical and often parasitic activity. While my attention to her as an individual artist may seem to replicate the charismatic conception of artistic individuality and creative autonomy, it should be clear that the relations that artists entertain with institutions are not only defined by artists' subjective dispositions but depend on changing structures and contradictions within the spheres of cultural activity themselves.

To discern the conditions of possibility for a critical art practice means to consider the possible-impossible of social formation as it is revealed in practice. *Services* is just such a complex discussion-exhibition work. Devised by Andrea Fraser and Helmut Draxler, it was subtitled *The Conditions and Relations of Service Provision in Contemporary Project Oriented Artistic Practice*.[28] In the following I argue that *Services* is an exemplary work of critical art inasmuch as it attempts to work through a

number of contradictions and implications for the transformation of site-specific art, institutional critique and discourse-based institutional analysis in the 1990s. Not only does it attempt to map out the development of tendencies in the social space, understood in terms of a global division of labour, but does so with acute attention to the question of subjectivity, understood reflexively in a situation whose outcome depends on interaction with other cultural producers at a specific moment in time.

Services is a performance and discourse-oriented piece in which the relation between the artist and various fragments culled from the institution's administrative matrix is reduced to the relation between Fraser, or Fraser/Draxler, and a group of artistic peers. In the proposal for *Services*, Fraser and Draxler outline a framework for an exhibition that would bring together individuals who would discuss the relations and conditions of project work, defined as "service provision," where artistic labour is spent without there being a finished material product, and consequently, where there may not be adequate remuneration or long-term recognition.[29] The two-day working-group discussion, which took place at the Lüneburg University Gallery, brought together artists and curators whose work is premised on an engagement with the subject and specificity of *Services*. Documents relating to the history of professional artists' organizations and collectivization, as well as contracts and documents relating to the participants' recent projects, were collected for display in the exhibition space and were available to be photocopied for the duration of the exhibition. The working-group discussions were videotaped and screened during the remainder of the exhibition. The project work in question concerns various forms of materialist art practices including conceptual art, institutional critique, post-studio, activist, site-specific, and community public art. While these practices have sought to transform the modes of production and reception of cultural work, they have also tended to participate in the transformation

of professional artistic activity into service provision. Fraser's concern, as stated in a number of articles published independently of Draxler, is that the critical intentions of artists whose practices are based in project work may be undermined by institutions, and by artists themselves as a specific cultural constituency, when institutions actively recruit artists – often artists with no history of project work – to provide artistic services.[30] Given these working conditions, *Services* assembled artists to discuss the manner in which institutions have usurped their prerogatives, actively marketing critical tendencies and limiting art's non-economic determinations.

Andrea Fraser (in collaboration with Helmut Draxler), *Services*, 1994.
Courtesy of the Kunstraum der Universität Lüneburg.

Before *Services*, Fraser participated in a number of informal discussions with project artists Michael Clegg, Mark Dion and Julia Scher. These artists were concerned with the fact that numerous art exhibitions at that time included requirements for site-specific project work. In the year that these discussions took

place, 1993, project work was commissioned for exhibitions in Chicago, Antwerp, Vienna, Graz, Firminy, as well as the Venice and Whitney Biennials.[31] Fraser later conceived *Services* as a differential intervention, taking into account the interests and investments of artists and institutions, and also recognizing the situation as a critical moment where artists and curators had the opportunity to act collectively to reformulate labour relations with art organizations through professional self-regulation. Fraser did not say to what ends *Services* should be used, but rather, sought to produce an alternative to the competitive organization of exhibitions, which guarantees mutual relations of exploitation among practitioners. Through the assessment of the situation by the practitioners involved and the very enactment of the problems at hand in the exhibition itself, the piece further explored the articulation of "the subject of site specificity."

Reading *Services* involves numerous strategies of interpretation that are marked by different material forces and regimes of truth. There is no singular interpretation of the project and this fact is emphasized by Fraser's efforts to minimize her presence by functioning as curator and organizer, by doing this in collaboration with Draxler, and finally, by allowing the accumulation of documents to stand in and outweigh any desire to represent the artist's personal interests. Minimizing the drama of orchestration, the construction Draxler/Fraser operates as host for the interventions of their invited guests, competitors, co-conspirators and colleagues. *Services* enlists the cooperation of artists and curators who appear to be trapped within the terms and conditions of a competitive and hierarchic power structure. The same institutions that commission project work, and through the privatization of their public functions, increasingly monitor the speech of critical artists through sanctions or, inversely, demand that artists provide concrete solutions to social, cultural and economic problems.[32] Paradoxically, it is the partial liberalization of the field, its limited social function, which allows for corporatization

through corporate funding.[33] In a more restricted and restrictive cultural and political economy, the efficiency of the market allows institutions to recuperate any critical work that seriously challenges the technocratic manipulation of common concerns, interests and investments. *Services* brought to light documents pertaining to the history of the struggle for collective organizing and added to this existing stock the tracts and contracts of the participants. While the overdeterminations of competition were meant to be shifted toward an analysis of shared responsibilities, the difficulties of social antagonism and misunderstanding were allegorized *in situ* through the spectacle of who talked the most, who talked the loudest, who didn't need to talk, who took responsibility, who assumed guilt, who acted innocent, who didn't know what was going on, and who was justifiably annoyed.

Acting as mere functionaries, the artists Draxler and Fraser express and betray the benign affirmation of petty-bourgeois culture in the context of neoliberalism. As a space of collective negotiation, *Services* allows for the restructuring of institution-alized discourse and makes room for the possible-impossible. The power of each participant amounts to a power of potential or virtual collectivization and a power to elaborate the institutional conditions of that power. *Services* attempts the impossible by bringing together the site of production and the site of consumption; it symbolizes and materializes an exhibition dedicated to performing service work as service to a service community and by the service community with the unknown outcome of who or what this service would ultimately serve.

Does the reflexivity of this project make it different from other service-oriented projects? According to Fraser:

> I would say that we are always already serving. Studio practice conceals this condition by separating production from the interests it meets and the demands it responds to at

its point of material or symbolic consumption. As a service can be defined, in economic terms, as a value which is consumed at the same time it is produced, the service element of project based practice eliminates such separation. An invitation to produce a specific work in response to a specific situation is a very direct demand, the motivating interests of which are often barely concealed and difficult to ignore. I know that if I accept that invitation I will be serving those interests – unless I work very hard to do otherwise.[34]

Services attempts to replace aesthetic disinterestedness with reflexive interest, providing institutions with a model of contemporary avant-garde production, and providing cultural constituencies as well as interested audiences with a model for transforming the art system into a real social force. The object of critique in *Services* is not a foreign power, but the way we ourselves are involved in maintaining the reproduction of artistic autonomy as the basis of economic investment and self-exploitation. This critique necessitates an objectification of the demand for art that institutions reproduce and the competitive struggles artists enter in order to reproduce belief in the value of works, which then figures as the objective basis for this demand. *Services* elaborates this contradiction by objectifying the specificity of the relation between demand and supply (commerce) as also a subjective relation. The specificity of the work derives, paradoxically, from its formal distance from the belief in a categorical difference between the sphere of cultural production and the sphere of economic value, a constitutive split that artists perpetuate through their specialization. *Services* performs an artistic service as an excess, an unassimilable remainder and a point of failure (since belief guarantees distance) in the edifice of the enlightened elitism of the new service art with a human face.

Like *Museum Highlights* before it, *Services* proceeds by dividing its audience, addressing the objective conditions of

competence with regard to cultural value. Making art profes-
sionals and art students the primary audience for *Services* created
the potential for audience members to become actors within the
project; it underscored the lack of opportunities for co-operative
dialogue, without, however, making dialogue and relationality
the basis of a new aesthetic. Fraser/Draxler thus perform the
function of what Bourdieu defined as heresiarchs and ascetics,
disabused "new style autodidacts" and taste-makers who,
because they are alienated from their own destinations, reveal
the dangers of the field. For this reason, the reconstruction of the
field is provisional since the participants must continue playing
the game.

In a 1997 essay, Fraser outlines some of the assumptions of
public service provision on the part of institutions. She writes
that the demand for service and community-based projects in the
early-to-mid 1990s "appeared to be related to a need by publicly
funded organizations to satisfy the public service requirements
of their funding agencies."[35] This demand and perceived need
for project work marks the specificity of not only the internal
relations of the artwork (or intervention) and the site (however
broadly the site may be conceived), but also the external
relations between the artist and the sponsoring organization.
How then do the external limits condition the internal limits?
Public projects satisfy a need on the part of the public to believe
that public institutions will always exist as they currently do and
justify the growing control of corporate and state agencies.
Fraser/Draxler do not propose that artists must accelerate the
process of privatization so that a genuine confrontation between
forces can take place. Theirs is the position of what Slavoj Žižek
refers to as the role of the *femme fatale* in film noir. In contrast to
the view that the *femme fatale* threatens the detective (the partici-
pants in *Services*) with castration, Žižek argues that what is
threatening about her is the fact that, as symptom of the
detective, she is impossible to locate in the opposition between

master and slave. Her destiny is to become the victim of her own game.[36] We could say then that the *femme fatale* figure of Fraser/Draxler assumes her own fate as a nonpathological subject. She reveals that the institution is a fantasy construction that does not know all. The transference of guilt in *Services* to other cultural producers thus depends on the institution as a network of intersubjective relations.

Fraser later drew the conclusion that the implications of *Services* were not addressed by the participants and were even humorously disavowed by the artists Renée Green and Stephen Dillemuth.[37] She argues that the institutionalization of site speci- ficity and project work has proceeded unchecked and according to market logic. This is not merely imposed from above, but must somehow be consistent with the needs of artists and curators who see themselves as being in competition with commercial enter- tainment. This situation has allowed for a shift in the 1990s from public funding for culture to corporate funding and business models for art. The function of art as a public service and a social good nevertheless transcends changes in the socio-economic structure. Here we come to appreciate an important aspect of the theory of autonomy. At the point of interstitiality, Fraser/Draxler maintain the use of this residual rhetoric in order to pursue a critical and emancipatory agenda. The success of *Services* thus depends on the incorporation of other artists and the public into a macro power bloc set against the increasing privatization of the field. There is no question then of declaring the end of aesthetic autonomy, but instead, what we find in this work is a sounding out of social contradictions within the new order of neoliberal cultural administration.

As with the device of Andrea Fraser/Jane Castleton in *Museum Highlights*, Fraser's relation to *Services* is both performed and embodied, embodied at the level of the artist's scholastic habitus and performed as one participant among others in a structure of impossibility. Fraser and Draxler's interlocutors understood that

the goals of the exhibition were written into the proposal. The performance of the working-group therefore operated as a taste-making, taste-destroying exercise. The participants also likely understood that to reject professionalization was to reject the system that exploits them and through which they exploit themselves. To adopt professionalization amounted to the same, but with the added burden of guilt. By linking the field of cultural production to the field of power in general, and through the agency of a subjective investment in its conditions and relations of production, *Services* activated art as a critical force against the real and illusory consequences of autonomy.

Chapter 2

Community Subjects

Criticism of community art provides new ways to consider the question of subjectivity from a non-essentialist perspective that affords us the occasion to conceptualize the relationship between subjective and social formations. In relation to developments in political theory, the use of the two terms community and subject implies a series of displacements of liberal, nationalist and multiculturalist conceptions that function in terms of what Michael Hardt and Antonio Negri, after Gilles Deleuze, refer to as "capture devices," systems of incorporation and differentiation that alienate living, productive labour from autonomous self-valorization outside the decision-making power of the state and the coercive forms of capitalist integration.[1] From a Lacanian, psychoanalytic point of view, such capture devices are the *points de capitonnage* (points of ideological suturing) that are inherent to subjectivity and that operate through processes of identification and disidentification. What do today's creative and culture industries want from community subjects? How does identity relate to the voluntary class of virtuous citizens that is today expected to empower the traditional face-to-face community against the vagaries of the neoliberal capitalization of markets, which includes increasing poverty and economic disparity, crumbling infrastructure, mass displacement of populations through unemployment, neo-colonial war and famine? Finally, how can we reimagine a community subject that is immune to the forms of democratic contestation that seek a mere surface reorganization of capitalist social relations?

Superflex, *Free Beer*, Copenhagen University, 2005.
Courtesy of Superflex.

These are some of the questions that are posed by today's socially engaged community art. In the following I consider two competing paradigms of community art and propose a third, alternative framework for critical cultural practice. The first of these is Nicolas Bourriaud's *esthétique relationnelle*, first proposed in 1998.[2] Bourriaud describes relational work, for instance the work of artists like Rirkrit Tiravanija and Liam Gillick, as unfinished, open-ended works that do not provide collectible objects but that are oriented toward social interaction. The creation of communal spaces like bars, lounges, and libraries allows for connective possibilities, participation and unexpected encounters. The low-fi, in-between aesthetic of relational works is nevertheless related to a somewhat deterministic criterion: the shift to a post-Fordist experience and service economy. Bourriaud's idea of relational aesthetics has received the kind of

approval that comes from its association with the work of internationally recognized artists. The criticism it has received, however, is due precisely to its rather confused approach to critique.[3] Despite the idea that the participant viewer is part of the work, the model of service provision that Bourriaud has championed willfully ignores the divisions of labour that structure the field of culture. While he attempts to shift the question of value away from labour and toward various other economies, or "powers," his emphasis on "freeness" and "open-endedness" results in a kind of inertia that makes the experience of the work not unlike the experience of the rest of everyday life in a world of exchange. What is significant for our discussion, however, is the fact that relational aesthetics seeks to shift art's focus away not only from modernist avant-gardism, but from the postmodern preoccupation with identity. Fixed agendas are replaced by an ambient transcultural mixing and the confusion of codes.

One critical example of relational work is the Swiss collective Superflex's *Free Beer* campaign. *Free Beer* is an "open source beer" that is modeled on file sharing. The recipe for the beer is available to anyone through a Creative Commons license that allows Superflex to bypass the conventional copyright restrictions on intellectual property. *Free Beer* has been shared on numerous occasions and in particular at the inaugural gathering at the Copenhagen IT University in 2005. Another example of relational work is Piotr Uklanski's *Dance Floor* of 1996, which is now part of the collection of the Guggenheim Museum in New York. Uklanski has stated that he set out to create a work that would be "all generosity and no ideology." In both cases we could offer the criticism that while the artists seek to create convivial experiences, they ignore the specific conditions in which their work is produced and received, not to mention the fact that the freeing up of copyright restrictions is one of the contradictions of the liberalization of markets. As Slavoj Žižek has argued, the dream

of "frictionless capitalism" is shared not only among marginal, anti-establishment hackers and anti-globalist radicals, but also by big executives like Bill Gates and conservatives who consider themselves opposed to centralized bureaucracy, authority, routine and industrial production.[4] How then are patronage and the conditions that structure the field of production reflected in the participatory emancipation of spectators?

Piotr Uklanski, *Dance Floor*, 1996. Guggenheim Museum.
Photo Cayley Sorochan.

A second model for engaged community art is Grant Kester's idea of "dialogical aesthetics," a theory of contemporary art that is developed in his book *Conversation Pieces*.[5] Kester expanded his new theory as an offshoot of the "littoral art" movement that emerged in Europe and North America in the 1990s. Littoral artists are concerned with politically efficacious activist art. The major premise of dialogical aesthetics is that twentieth-century avant-garde art is largely mistrustful of the communicational

model of dialogue and has resorted to various non- or anti-discursive means to radicalize art production: shock, defamiliar-ization, abstraction, etc. Translated in simple political terms, Kester seems to be suggesting that modern aesthetics can do more to contribute to progressive social change if class struggle is replaced with social collaboration. Rather than producing trans-gressive works that merely contribute to art's estrangement from the public and that reify the exclusiveness of the field of cultural production, dialogical artists make work that is participatory, deliberative, democratic and pedagogical. Dialogical artists are not interested in the celebrity status of the individual artist and signature styles are substituted for whatever means suit the needs of a project.

Perhaps the most notable example of communicative art practice is the work of the Viennese collective WochenKlausur (Weeks of Enclosure). In the past two decades, WochenKlausur has created numerous projects that propose creative solutions to social problems affecting the unemployed, the homeless, drug addicts, immigrants and the handicapped. The problems they address are endemic and are not solved by existing divisions of administrative expertise and legal jurisdiction. The artists use their status as autonomous and creative agents to oversee discus-sions among selected participants and to propose means to improve social coexistence. The criteria for quality and success are not aesthetic but are determined in advance by the deliberate intentions of the intervention. In order to facilitate the public acceptance of the work, the instruments of the bourgeois public sphere, the mass media and the art system, are strategically co-opted and politicized.

There are some problems related to groups like WochenKlausur's subordination of aesthetics to an instrumen-talized or operative notion of what is "good social activism." In *One Place After Another*, Miwon Kwon raises the problems associated with the assumption that communities are coherent

WochenKlausur, *Boat Talks*, Zürich, 1994. Courtesy of WochenKlausur.

and unified.[6] She suggests instead that communities are unstable and, in the words of Jean-Luc Nancy, inoperative.[7] Kwon also addresses the issue of institutional pressure. As socially engaged community art is increasingly promoted by institutions and granting agencies, curators, critics and adminstrators take on a greater role in the integration of independent social practices with management critera of success. Kester states elsewhere that this results in the ideological subsumption of community art within the "moral economy of capitalism."[8] Artists work with community subjects whose social disadvantages are individualized and whose path to social improvement is clearly marked out in relation to existing state institutions as well as free market, entrepreneurial solutions.

Kester seeks to defend politically motivated activist art against the depoliticizing attitudes of the institutionalized artworld. The problem for me is not that he downplays aesthetic criteria, but that he diaparages avant-garde practice. This prevents him from considering how it is that the avant gardes

have traditionally associated both aesthetics and communication with ideology. The subject that is represented in avant-garde art is the subject in ideology. For Kester, as for many critics who have been weaned on postmodern difference politics, all reference to class politics and dialectics (or the kind of dialogics proposed by the Russian formalists) is associated with the fixing of identity and with masculinism. What is at stake in the repeated pronouncements of the death of the avant garde and the death of communism is the belief that there are no alternatives to global economic neoliberalism. In "Multiculturalism, or, the Cultural Logic of Multinational Capitalism," Žižek analyzes the hidden logic of contemporary micro-politics.[9] For Žižek, the kinds of cultural politics that are based on gender, race and sexual difference typically work to preserve the category of the propertied white male as the unstated superego point of exclusion, thereby failing to properly politicize social reality. The result is post-politics, a politics in which the social administration of cultural tensions operates as a support for existing forms of transnational capitalism. By design or by neglect, difference politics fails to address the ideological processes that suture subjectivity and social reality and willfully undermines any effective politicization that would challenge the current state of things.

Žižek argues that the proper response to the problem of cooptation is not the way of the superego – the impossible embrace of or the refusal of all identification with cultural institutions, a catastrophic sacrificing of oneself – but rather the authentic revolutionary activity that could change the situation we find ourselves in. We could call this, after Lacan, *sinthomeopathic cultural praxis*. The sinthome is the complex that structures the subject's libidinal attachments. As such, the sinthome acts as a means to consider the division of labour between reality and fantasy and the possibility of repositioning the utopian drive in relation to social change. In a sinthomeopathic practice there is

Thomas Hirschhorn, *Bataille Monument*, 2002. Documenta 11, Kassel, 2002. Photos: Werner Maschmann. Courtesy of Gladstone Gallery, New York.

no security in the impossible exit from the institutionalized artworld. Instead, one lends oneself to institutional arrangements, the symptoms of contemporary cultural production,

while maintaining the fantasy of critical distance, which is not kept to oneself but made public through symbolic means. Sinthomeopathic solutions avoid the fetishism of singularity that theory has recently turned to as a means to avoid class analysis. It does so by considering the prohibitions and refusals that structure the reconfiguration of postmodern attitudes toward traditional regimes of art and spectatorship.

What I am proposing relates to a process of subjectivization and not a programme for advanced art production. In contrast to the previous models of community art, I am not proposing a new aesthetic. If Kantian aesthetic philosophy has any relevance today, it could serve to remind us that aesthetic judgement is a human faculty and not a quality of objects. Further, the faculty of judgement, as a socialized system of taste, works to distinguish and classify social dispositions, turning aesthetic criteria into matters of struggle. The universal determinations of the aesthetic should therefore not only be deconstructed in such as way as to reveal what they exclude, but should be submitted to a radical materialization of the processes of subjectivization. I would like to suggest as an example of sinthomeopathy Thomas Hirschhorn's *Bataille Monument* of 2002, constructed for Documenta 11 in Kassel, Germany. This work bears many resemblances to other examples of community art and as such partakes in the various manifestations of contemporary social and cultural experimentation. The project was undertaken with the collaboration of a Turkish immigrant community and the various parts of the monument were built in their neighbourhood. Hirschhorn lived "in residence" for several weeks as well as for the 100 day duration of the exhibition. The monument was made available seven days per week, twenty-four hours per day and was accessible without charge. This temporary monument was built with the help of community members, including children, and functioned as a poetic homage to the renegade avant-garde Surrealist, Georges Bataille. Given that many of the participants

would not likely be familiar with the figure of Bataille, a pedadogical component was devised and community workshops were hosted by local philosophers. The purpose of the *Bataille Monument* was therefore to publicly integrate avant-garde ideas and practice.

While the liberal multiculturalist attitude towards "the public" would likely dismiss Bataille as a suitable topic for public discussion, Hirschhorn's open pedagogy does not determine in advance what is and what is not suitable for mass consumption. He works with the space of autonomy as part of a deeply subjective investment in the formalization of oppositional energy. Whether this energy gets channeled in the direction of the usual institutional designations or towards some kind of socio-cultural transformation is not a responsibility that Hirschhorn takes solely upon himself. While highly capitalized forms of communication are structured in terms of the commodification of experience, affect and information, Hirschhorn's "informalization" of relationality and dialogue makes space for the reorientation of content in the direction of a universally accessible collective experience. Hirschhorn's post-minimalist approach to over-production signals the excess and the "accursed share" that structures the contemporary economy of cultural production. At the same time, by making use of everyday materials, this excess is brought within reach of the popular classes and made available as a tool for cultural education, collective production and political emancipation.

Chapter 3

In a Way We Are All Hokies: Polylogue on the Socio-Symbolic Frameworks of Community Art

The idea of community is without doubt the liberal equivalent of the conservative notion of "family values." Neither exists in contemporary culture, and both are grounded in political fantasy. A single shared social characteristic can in no way constitute a community in any sociological sense.

– Critical Art Ensemble

Although functioning as a support for the totalitarian order, fantasy is then at the same time the leftover of the real that enables us to 'pull ourselves out,' to preserve a kind of distance from the socio-symbolic network.

– Slavoj Žižek

At a time when community art is sponsored by conservative governments and private foundations, how is it possible for socially engaged artistic practice to distinguish its procedures and effects from the political restoration of class power? While neoliberalism has in fact been responsible for a "trickle down effect," it has not been the kind that can be tied to productive economic growth, as its proponents used to say, nor have we seen any significant increases to social wealth. What has trickled down has mostly been the anti-democratic fallout of social policies that are designed to dismantle the state provision of social services and to protect the capital markets and investment options of the wealthiest among us. The prevalence of the concept of community in contemporary art practice promises a similar

devolution of hierarchies, but it too has not resulted in the dismantling of institutionalized protocols.

The most direct function of community within market-oriented neoliberal thinking is as an adjunct of the devolution of responsibility for social welfare away from the state towards the community, and further, from the collectivity to the individual.[1] While the rhetoric of reform appeals to traditional notions of community, what is implicit in neoliberal governmentality is a reorganization of the relations between the state and civil society that seeks to ensure, through relations of force, flexibilization, corporate restructuring, risk management, hierarchy and competition, the greatest amount of self-exploitation on the part of individuals, defined as units of capital. Following the writings of Pierre Bourdieu, we could say that these relations of force appear to us as symbolic force, and consequently as symbolic currency that is directly tied to cultural capital.[2] Where governments no longer oversee the provision of social goods and the reinforcement of democratic politics, a new, spontaneous and voluntary class of virtuous citizens is expected to empower the traditionally defined face-to-face community against the vagaries of poverty and exploitation, to restrict diversity, and to provide the leadership of a "shadow state" that is subject to neither democractic control nor criticism.[3] One paradox of the neoliberal vision of private-public partnerships is that individuals and communities come to function interchangeably. Where one can be found, the other is presumed to exist. The new hybrid form of subjectivity that corresponds to the neoliberal use of the terms participation, partnership, consensus and empowerment can provisionally be called the "community subject." This form of subjectivity brings with it what Jacques Rancière calls "post-democracy," the "paradoxical identification of democracy with a consensual practice that suppresses political subjectivization."[4]

We Need to Talk

In many versions of the new community art, there are efforts by activist artists and collectives to not only work at the level of representation, but to actually provide services that operate as social safety nets. On this topic, Nina Möntmann mentions the project by HaHa that was part of Mary Jane Jacob's 1993 exhibition of community art, *Culture in Action*.[5] This Chicago-based collective worked with a group of volunteers to provide hydroponic greens for people who are HIV-positive, as well as AIDS education to the local community. The question I want to ask concerning this and numerous other similar examples of social practice is the extent to which the political and ideological relations that are implicit in them function to challenge or reproduce the socio-economic relations that work to create a new community subject. While socially engaged community art appears to provide the elements necessary for the transgression of the rules against which we might imagine an avant-garde supercession of the state of the art, it is precisely the social aim and function of new practices, and not their specifically artistic telos, that ostensibly shapes their organizational and participatory attributes. This social function shifted in the 1990s from a discussion of public spheres and public spaces to that of an inclusive operationalization of the concept community.[6]

To date, perhaps one of the most notable theorists of community art is the American critic Grant Kester. Kester's 2004 publication, *Conversation Pieces*, opens with a series of qualifiers for socially engaged practice. The specific term that he has coined to describe engaged community art activism is "dialogical aesthetics." Like other critics, Kester wishes to provide a critical framework for what he perceives to be a "new aesthetic paradigm."[7] Despite more than forty years of the demateralization of the work of art, and nearly one hundred years after the anti-aesthetic provocations of the Futurists, Dadaists and Surrealists, Kester makes the careful assertion that the new art

cannot be perceived or appreciated if the viewer makes use of the conventional criteria of art criticism: determinate objects rather than processes, individual responses rather than social effects, formal appearance rather than social content. Dialogical art, he cautions, appears unaesthetic.

The main argument that Kester makes for dialogical aesthetics is that it challenges the traditional avant-garde emphasis on anti-discursive rupture, sometimes understood in purely formal terms, as in the criticism of Clive Bell, Roger Fry and Clement Greenberg, and sometimes associated with the avant-garde challenge to the received forms of artistic represen-tation. We can imagine here almost all of the devices that have informed aesthetic modernism: the focus on medium and technique, anti-narrative, anti-perspectivalism, collage, montage, alienation effects, automatic writing, agit-prop, the emphasis on the unconscious, language, ideology, dialectics, etc. In such avant-garde production, he argues, the artist's non-commu-nicative or anti-discursive strategy becomes inherently oppressive. Either the artist mistrusts communication and associates it with representational transparency or the artist fails to become involved in a conversation that would leave open the possibility for the acceptance of the viewer's response.

Wishing to defend politically motivated activist art against the depoliticizing structures of the institutionalized artworld, Kester finds himself disparaging the canon of avant-garde practice and, in the process, imposing rather strict criteria that derive from seventies pluralism and eighties difference politics. From the point of view of radical class politics, these choices are not without consequence. Another problem in his argument is the distinction he makes between the anti-discursive discursivity of the artist and what appears to me, as a consequence of this view, to be the ostensible non-discursivity of the audience, unable to manage, interpret and recuperate the shocks of modernist "anti-aesthetics." This distinction between dialogical

aesthetics and the social analytic of the avant garde, unfortunately, separates contemporary practices from a long tradition of critical thinking, from Freud, Benjamin, Adorno, Brecht, Lukács and Artaud to Saussure, Barthes, Lacan, Derrida, Kristeva, and countless others.[8] The avant gardes, however, do not associate communication with fixity, as Kester argues, but associate the fixing of meaning with the operations of *ideology*. If there is a weakness in the theory of dialogical aesthetics, it is the postpolitical assumption of a subject outside of ideology. Because of this, the theory of dialogical aesthetics, I would argue, is more easily recuperable by liberal ideology and neoliberal institutions. This is perhaps intentional as a pragmatic compromise.

For Kester, all reference to class politics and all materialist philosophy is conveniently associated with the fixing of identity and with masculinism. Such an unsubstantiated critique of Marxism and dialectics should be recognized as the only significant, constructive element in Kester's theory. Because of this, all of avant-garde production is consigned to the ghetto of an "antidiscursive tradition" and associated with a paradigm of the "naughty artist." But who is being naughty here? Kester's somewhat popular use of the terms "dialogics" and "everyday language" would benefit from some acknowledgement of the critical use of those terms in the writings of Mikhail Bakhtin, Paolo Freire and Henri Lefebvre. Kester's almost complete dispensation with negation reduces sociology to the tasks of art criticism. Negation makes its limited appearance in *Conversation Pieces*, paradoxically, as part of an unstated, and indeed vanguard critique of the canonization of avant-gardism and autonomy.[9]

Kester's association of avant-gardism and autonomy with conservatism, understood in terms of the postmodern shibboleth of a "universalizing discourse," creates serious problems in his work, in particular, as he attempts to defend it from public debate. This can be noticed in his somewhat aggressive response to the London-based art critic Claire Bishop. Bishop emerged in

the 2000s as a notable if sometimes reviled critic of contemporary art. One of her first significant contributions was an essay titled "Antagonism and Relational Aesthetics," which was published in the journal *October* in 2004.[10] In it she argues that critics should attempt to define some of the criteria with which we might judge the new community-based and collaborative art of the 1990s. While Bishop's criticism may in fact be dependent on a formalist, pleasure-based methodology that Kester associates with mainstream art criticism, it does not prevent her from asking important questions about this new *aesthetic* paradigm. Bishop contends that just because a work encourages dialogue and participation, this alone does not make it democratic. What types of relations are being produced, she asks, for whom and why?[11]

Defending the work of Thomas Hirschhorn and Santiago Sierra agains the "relational aesthetics" of Liam Gillick and Rirkrit Tiravanija, Bishop counterposes an "avant-garde rhetorics of opposition and transformation" against post-structural "strategies of complicity."[12] In the work of artists like Hirschhorn, there is the admission of a degree of formal autonomy that is based in neither the contradictions of Greenberg's revolutionary art-at-a-standstill nor Adorno's negative dialectics and modernist refusal. In comparison with such work, she calls for the analysis of "relational aesthetics" at the level of criticism and not as a prescription for artistic practice.

In a later piece, Bishop refers to the emphasis on collaboration and participation in contemporary art as the "social turn."[13] She argues that socially collaborative art constitutes "what avant-garde we have today: artists using social situations to produce dematerialized, anti-market, politically engaged projects that carry on the modernist call to blur art and life."[14] She contends that because the "politics of inclusion" operate in tandem with state and corporate interests, artworks need to be discussed as art and not only in the context of their stated ethical intentions.

The essay takes issue with Kester's position against avant-garde art that attempts to maintain a critical distance from its audience and that in some cases risks offence, shock, or didacticism. Bishop argues that the "discursive criteria" of socially engaged art should not be to renounce authorial control nor to withdraw from the logic of aesthetic autonomy as the condition of art's instrumentalization.

Given the arguments put forward in *Conversation Pieces*, Kester's response to Bishop's essay was not altogether surprising. In a letter to *Artforum* he reiterated his critique of the "quasi-detached perspective of the artist," a tendency or affective complex that I argue he should ascribe to the field of cultural production itself, including consumer culture, rather than to individuals.[15] What was less predictable was the hostility with which he sought to defend the grounds of community art against Bishop's idea of participation, a stance that resulted in his accusation that she is part of a "paranoid consensus" to protect the institutionalized art world.[16] This paradoxical accusation allows him to distance his position from structuralism, psychoanalysis and Marxism and thereby avoid all questions of relative and critical autonomy. I say paradoxical because Kester's attack on Bishop allows him to privilege the autonomy of his position and the artists he champions from the rest of the field – an impossible task. If anything can account for Kester's theoretical opportunism in this incident, which he largely retreated from in later interviews for *Circa* and *Art Journal*, it is what I perceive to be his understanding of artist activists as morally exemplary. Could it be that Kester's identification with such contemporary artist-activists allows him to participate in the classic avant-gardist overturning of both phylogenetic and ontogenetic peers? Is the privileged community of community art not therefore the community of radical activist artists?

In his *Art Journal* interview with Mick Wilson, Kester continues to lambast avant-gardism, representing it as a hygienic

discourse aimed against kitsch, activism, audiences and the vagaries of social life.[17] The avant garde, according to him, leaves no room for a positive conception of community. Community, he argues, and according to the theories of writers like Ernesto Laclau and Chantal Mouffe, Jean-Luc Nancy, Gilles Deleuze and Jacques Rancière, is always thought be "an expression of the dominant power," "a symptom of the extreme fear of predication in the poststructuralist tradition." My main point of contention with Kester is not that community is *always* an expression of the dominant power, but that *too often*, within existing social relations, this is precisely the case. Furthermore, I would argue that the resources of post-structural thought are not limited to members of the artworld. Kester is hardly the first person to have announced the death of the avant garde. However, what might help situate the advent of community art in more historically salient terms is some discussion of the purported death of communism. To begin to think through the notion of the death of communism might not only allow us to address this so-called post-structuralist approach to community, but also the relation of neoliberalism to the subject of community.

Death by Community

If a theory of community art is to have any universal relevance, it must be able to grasp the problem of irresolvable differences and this is something that has been implicit in the avant-garde emphasis on non-discursivity, especially if by discursivity we also understand something like the integrating function of capitalism. The immanence of difference within any community formation is also the place from which conflictual and traumatic relations draw their sense of effective meaning. In *Homo Sacer*, Giorgio Agamben relates the impossibility of community to Alain Badiou's notion of the state of exception:

Badiou's thought is, from this perspective, a rigorous thought of the exception. His central category of the event corresponds to the structure of the exception. Badiou defines the event as an element of a situation such that its membership in the situation is undecidable from the perspective of the situation. To the State, the event thus necessarily appears as an excrescence. According to Badiou, the relation between membership and inclusion is also marked by a fundamental lack of correspondence, such that inclusion always exceeds membership (theorem of the point of excess). The exception expresses precisely this impossibility of a system's making inclusion coincide with membership, its reducing all its parts to unity.[18]

I hope to show that the most radical exception in neoliberal constructions of community is that of communism, and also, that the absence of an emancipatory concept of community can be directly tied to the purported death of communism. I wish to do so not by privileging socially engaged art, but the community discourse that was set to work in the aftermath of the multiple shootings at Virginia Tech State University in April of 2007. I focus on this event because here, in stark contrast to dialogical aesthetics, what is repressed is precisely the kind of social criticism that could lead to an analysis of the dominant forces that shape socio-economic reproduction.[19]

Recent theoretical approaches to the question of community, those that are based in deconstruction, phenomenology and post-structural theory, are often less concerned with the identity of a community – its basis in tradition and origins, and the symbolic and cultural rituals that inhere in its collective social practices – than with the management of boundaries and differences through processes of inclusion and exclusion. An early account of the sacrificial aspects of community formation was proposed by the Surrealist Georges Bataille and the radical *Acéphale* group that formed around him and his courses at the Collège de Sociologie

André Masson, cover drawing for the first issue of *Acéphale*, 1936.

in Paris in the 1930s. The goal of the anti-capitalist *Acéphale* was to create a sacrificial community that is non-hierarchical – the name itself refers to a headless body – and to ecstatic rites of incorporation that do not compromise the sovereignty of individual members. In the review of the same name, published between the years 1936 and 1939, Bataille called on radicals to

separate themselves not only from fascism, but from all social movements, including socialism.[20]

In the spirit of Nietzsche, Bataille rejected all appeals to instrumentalism, including the call for justice and freedom. Giving oneself to the future, he wrote in the first issue, is set against all occasions for political parties and the odour of death in patriotism. Democracy neutralizes all antagonisms and excludes radical change. For Bataille, the universal community is unlimited and without rest, it is eternal and never achieved. In the postwar period, he would be more explicit in relating this principle of the unachieved with sacrifice and the cruelty of art.

Bataille's ideas have held a certain interest for newer theories of community. An early intervention in contemporary discussions on the "discursive construction of community" is Maurice Blanchot's 1983 elaboration of Bataille's idea of the founding of a community of sacrifice through its undoing, or what he calls désoeuvrement.[21] The Acéphale represents not only a dissolution of political involvement but also the fact that absence, death and indeterminacy are immanent to community. According to Blanchot, to posit the "absolute immanence" of community is to subvert the experience of absolute individuality. Individuality and community, then, are the coordinate terms that ruin the possibility of one and the other in contestation, in unworking and worklessness. Writing about the ambiguous "being-together" that followed May 68, Blanchot notes that "the people" was always ready to dissolve itself:

The people... are there, then they are no longer there; they ignore the structure that could stabilize them. Presence and absence, if not merged, at least exchange themselves virtually. That is what makes them formidable for the holders of a power that does not acknowledge them: not letting themselves be grasped, being as much the dissolution of the social fact as the stubborn obstinacy to reinvent the latter in a

sovereignty the law cannot circumscribe, as it challenges it while maintaining itself as its foundation.[22]

For Blanchot, "the people" is an incompossibility, an abandonment of the traditional notion of community, whether that is thought of as the face-to-face community of people who happen to know one another or the elective community of friends. All totalizing forms of association are efforts to make the traditional community an elective one, and the destiny of these forms is written in practices of exclusion. Following upon the notion of the negative community, of the unworking of sacrifice, Blanchot proposes a community of beings who are exposed to one another, "the community of those who have no community."[23] The new idea of the individual that emerges from this is equally unworked in the sense that subjectivity cannot be revealed. Rather, subjectivity is inclined. Jean-Luc Nancy uses the word *clinamen*, meaning an inclination or a relation that undoes, that unbinds the ties of the known community.[24] He also describes this idea of unworking as *compearance*; by appearing together, the unworked community is the community that does not establish itself.

In the liberal philosophical tradition, individual rights vie with notions of civic incorporation. Nancy deconstructs this opposition by focusing on the impossibility of an absolute immanence of either pole. The individual is the result of, or causes, the death of community, the impossibility of communion.[25] The community, on the other hand, is the result of, or causes, the death of individuals; it exposes rather than incorporate and subsume the finitude of individuals. "To say that community has not yet been thought," Nancy writes, "is to say that it tries our thinking, and that it is not an object for it."[26] Both death, dying for love of country, and love, the exposure of being, are posited as forces that represent the impossibility of immanence. Immanence of identity, my limit, is the absoluteness

that dissolves the possibility of community.

Nancy's work is helpful for considering both the forms of political incorporation and Bataille's alternative. In the first case, Nancy refers to the concepts of justice, freedom, and equality that form the background of a "*human* community."[27] In all communitarian undertakings, especially those that subsume the individual to the regulatory functions of a territory, a state, science, religion, identity, culture, or tradition, "the individual can be the origin and the certainty of nothing but its own death."[28] All of these, he states, can be related to the Christian emphasis on communion, understood as the loss of community. Death is not the example of this loss, but rather its truth. He writes:

> This is why political or collective enterprises dominated by a will to absolute immanence have as their truth the truth of death. Immanence, communal fusion, contains no other logic than that of the suicide of the community that is governed by it... The fully realized person of individualistic or communistic humanism is the dead person. In other words, death, in such a community, is not the unmasterable excess of finitude, but the infinite fulfillment of an immanent life: it is death that the Christian civilization, as though devouring its own transcendence, has come to minister to itself in the guise of a supreme work.[29]

According to Nancy, the kinds of "literary communism" that were proposed by thinkers like Georges Bataille and Walter Benjamin sought to extract themselves from all pre-established forms of community. Their proposals went unrecognized in all "real" communisms and so Nancy abandons the concept altogether for something that has no name and no concept, something that takes into account the modalities of *solitude*, *rejection*, *admonition* and *helplessness*. Community is what happens to us in the wake of society; community is what justifies death

and suffering, and is revealed in the death of others.[30] The impossibility of communion, of a communitarian being, means that it is impossible to make a work that is not a work of death.[31] If community is therefore not a project of fusion, it also represents the impossibility of absolute exclusion. All forms of finitude co-appear with being-in-common.

One might ask of Nancy's work, what is solitude and admonition in comparison with solidarity, criticism and learning? I would argue that the limitation of the fate of the individual within communistic humanism to that of death is rather appropriate for an age that is obsessed with the possible disappearance of humanity. Somewhere along the way, however, our environmental conditions have been confused with our biological predispositions. As Freud observed with regard to death drive, the meaning of life is in fact death. If anything, communism recognizes this universal attribute and seeks to make emancipatory change the mode of social relations in the space between life and death, between human needs and human relations of production. Regardless, what avant-garde practice seeks to enact corresponds roughly with what Nancy calls the "sharing of community," even when it does so through gestures of negation. Avant-garde shock operates, precisely as Kester states, in the manner of the "subject supposed to know."[32] What I propose as an example for my elaboration of a social theory of the community subject is not a collaborative and participatory, process-based art project, but the collective response to the catastrophic destruction of New York's Twin Towers on September 11, 2001, and the massacre of students and faculty at Virginia Tech State University on April 16, 2007. In both cases, what is significant is not the suicidal logic of the assassins, but the consequent political and cultural construction of victim status and how such a status is designed to evade the kinds of knowledge that we traditionally would have received in such situations from the avant gardes. In the months following 9/11,

progressive intellectuals were hard pressed not to remind the public of the statistics concerning the deaths that are caused daily by war, poverty, famine, lack of resources and lack of medical treatment, and especially those that can be directly attributed to the policies of democratically elected liberal governments and unelected trade bodies.

While the Virginia Tech massacre might not be a large enough incident to incite a wholesale "war on disaffected youth," its reporting on CNN and the major news networks allowed mourning and community to come into visibility as terms of propaganda. The only social criticism that was proposed in the wake of the Virginia Tech shootings were recriminations on the part of right-wing commentators that security measures, including mental counseling for Cho Seung-Hui, had not been adequately undertaken. Certainly, after the shootings, a security theatre had surrounded the Blacksburg campus. While the assassin's written and videotaped "manifesto" had the features of class conflict, with wishes "to inspire the weak and defenseless people" against the senseless wealth accumulation of "rich kids," it was treated in terms of a race-based crime. Fearful of a race-based backlash against Koreans, various Asian groups communicated special apologies.

One day after the shootings, Laura and George W. Bush attended a special "Convocation for the Victims of the Virginia Tech Massacre." Bush's speech underscored the importance of community, family and God as sources of strength and renewal. The closing speech by Virginia Tech poet and Professor of English, Nikki Giovanni, seemed less doctrinaire. She associated the Blacksburg tragedy with the plight of all innocent children who suffer needlessly. The main thrust of her speech, however, was the assertion of the doxa of identity: "We are Virginia Tech, We are the Hokies, We are Virginia Tech." After her speech, the thousands who filled the auditorium broke into the Hokie chant: "Let's Go Hokies!" To further underscore the usefulness of the

shootings as a means to build a politically coherent sense of unity, a Hokie Spirit Memorial Fund was established in memory of the victims and was administered by Kenneth Feinberg, "special master" of the Federal September 11th Victim Compensation Fund. Bush's central role in the convocation was to depoliticize this confused and formless mass through an evangelical message of spiritual salvation that is unrelated to questions of class power.

In what way, then, is there an overlap between community art and the expression of the Hokie community? If the community artist has the function of the analyst who is "supposed to know," as Kester suggests wryly, then this artist should also have the ability to steal our enjoyment of the fantasy of community. Our access to knowledge and loss of enjoyment would come through our awareness of the objectivity of belief. However, the stupidity of the ritual expression of community is not just superficial. As Žižek explains, our sense of being outside the social game defines out true position inside the game, maintaining the fantasy of a distance. This is what Lacanian psychoanalysis considers the radical externality of the big Other, the superego injunction of enjoyme(a)nt as the place where truth is articu-lated.[33] Community in both cases is a fantasy object. The lack of community is repressed and imagined as one's own desire, made conscious and objectified in terms of a normal form of intersub-jectivity, or a rational (relational) instrumentalization of the self. Symbolic identification, a kind of symbolic castration, thus takes a recognizable shape in terms of something or someone that makes it obvious that society does not work. In this something Other, we recognize the truth about ourselves.

In a way we are all Hokies. The question is: where might this knowledge come from and how do we use it? In *Welcome to the Desert of the Real*, Žižek proposes that there are two ways of reacting to traumatic events.[34] The first, the way of the superego, reasserts the violence of the obscene social law "in order to fill in

the gap of the failing symbolic law." We could say that the Virginia Tech convocation was more a validation of Cho Seung-Hui's crimes, presented in an inverted form, than an effective counterpoint. The second way of reacting is the way of the authentic act. With this latter option, we could hope to demonstrate the falsity of the post-politics of liberal multiculturalism, which would make Virginia Tech a mere matter of ethnic tension and local administration. Allow me to provide another example.

On the day after September 11, 2001, I met with a class of undergraduate students at the Rochester Institute of Technology, where I was hired as an adjunct instructor. Instead of lecturing, I proposed a class discussion about what this catastrophe might mean to us at that time. The two responses that I remember most were diametrically opposed. The first, by a young conservative student, was a warning to the class against taking orders from men in little red suits who like to sit in circles like Smurfs. The second came from an anarchist student, who, less enthused, reminded his classmates that the U.S. government is involved in many activities around the world that most Americans do not know about. The two could be brought together in order to create a picture of the political unconscious of American youth. Somewhere in a distant land, a community of cartoon characters is trying to maintain a social democratic society, but the corporate-led U.S. military simply won't let them live in peace. Do we not have here the necessary ingredients to understand Cho Seng-Hui's sad performance as a videogame avenger? An authentic response requires that we resist the pressure to meet fire with fire, to reassert harmful ideological commitments as a way of avoiding subjectivized responsibility.

We Communists

What I would like to suggest by comparing the neoliberal vision of community with that of advanced criticism of community art is something that could tell us more than the simple idea that

community is socially constructed. Community is a privileged signifier at this moment in history, one that authorizes discussions of participation, collectivity, collaboration, reciprocity, consensus formation as well as cultural difference, cultural critique, agonism and activism. Identification with community, however, eventually encounters the problem of situation and conditionality. Perhaps we could reconfigure the current historical situation by considering Alain Badiou's concept of event, and in particular, his discussion of the death of communism.

Badiou opens his essay on "Philosophy and the 'Death of Communism'" with a question: "Will the invocation of death allow us to find an appropriate way of naming what we have witnessed?"[35] Badiou argues that long before the collapse of the Soviet Party-State in 1989, what disappeared was an operative use of "we" that could function as a referent for we communists, we revolutionaries, we engaged in class struggle. This we, like the human community described by Nancy, has been dragged in blood and effectively abolished. By order of the state, it is not so much communism that has been killed, but "political thought conditioned [by] a philosophy of the community."[36] What we communists once referred to was the universal community. The death of communism, in the limited form of the breakup of the Soviet empire, is therefore not on the order of what Badiou calls an *event*, since death itself is not an event, but a "return of the multiple to the void from which it is woven."[37]

The paradoxical status of the convocation at Virginia Tech is that of a celebration of the nullity of state power where the victim is transformed into the subject of community ideology, the subject of a spiritualized community where each subject is supplemented by the mediation of an identification. In contrast to such stagings of community, an event is the transformation of a situation in which everything remains unredeemed. One of the ways that we can understand the quest by contemporary

constituent practices to produce sites of resistance that are non-institutionalized is by considering Badiou's alternative to the popular French slogan, *tout ce qui bouge n'est pas rouge*. This slogan asserts that not all good ideas are leftist (red). Badiou counters this with the statement *tout ce qui bouge n'est pas évènement*: not everything that happens is on the order of an event. Badiou's idea of an event as the promise of truth delivers all notions of universal emancipation from the *coups de grace* that fix revolutionary movement in battles that were waged and lost long ago, or at specific moments in time. Communism for Badiou is the "trans-temporal subjectivity of emancipation."[38] The current instrumentalization of community is an attempt to reduce and eliminate this *subjective* form of communist movement through frameworks like 1968, 1989 and 9/11. The aesthetic instrumentalization of community is an attempt to reduce this subjective form of communist movement through temporal frameworks like connective, relational and dialogical aesthetics.

Badiou considers the task of philosophy to be the extraction of words like communism from the historical frameworks that relativize them. Communism, he writes, is the "philosophical and eternal concept of rebellious subjectivity"; it is a term that allows us to think the "ontological concept of democracy."[39] Communism is thus a term that resists the salutary notion of the death of art in the form of its articulation as social movement. If the truth of art also has the dimension of an event, what is it that art exposes us to and in what ways will the truth of community art be thought to have been subjectivized? What new situations will emerge as a result of what exists and what supports action?

It may be that socially engaged community art will not be the final stage of the eradication of the difference between art and life, but a practice that will bring aesthetics one step closer to communism and the idea of justice. How can it do this? Here we might wish to consider Jacques Rancière's notion of the artist as a

double being.[40] The artist is expulsed from Plato's community not only because of the falsity of images, but because the artist causes a split between the usual distribution of the sensible, the common universe of work where people occupy a delimited space of possibility, a particular private space-time within the division of labour. What is common to all is this polemical distribution of modes of being, or what Rancière terms an "incorporated conception of community." This commonality of community is effectively a particular way of excluding people from participation by reducing them to ascribed occupational tasks.

What the artist introduces is a disruption and a re-distribution of the sensible through the public staging of what is common to all and thus an exemplary possibility of participation inasmuch as the artisan has separated himself or herself from their occupation. This is no doubt why today's community artist is so polyvalent, not only because flexibility is the watchword of a post-Fordist mode of production, but because the mimetic function of art is today widely distributed across the entire social formation. And this is perhaps why Kester should not be so weary of the "anti-discursive" hubris of the avant-garde artist or the incorporated role of the creative worker in the alternative arts sector, since the powers of redistribution that are at play in the representative regimes of art, those that separate art from moral and social criteria, are precisely those that work to stabilize what is common in modern art. The very specificity of the space of autonomous practice is what allows it to abolish the hierarchical distribution of the sensible, and thus, to abolish itself.[41]

Inasmuch as dialogical aesthetics becomes another form of stabilization, it ceases to effect a redistribution of the sensible and enters a newly reproduced institutional space. Here, Rancière's critique of the division of labour meets Badiou's "we" of thought and rebellious subjectivity. The becoming-sensible of

thought approaches the artistic representation of work as a production, that is, a new distribution of the sensible that unites the activity of production with its visibility. This transformation of the sensible, Rancière asserts, has led to the avant-garde abolition of art as a separate activity.[42] What we have here is the true basis of dialogics as the bringing of human activity into speech, and also, Rancière adds, as "the struggles of the proletariat to bring labour out of the night surrounding it."[43]

Chapter 4

A Brief Excursus on Avant Garde and Community Art

We had escaped the unbearable weight of being artists, and within the specialization of art we could separate ourselves from site-specific artists, community artists, public artists, new genre artists, and the other categories with which we had little or no sympathy.

– Critical Art Ensemble

In 1984 Krzysztof Wodiczko wrote a broadside against the Canadian cultural state bureaucracy titled "For the De-Incapacitation of the Avant-Garde."[1] The article addressed the contradictions of incorporating "left" and "libertarian" ideas into a centralized state bureacratic system. Having come from Poland, where artists at that time feared assimilation into the technocratic rationality of the state apparatus, the "parallel" institutions supported by government grants appeared to him to pose a similar danger. In both cases, he considered the function of the state to be the appropriation of those critiques it could use to reinforce its legitimizing functions. Ostensibly, this could be achieved by financing radical cultural magazines, film and video.

The problem with avant-garde artists in the West, Wodiczko argued, was that they had begun to accept their own productions as ideology and had conflated political ideology with artistic utopia. In this context, artists who mistrusted their avant-garde forebears were caught in an endless rehearsal of the critique of formalist modernism, forging new idioms that could ostensibly escape a linear account of art's immanent unfolding. With the

advent of postmodernism, art's privileged position within the division of labour became a bulwark against further radicalization of the sphere of cultural production. Rather than radicalize culture as a product of capitalist social relations, postmodern pluralism concluded that the avant garde is dead and withdrew to what Hal Foster calls a relativistic "arrière-avant-gardism" that considers itself liberated from the teleological framework of history and the determinations of ideology.[2]

Wodiczko also recognized that artistic and political avant gardes did not share the same attitudes toward the degradation of art. Where one called for art's destruction, the other wished to salvage its compensatory effects. In the absence of a revolutionary situation, the embattled artistic left could not distinguish itself from the liberal state bureaucracy that supported it. It appeared serious and militant, but did not dare unmask itself. The solution to this impasse, he argued, could be found in a critical public discourse on the aims of an avant-garde programme that would lead to the de-ideologization of its processes and a confrontation with the "enemy," which included the culturally conservative political left. In this sense, the left could liberate itself from itself. It could do so if it was involved in cultural action that challenged the system of culture as planned bureaucratic administration.[3]

What might Wodiczko's ideas mean for us today in the context of the neoliberal administration of creative labour and the growth of what the radical collective BAVO refers to as "embedded" forms of cultural activism?[4] As Nina Möntmann has also argued, recent models of community-based art need to be considered against the background of the dismantling of state-organized social infrastructure in the Western world.[5]

Within some circles of advanced cultural theory and practice, there is often little tolerance for the idea of an avant garde and cultural authority itself is mistrusted. In the context of a late capitalist post-politics, the political vanguard is often subsumed

under the pluralism of liberal multiculturalism. Because of this, a multitude of decentralized practices appears to be both the promise of a post-identity politics as well as the grounds of a self-regulating biocapitalism, which works to produce as well as manage cultural conflict. At the same time, however, the counter-globalization movement, referred to in Europe as "the movement of movements," provides a clear message that there are alternatives to capitalist hegemony.[6] What forms of socially engaged cultural practice can we envision that refuse complicity with the current ruling order?

Dictatorship of the Precariat

The project of a contemporary avant-garde cultural practice entails an anti-essentialist re-examination of the question of universality as the level at which political emancipation is subject to hegemonic operations. Within the state apparatus, a great deal of attention is now being given to the administration of art in terms of "creative industries" that rationalize "immaterial" cultural and intellectual production according to flexible production strategies that benefit capital accumulation. Post-Fordist or post-industrial capitalist production are the terms used to describe the development of markets that involve cultural, intellectual and biogenetic property. In this context, the left's emphasis on social and economic precarity within a flexible labour market has become an important point of collective resistance to neoliberal governance. However, the critique of the state disciplinary apparatus has been obviated by Michel Foucault's influential description of the way that human beings become subjects through forms of self-government that are based on how people perceive what is desirable and what is possible. Socio-economic precarity can thus be explained as part of a self-precarization that is entrenched through new conditions of productivity, discipline and security. State power is thus demate-rialized and is replaced with self-interest and the management of

open markets. A concomitant entrepreneurial view of the self complements the management of economic liberties, producing what Foucault refers to as biopolitical subjectivity.[7] The power of labour is thereby subsumed within a flexible market logic that almost completely determines the relations of production. With regard to creative labour, the autonomy of the market replaces the avant-garde notion of the critical autonomy of the work of art as part of a critique of social inequality. Consequently, the position of the precariously employed artist figures not only as the product of hegemonic market relations, but as what Slavoj Žižek describes as the universal exception, the particularistic example that embodies the truth of the contemporary art world as a whole. On this score, artists are hardly alone in their struggles.[8] The level of competitiveness and inequality that structures the field of immaterial, creative and cognitive labour is similar to the unevenness that is maintained by neoliberal governments in almost all spheres of biopolitical production.

One immediate solution to post-Fordist economic precarization has therefore been to name it. Demonstrators at the 2004 MayDay Parades in Milan and Barcelona, for instance, referred to themselves as, variously, the precariously employed, precariats, cognitive workers, cognitariat, autonomous activists, affectariat, and so on, and proposed flexicurity – rights and protections for the precariously employed.[9] As Angela Mitropoulos has remarked, the demonstrators are alert to the fact that the quality of precarity belongs to both labour and to capitalism. Whereas Fordism seeks to cretinize the worker, she writes, post-Fordist decentralization and flexible accumulation harness the productive capacities of desire, knowledge and *sociality* itself.[10]

The problem of the artworld precariat might be summarized with Gregory Sholette's concept of "dark matter."[11] Dark matter describes the work of autonomous and participatory cultural production by amateur, informal, unofficial, autonomous,

activist and non-institutional workers. This dark matter is largely invisible to those cultural administrators – curators, directors, collectors, critics, historians and artists – who are the gatekeepers of large cultural institutions. However, the same institutional art world is dependent on this dark matter as well as the resources of its members who purchase magazines and books and who attend exhibitions and conferences. What, he asks, "would become of the economic and ideological foundations of the elite art world if this mass of excluded practices was to be given equal consideration as art?" The situation we are confronted with is one in which, as Sholette argues, dark matter is no longer invisible but is gradually being recovered by private and institutional interests. Politicized micro-practices are given specific designations, meanings, and use-values as they are directly integrated into the globalized commercial art matrix. Sholette argues that the capitalist valorization of creative labour is a problem for culture because it "forces into view its own arbitrary value structure."[12] The affective energies of those who are excluded from the inner circles of the transnational culture industries, he concludes, need to be linked to actual resistance to capital, patriarchy and racism, and block the art world's mediocracy from appropriating their histories.

This situation, as I see it, can benefit from a reconsideration of the traditions of avant-gardism, which many cultural producers and theorists dismiss or distinguish sharply from activist and community-based practice. Because of their own resistance to avant-gardism, radical artists submit themselves to forms of liberal cultural blackmail. Artists today are expected to provide constructive critiques of the system but not threaten public institutions, class hierarchies and other legacies of bourgeois liberalism; to intervene in culture but not appear aggressive or be seriously prepared to fight for political equality – which would result in being dismissed as intolerant of people's differences; to understand the complex history of aesthetic and cultural

radicalism and to incorporate this into intelligent forms of collaborative practice, but to stand back or compromise when the situation requires that you assume a dominant position of authorial integrity.[13] It is not surprising that the withdrawal from avant-gardism and from a radical criticism of disciplinary societies is accompanied by what, on the surface of things, is its opposite: sociability, collaboration, dialogue, participation, community consultation, etc. These modalities and methods, according to Hal Foster, "risk a weird formalism of discursivity and sociability pursued for their own sakes."[14] However, this is perhaps where the potential radicality of formalism should be acknowledged and the assymetry of form and content be considered. Why, we should ask, is socially engaged community art considered to be among the most vanguard forms of contemporary art and, if so, in what ways does it renounce formalism? The blackmail situation provides two obvious solutions: either one defends the socially maligned space of autonomy, but, if successful, risks having one's work recuperated as capitalist investment, or, one plays the disciplinary culture industries at their own game, sublating the opposition between art and life, art and society, and thereby producing complex forms of critical activity and risking, if successful, being ignored or even becoming invisible as an artist or an art collective. Many of the most challenging artists of the last two decades have chosen the latter path. However, we can see here how the path of self-precarization is not only overdetermined – least of all by the kinds of capital that are associated with criticality – but full of contradictions. Many of the most vanguard directions in today's late capitalist world of post-structural post-politics demand a withdrawal from avant-gardism as *passé*, modernist, masculinist, totalizing, utopian, and so on.

This kind of liberal cultural blackmail, inasmuch as it comes from progressive artists, theorists and historians, is especially harmful given the economic pressures that come from and that

are also imposed on cultural institutions. Current trends within the creative industries have contributed to a wholesale devaluation of avant-garde aesthetic autonomy, moving in the direction of cultural brokering and corporatization. The market indicators that drive so much cultural production today would merely be incidental if artists, curators and critics themselves had not conceded so much cultural and intellectual ground to the logic of the "end of history." At a recent conference, a prominent Canadian cultural theorist challenged my ability to speak of global capitalism without considering that cultural differences introduce gaps in what might otherwise appear as a total world system. The point here, however, is not to deny the links between difference and system but to consider how the workings of capital cannot be dissociated from notions of particularity. In the following I take this manifestation of the prohibition against avant-gardism as symptomatic of contemporary cultural theory and practice, a kind of belated postmodernism, and further, as a probable explanation for the growing salience of the discourse on precarity.

The Elephant in the Room

One of the abiding characteristics of the avant garde, and this is partly what helped create the sphere of modernist autonomy, was its distrust and dislike of market relations. Having been created by those same market relations, the avant garde wished to subvert them from within, both through strategies of formal reflexivity and medium specificity as well as through infusions of socially and politically radical content. Believing in the ability of art to change life, the avant garde sometimes ignored the ways that aesthetic practice serves to reproduce power relations and class antagonism.[15] Whereas modernist artists sought to challenge and transcend the given standards of cultural production, thereby reproducing the field, the historical avant gardes did this with the goal of politicizing the sphere of cultural

production itself. The avant-garde artist, in Peter Bürger's well-known formulation, sought to contest and transform the institution of modernist aesthetic autonomy, and in the process, to transform social relations.[16] For an avant-garde work to be successful, it had to function in terms of what Bourdieu calls "dual-action" devices, both reproducing and not reproducing the field of culture. One of the means by which this could be achieved was the radical separation of art from taste and habituated sense perception. This strategy also contributed to avant-garde art's estrangement from audiences, eventually leading to a game of agonism and provocation, and, on the part of liberal culture, anticipation and commodification.

Contemporary art resorts to milder versions of this story, working with concepts of critical collaboration or complicity as alternatives to the stormy weather called forth by the concepts of alienation and class struggle. The sociological determinants of cultural appreciation and the distribution of cultural wealth, however, are misconstrued when contemporary socially engaged community artists presume to perform non-contradictory acts of benevolence.[17] Neither can art escape its conditions of determination, nor can it be reduced to them. Beholden to a liberal model of the needy public or a multicultural model of diversity, much contemporary art refuses to challenge audiences in ways that are associated with avant-garde resistance. In two of its most recent manifestations, Nicolas Bourriaud's "relational aesthetics" and Grant Kester's "dialogical aesthetics," political claims and social protest are to be renounced in favour of dialogical interaction, and the artist is expected to renounce claims to authority and authorship.[18] These critics not only seek to transform the way that artists interact with audiences, but decry the sort of activism that takes the form of militant struggle, whether in the form of agitational work or utopian projection. What is proposed instead is ambient conviviality, reformism, and interaction. Consequently, many forms of socially engaged community art

lack an adequate theory of social politicization. While contemporary community art practices are obviously concerned with some kind of conscientization, many artists hold that this should not come about as the result of a confrontation with the public. Artists may seek to solve particular social problems, but the singularity of these problems is separated from their universal determinations. As a result, a kind of therapeutic pragmatism calls for artists to collaborate with institutions, avoiding the kinds of risk that would be required to challenge the ruling bourgeois order. And yet, the overcoming of the distinction between art and life perseveres as the *leitmotif* of advanced practice. What is it then that contemporary community artists seek to overcome?

The following considers the symptomatic nature of the prohibition against avant-gardism and even the prohibition of the prohibition itself as a serious topic of discussion. The example I wish to provide is Komar & Melamid's *Asian Elephant Art and Conservation Project* (1995-2000), which I take to be a serious satire of contemporary community art. The type of community art I have in mind is best represented by Mary Jane Jacob's well-known curatorial venture *Culture in Action*, the 1993 instalment of the annual *Sculpture Chicago* summer festival.[19] *Culture in Action* was dedicated almost entirely to community-based projects for which the artists created pieces that emphasized dialogue, participation and interaction. Notwithstanding the merit of many of the individual projects, what concerns me here is the manner in which the curatorial framing was decidedly anti-avant-garde. The rhetoric of *Culture in Action* was that art provides a redemptive, therapeutic healing of social divisions. In contrast, what Komar & Melamid are interested in with *Elephant Project* is precisely the problem of the integration of living labour within a global capitalist mode of flexible accumulation.

Briefly stated, Komar & Melamid's *Asian Elephant Art and Conservation Project* is a complex work that enlists the partici-

pation of Thai elephants and their "mahout" trainers.[20] After the ban on rainforest timber in 1989, the elephants and the timber workers became unemployed, forced to engage in tricks for tourists, panhandling and illegal work. Malnourishment led to the decimation of the mostly domesticated elephant population. By training some elephants to paint "abstract expressionist" canvases and then selling their paintings, Komar & Melamid raised hundreds of thousands of dollars for their care and that of their trainers. Paintings were auctioned off at Christie's and bulk sales were organized with hotel chains, thus raising awareness of the elephants' circumstances.

Elephant Project provides a clear indication of what Slavoj Žižek has explained as the truth of community, the fact that the deepest identification that holds a community together is not an identification with the written laws that regulate normal, everyday routine, but an identification with the transgression or suspension of the Law, an identification with an obscene secret code.[21] For our purposes, we could say that the deepest identification that structures the field of contemporary art production is not the particularistic political transgression of the new art of community, relationality and dialogue, the official art of our times, but an identification with the prohibition of avant-garde radicality. On this score, Komar & Melamid's elephant project is not an avant-garde work because it defies or parodies the politically immaterial mandates of relational aesthetics and the new community art, but because it exposes the obscene underside of so-called dialogical collaboration. How so?

Like the post-Fordist precariat, the elephants/artists are out of work. And what is the secret code, the unwritten law that gives artistic transgression its specific form if not the momentary *political* suspension of art for the sake of art's renewal? Is this renewal not also the admission of the pure symbolic meaningless of the aesthetic as a measure of value, in particular in the face of abjection, poverty and unemployment? This same fact is what

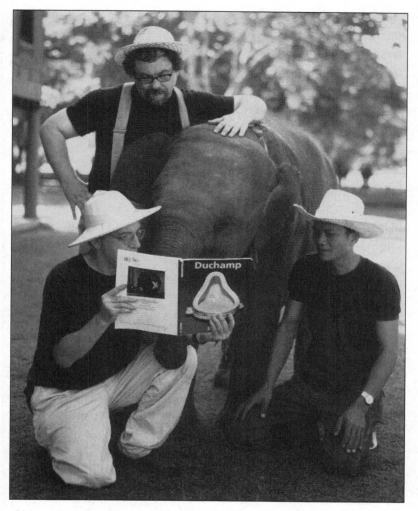

Komar & Melamid, *Asian Elephant and Conservation Project*, 1995-2000.
Photo: Jason Schmidt. Courtesy of Vitaly Komar.

constitutes the truly obscene side of this unwritten law; obscene because ever since Kant necessity has been ruled out as a hindrance to aesthetic judgement, and ever since Marx, enjoyment itself was transmuted into ideology. This is why in contemporary liberal multiculturalist discourse the term avant-

garde remains unspoken – not because its logic has been exhausted, but because avant-gardism continues to structure modes of enjoyment. And why not understand this in its full Lacanian sense as surplus enjoyment, the *plus de jouir* that signals the moment of flight from the analyst's couch?

What *Elephant Project* showcases is a realist art that is fully reflective of and integrated with the ideological apparatus of community art as the official art of neoliberal capitalism, where political rule is not exercised directly through police control but through the manipulation of popular opinion, which is represented here by paintings tailored to accommodate the taste for the generation of reality. *Elephant Project* unashamedly reveals how its very modes of procedure are drawn from the kinds of pre-existing practices that are commercially successful, in this case, from the success of "Ruby," the painting elephant of the Phoenix Zoo. For artworld audiences, however, the key referent is not elephant paintings but community art. On a basic level, and in an avant-garde sense, the artists attempt to make the form (the conceptual contours of the work) the specific characteristic of the work within the more general and overarching category of content (the organization of means of subsistence for unemployed elephants in the context of both ecologically sensitive de-industrialization and the permutations of contemporary art within the culture industries). This critical use of realism allows the obscene prohibition against avant-gardism to come to our consideration. It does so by associating relationality, dialogue and collaboration with relations of class power. This point is brought home by the way that *Elephant Project* involves not only the representation of disenfranchised communities, not only the avid participation of artworld insiders, but also the determining power of collectors, including Thai royalty.

As with their previous poll-based projects, Komar & Melamid manipulate the range of responses that one can anticipate in reaction to the work. These sociologically typical responses are

treated like readymade components of the work, engineered in advance as means to engage viewers in an extended reflection. The photograph of the two artists teaching a baby elephant and its trainer about the work of Marcel Duchamp provides a glimpse of this intentional, authorial approach. The elephants are not so much producing abstract expressionist canvases but are part of an extended materialist strategy to re-conceptualize community art. The ideational and psychological aspect is crucial here. Among the readymade structures of feeling that Komar & Melamid activate are the responses that viewers may have about the project: "Do Komar & Melamid think that people will actually be moved by the paintings, or the project as a whole?"; "Does the public appreciate all of the ironic references to Marcel Duchamp, Jackson Pollock, etc.?"; "Aren't they merely creating another investment opportunity for the art market?"; "Aren't they merely reproducing the structures of neocolonialism?" What happens, then, when people take their antics seriously?

The critical aspect of this project is not only that Komar & Melamid take their work seriously as community public art, but also that they simultaneously engage in an over-identification with the ideological structure of community art that is capable of exposing the links between cultural activism and the economic function of cultural production within the new neoliberal "creative" economy. The project does so in part because it makes use of the lessons about ideology developed by the two artists in response to Socialist Realism. The name I give this kind of practice, following Žižek's interpretation of Lacan, is a *sinthome-opathic practice* in which subjects hold on to their deepest libidinal attachments. By both learning from the public what it wants and making this the subject of the work (the symptomatic aspect of public opinion), *Elephant Project* reveals the meta-rules of community art as part of the neoliberal art market. This aspect of over-identification is what Žižek refers to as the "manipulation of transference," a situation that begins with the "subject

supposed to know." The artists put in place the function of "the subject supposed to know" through a strategy of interpassivity. By listening to what the public wants, they are relieved of the superego injunction to be amused by the spectacle of elephants painting. Their role as mediators resembles what television provides in the form of canned laughter. However, in this case, the canned laughter is made reflexive by the plight of the elephants and as such provides a Brechtian lesson. This allows for a shift from belief to knowledge. For Lacan, the function of the symbolic order, an impersonal set of social regulations, refers to belief rather than knowledge. The assymetry between the subject supposed to know and the subject supposed to believe reveals the reliance of belief on a big Other (a sort of impersonal superego) that relieves us of responsibility for what we desire. In terms of psychoanalytic transference, the unconscious desire of the patient can be perceived inasmuch as the analyst is considered the subject supposed to know (to know the unconscious desire of the patient). As viewers of the work, then, we are caught in a transferential confusion of belief and knowledge. With whom are we expected to identify: with the members of the public who are confounded by the full panoply of Komar & Melamid's avant-garde exposé, or with those of us whose libidinal investments are most fully constituted by fantasmatic identification with contemporary art? With what are we expected to identify: with art's exceptional power to transcend and heal social divisions *within* actually existing global capitalism, or with the possibility of a critical autonomy that can reconstruct and alter the field of cultural production?

Before we seek answers to these questions, however, psychoanalytic ethics requires that we attend to the transferential reversal that defines the psychoanalytic cure. Because the function of the subject supposed to know is here occupied by elephants and not human beings (if one was to ignore the role of their trainers), it is easier for us to see how our ideological

obsession with the desire of the Other locates the truth in something or someone that exists *as such* and that is to be brought into political representation by the poetic subtleties of the public artist, or, the not so subtle philanthropy of state and corporate granting agencies, and a few collectors. If what takes place at the end of psychoanalytic transference is the shift from desire to drive, then what an effective sinthomeopathic practice like Komar & Melamid's can do is shift the coordinates of both art producers and the public towards the understanding that desire (defined by Lacan as the unconscious rules that regulate social interaction) has no absolute support in the symbolic law that separates art from politics, pleasure from necessity. In other words, psychoanalytic ethics requires that we subjectivize the field of social relations, that we think for ourselves rather than follow the dictates of the obscene unwritten law. This law, as I have argued, includes the injunction against avant-gardism that informs the current manifestations of much socially engaged community art. The injunction itself, as a symptom of our cultural condition, needs to be brought into relation with the official art of our times. *Elephant Project* does this by identifying with community art as one of the most advanced forms of cultural and biopolitical production within neoliberal societies.

Komar & Melamid's strategy of learning from what the people want should inform and not constrain our relation to a critical community art. It underscores the role of collaboration as a symptom of today's ideologization of social relations. The problem then for the avant garde of public art in the age of neoliberal globalization is not that of collaboration *versus* antagonism, of contingency *versus* universality, but the enabling of a radical subjectivization of art and politics. The incorporation of various community contexts into the frame of art and thus within the flexible production strategies of the creative industries is not, strictly speaking, a form of mass deception, but also a self-deception. We are and we are not that community.

Chapter 5

Welcome to the Cultural Goodwill Revolution: On Class Composition in the Age of Classless Struggle

The widespread abandonment of critical dialectical realism on the left has occasioned a number of theoretical common points among anti-capitalist artists and activists. Whereas one often hears that this is an outcome of historical experience and therefore progress in matters of praxis, the widening gap between theory and practice demands of us that we work through the aporias of this dilemma. As Theodor Adorno once argued in his essay on commitment: "the controversy over commitment remains urgent, so far as anything that merely concerns the mind can be today, as opposed to sheer human survival."[1] Following the success of Foucault and Deleuze in academic circles, and the importance of Hardt and Negri's *Empire* in the wake of Seattle and subsequent anti-globalization protests, North American activists have in the last decade turned to the theoretical work of the Italian autonomists and in particular the writings of Antonio Negri, Maurizio Lazzarato and Paolo Virno. The latter have argued that the conditions of production in post-Fordist societies require new thinking in matters of social and political organization, changes that are facilitated by networked resistance and new forms of cooperation and worker self-management. Mixed in with protest activity and critical writing are the ongoing debates between anarchism, communism, and social democratic trade unionism. Beyond the many examples of grassroots and institutionalized "anti-capitalist" organizing, the current view among activists is that the "movement of the movements" needs to go beyond counter-summit protest and

shift toward popular front mobilizations.

In these same years, the work of Alain Badiou and Slavoj Žižek in particular has provided a lively counterpoint to the theoretical shortcomings of the anti-globalization movement, in particular on philosophical matters having to do with revolutionary theory, the subject's implication in ideology and the relation of radical democratic politics to class struggle. These writers have excoriated both liberal leftists and postmodernists for their lack of inventiveness concerning the relevance of the historical past to contemporary action. The notoriety of their ideas, somewhat in contrast to the direct influence of Deleuze and Guattari's schizo-anarchism on the counter-globalization left, has yet to fully take root, at least, at the level of practice. What I wish to provide in this essay are some reflections on the relation of social class to cultural production that could potentially bridge some of the aporias that separate anarchist from communist tendencies. By crossing Pierre Bourdieu's work on culture and class distinction with Peter Bürger's historical model of the development of the "institution art," I hope to provide a working model with which to think through the contradictory situation in which today's international petty bourgeois class deliberates the possibility of enabling ever more authoritarian forms of transnational capitalism.

On many levels, the potential for critical discussion and action today is seriously circumscribed by institutional conservatism. In his four-volume theory of the state, Henri Lefebvre argues that official humanism has accomplished very little for human beings and much more in terms of the consolidation of the state. From this, humanism passes to individualism, sustained by libertarian ideals but nevertheless abandoned by the state in economic and political terms. Only bourgeois anarchism affirms individualism in its reductive dimensions, where it cannot even be named as such and instead passes over into struggles for identity – without, it should be added, altering

the mode of statist production and emerging as petty bourgeois initiatives.[2] Here the role of elite intellectuals is circumscribed by their connection to the middles classes and the relation of this class to the state. The key characteristic the bourgeois elite is that it believes itself cosmopolitan, open to strangers and foreignness and to innovation. From this group leftist intellectuals have difficulty distinguishing themselves and consequently come to believe in their marginality. Focused on culture, they offer new models of consumption as a form of revolution. Investments of affect and romantic individualism, Lefebvre writes, flounder against the harsh reality of global markets and capital investment.[3] Whereas the left's intellectual contribution to thinking through the limits of neoliberal economics, both socially and politically, gained respectability in the wake of the economic bank bailouts of 2008, the ideological reaction was equally noticeable. Meanwhile, cadres in the culture and knowledge industries might agree with the critiques of global capitalism but they consider radical solutions to be too idealistic. They are more likely to talk about a left imaginary than a left party. In the artworld, the crises of capitalism are to be overcome with theoretical deconstructions of modernist legacies that do more to indicate the decline of symbolic efficiency than the will to engage in radical change.

None of this comes as a surprise when we consider the prohibition on class politics that has structured so much social thinking in the decades since Reagan, Thatcher and Mulroney. However, because neoliberalism has remained the privileged formula for both state policy as well as international forms of governance, *class polarization* – a process of actual polarization between the rich and the poor combined with an entrenched "middle" class phenomenon of petty bourgeois identification with the liberal ideology of classlessness – has taken place on an increasingly global scale. This transformation has occurred primarily in relation to the growth of a distinctly international

petty bourgeois class formation. Its optimism concerning the public virtues of democracy masks the latter's basis in market capitalism and altogether ignores the imperialist relations on which industrial and post-industrial capitalism have been built.

What are the political characteristics of this tertiary "middle" class and what can an "orthodox" class analysis contribute to thinking through the perils of anti-capitalism in a world commandeered by forms of neoliberal governance? If we could adequately address this question, I argue, we could better understand the relentless capitalization of culture through the mediating role of political, cultural and educational institutions. What do the current institutional forms of cultural production reveal about the ideological function of class? What kinds of cultural criticism are appropriate to a renewed engagement in social and political contestation that takes class analysis into consideration?

Autonomy, Institution, State

Among the key Marxist concepts that allow for an appreciation of the ideological function of culture is the concept of autonomy, understood superstructurally as the relative autonomy of art from its economic conditions of production. Modern art, a product of the division of labour, is structured unevenly in relation to class distribution. Understood in terms of ideological relations, autonomous art is a relatively independent aspect of the social space. While some seek to find here a space of utopian possibility and projection, they typically ignore what Lefebvre referred to as the state mode of production, a reality of modern technocratic production that since Stalinism has effectively overcome the cultural and nationalist trappings of the state form. No wonder then that so much writing has currently focused on the place of culture in economic growth, from concerns with the precarious working conditions of artists to the culture industries boosterism of urban governments and the cost accounting of

federal agencies. Notwithstanding the lingering confusions about the sublation of art and life that finds perhaps better solutions in cultural studies work on representation, it is this new discourse of the neoliberal engineering of culture that has led many on the left to do away with autonomy. However, no amount of theorization will alter the fact that art, as a form of capital, acts in concert with the concrete universal that structures the chain of signifiers in the hegemonic production of social relations.

In his landmark text on the sociology of culture, Pierre Bourdieu described modernist aesthetic autonomy as a function of the reproduction of class society.[4] Cultural practice, he argued, and in order to reproduce itself, avoids the objectification of culture through the very transgression of the conventions of cultural production. Because artistic transgression further distances the cultivated dispositions of the dominant classes from the ethical dispositions of the dominated, cultural transgression works to reproduce class inequality. The contradictory aim of transgression, Bourdieu argued, is "contained within the limits assigned to it *a contrario* by the aesthetic conventions it denounces and the need to secure the aesthetic nature of the transgression of the limits."[5] The "historical" avant gardes attempted to counter this process through a politically motivated suspension of aesthetic priorities, a strategy of sublation that is sometimes mistaken as "political art."[6] Bourdieu's sociological and anthropological approach toward the sense of taste and questions of cultural disposition is one of the means whereby critical theory has followed a path that is distinct from the modernist emphasis on *a priori* assumptions concerning cultural authority. In contrast to Adorno, for whom the inexorable precariousness of culture was to be attributed to its resistance to the exchange values of liberal capitalism, Bourdieu identified the eradication of the sacred boundary that separates art from everyday life as a necessary stage in the resistance to the logic of accumulation.

In the same decade, a second major criticism of the concept of

autonomy was put forward by Peter Bürger in his *Theory of the Avant Garde*. Bürger defined the goal of avant-garde aesthetics as a subordination of the specific formal characteristics of the work of art to the general characteristics of the work's social and political content. In this sense, the historical avant gardes were not so much anti-aesthetic as dialectical in the proper Hegelian sense: art was to be mediated according to its social conditions of production, a notion that was best expressed by Walter Benjamin in his essay on "The Author as Producer."[7] The institutionalization of this critical or realist approach to autonomy by the capitalist culture industries, Bürger argued, had led in the postwar period to the separation of art from praxis and from the radical confrontation with class society. According to Jochen Schulte-Sasse's introduction to the English translation of Bürger's book, it was Oskar Negt and Alexander Kluge's notion of the consciousness industry that led beyond Horkheimer and Adorno's pessimistic view of negative dialectics – autonomy's withdrawal and compensatory function in a world of instrumentalized integration – towards a recognition of proletarian experience as a "historically concrete production of meaning."[8] While few have accepted Bürger's critique of the postwar neo-avant gardes, his theory of the development of bourgeois culture has more or less become a canonical text in the sociology of art.[9]

While postmodernism and cultural studies have made significant claims for the heterogeneity of language games and the diversity of modes of reception, Bourdieu and Bürger have effectively demonstrated that the reception of art coincides primarily with changes to its institutionalization. Bürger's thesis concerning the discursive institutionalization of art/autonomy, however, might mask some significant changes related to the eclipse of the theory and practice of avant-gardism. Few commentators today would deny the fact that cultural institutions are the object of constant criticism on the part of its own constituencies. If anything, this vanguard posture is enacted

today through its "post-political" reversal: complicity, compliance, identification and relationality as critical strategies. This cool, affirmative set of strategies, pressured by the logic of networking and careerism, is little more than a survival strategy within conditions of neoliberal governance.

It is in the 1960s and 70s, in the paradigm shift from the old left to the new left that the critique of alienation and reification was replaced by the critique of institutions, a consequence of the view that class struggle had been abolished, or neutralized, by parliamentary democracy and the welfare state, on the hand, and by bureaucratic socialism on the other. According to Gerald Raunig, the student rebellions of the late 60s were considered irresponsible by traditional leftist organizations because they disabled institutions: "They refused to channel their rage into the available political parties or labor unions and instead used Situationist and other artistic-*cum*-political methods to call for a thoroughly political objective: *L'imagination au pouvoir*."[10] While the new left, informed by post-colonial struggles and the American civil rights movement, challenged sexism, militarism, imperialism, environmental degradation and commercialism, it tended to conflate class struggle with the struggle to create alternative institutions.[11] Today, as a consequence, a hegemonic view of classless society has come to operate as the groundless ground of democratic struggles for social justice. Class struggle has disappeared, however, only to the extent that wealth creation in industrial societies has led to the disappearance of boundaries between classes and the rise of a tertiary "middle" or petty bourgeois class that is neither bourgeois nor proletarian. Despite its position as a working class, the petty bourgeois class of managers and service workers has witnessed a class polarization that plays a determining structural role vis-à-vis class praxis. As Nicos Poulantzas long ago argued, the petty bourgeois social formation reproduces itself through polarization. In the postwar period, its distinct class practice has been to abandon class struggle in favour of identity struggles and

the struggle against institutions.[12]

While the critique of institutions has allowed numerous forms of oppression to become the object of analysis and research, it also contributes to class inequality. What is missing from many of the new models of politicized cultural practice is a distinction between the kind of criticism that accepts the concept of social formation as an expression of the mode of production, and a Marxist sociology that explains social formation as the mode of reproduction of the modes of production. Institutions are key in this regard as they create a space of mediation that allows for the separation of modes of production from social relations. The prodominant ideological tendency is thus towards forms of "liberal communism" and the urge to create "alternative" institutions as complements to the new imperative towards networked sociality.[13] Non-alienated models of subjectivization are consequently proposed as ways of coping with and resisting today's "societies of control."

The search for a post-avant-garde aesthetic in contemporary art can be largely attributed to the dismantling of a nineteenth-century notion of the historical subject, including that of the proletariat as the historical class that is best able to overcome the contradictions of capitalist class relations. The main trends in contemporary culture remain thoroughly aesthetic, however, and because of this, the polarization of class factions as a feature of the dominant mode of capitalist production goes unrecognized. What Siegfried Kracauer once termed "the salaried masses" and what C. Wright Mills later referred to as the "white collar" world of the new middle class defines the situation of the majority of people in the West today who are in the position of traditional labour inasmuch as they do not control the means of production. However, because of their class situation, education and lifestyle ambitions, they identify with capital.[14] Class polarization, rather than cultural difference, is the open secret, the obscene supplement of contemporary post-politics and its

cultural manifestations. Contemporary aesthetic practices are thus not moves away from the emphasis on economic determination, but function more precisely as adjuncts to an impossible non-relational, and indeed, despotic class politics inasmuch as they make no claims to universality and abandon hegemonic struggle. The proper orientation for critical practice is not to find in the autonomy of the aesthetic sphere a free space for the figuring of utopian social possibilities, but to recognize in aesthetic autonomy an already compromised class practice, a self-relating that takes its own denial into account and that is constructed around its own constitutive void.[15] Cultural formations do not exist in themselves but through various rule-bound and antagonistic social structures that question the self-evidence of modes of production and normalization. If contemporary critical art practices pretend to dispense with autonomy, they do so in the same way that the rationalized capitalist economy dispenses with the language of class: in both cases, social classes are presumed to precede the structures and institutions through which they are reproduced. What is truly tragic for us today is not the loss of autonomy *per se*, but the sense of what this autonomy was and the kinds of resistance it might still provide.

Il n'y a pas de relation idéologique

One of the most succinct expressions of the links between globalization and social reproduction through culture has been Bill Readings' book, *The University in Ruins*.[16] Readings argues that in a world of transnational globalization, the language of economic management replaces that of cultural and class conflict. He cites Giorgio Agamben, whose book, *The Coming Community*, proposes that a new planetary petty bourgeoisie has replaced social classes and has "freed itself from the Fascist positioning of the [prewar] petty bourgeoisie."[17] According to Agamben,

The planetary petty bourgeoisie has instead freed itself from

these dreams [of false popular identity] and has taken over the aptitude of the proletariat to refuse any recognizable social identity... They know only the improper and the inauthentic and even refuse the idea of a discourse that could be proper to them. That which constituted the truth and falsity of the peoples and generations that have followed one another on the earth – differences of language, of dialect, of ways of life, of character, of custom, and even the physical particularities of each person – has lost any meaning for them and any capacity for expression and communication. In the petty bourgeoisie, the diversities that have marked the tragi-comedy of universal history are brought together and exposed in a phantasmagorical vacuousness.[18]

According to Readings, this global petty bourgeoisie refuses a specifically political dimension in favour of a purely economic and post-historical logic of administration.[19] In this sense, the liberal belief that North America represents a classless society has paved the way for the economic dominance of a global class that refuses all recognizable or fixed forms of social identity. This class considers both traditional bourgeois and socialist society to have nothing to do with its technical expertise and vision of the good life.[20] For the global petty bourgeoisie, one could say, there is no ideological relation.

The paradoxical class position of the petty bourgeoisie is that it is neither working class nor middle class but both. Its social effect is, on the one hand, class polarization, and on the other, a certain invisibility inasmuch as it privileges the thesis of class-lessness. Technocratic powers have learned to exploit this contra-diction to great effect and could do so because neoliberalism seems to them not only the engine of trade and deregulation, as the most advanced form of "turbo" capitalism, but also as a protective reaction to the vagaries of uncontrolled markets – noticed in particular in the creation of international trade blocks,

in religious fundamentalisms and xenophobic nationalisms.[21] In ways that Agamben could not have foreseen in the early 1990s, the militarization of the state in the capitalist democracies has been deepened through the biocapitalist manipulation of fear and delegitimation measures that have been normalized through the reactionary transformation of social institutions.[22]

These contradictions are visible, however, in both the recuperation and disciplining of cultural criticism. One example of the latter is the 2007 arrest, interrogation and detainment of sociology professor Andrej Holm by the German federal police. Holm was detained because his publications contained words like inequality, precarization and gentrification, words that were construed by authorities as the kind of language used by militant terrorist organizations.[23] Softer forms of censorship can take place through economic sanctions. For example, among the $45 million in cuts to arts funding announced by the Conservative Party of Canada in August 2008, Prime Minister Stephen Harper singled out small grants that had gone to "radicals," "left-wing and anti-globalization think tanks," "ideological activists or fringe and alternative groups" and "highly ideological individuals exposing their agendas."[24] If the civil liberties of artists and intellectuals producing politically-motivated work can be so easily revoked through repressive state action, it is partly because political power is distributed anonymously across all social institutions.[25] One should be careful not to overstate the control exerted by disciplinary state apparatuses, however, since the purpose of neoliberal governmentality is largely to produce self-interested subjects who can act autonomously within market relations of inequality.

According to Readings, the standards of excellence and evaluation criteria that now operate in universities, museums, the publishing industry and similar culture industry sectors, are subject to a constant evaluation vis-à-vis performance indicators, opinion polls, cost-benefit analysis, economic development statistics and marketing objectives. The integrative functional-

ization of culture requires that artists and institutions be allowed to experiment so that they can be better controlled by the power of bureaucracies and so that research can be synergistically tied to economic development.

Following Readings' analysis, contemporary cultural production can benefit from a re-contextualization of Bourdieu's theory of the "cultural goodwill" of the lower middle class as a key political sector of the social space. The general mode of production and consumption, or class *habitus*, that Bourdieu defined as the petty bourgeois mode was that of *allodoxia*: an empty form of goodwill and reverence towards high culture that is based in mistaken identifications combined with anxiety about one's social status.[26] While allodoxia owes its sense of distinction to the mode of consumption that is proper to legitimate culture, it confuses aesthetic disinterestedness with popular culture and prefers accessible versions of avant-garde experimentation. Here, as with avant-garde intervention, the political content of the artwork functions at the social level above that of its formal specificity, but the content is the impossible one of an unspecified form of the political.

The petty bourgeois mode of production and consumption attempts to operate as a disengaged and neutral index of the power of institutions to impose cultural capital.[27] By adapting Bürger's model of the sociological development of aesthetic autonomy to Bourdieu's study of the social space of positions, I would like to propose the formation of a new field of relations. Such a re-mapping of the universe of possibles allows us to perceive some of the ways in which the imposition of news forms of cultural legitimacy, including progressive models of practice, avoids what Bourdieu described as a discernment of reality in terms of class composition. Furthermore, the ascendancy of a global petty bourgeois mode of cultural production helps to explain the current status of radicalism and its submerged conditions of efficacy.

Within a petty bourgeois framework, the kind of avant-garde arrogance and insolence that is derived from the "heroic" certainty of possessing culture through serious engagement is replaced by the permanent anxiety of those who pretentiously overidentify with culture.[28] They are, we could say, "possessed" by culture in the same way that bourgeois ideology is "possessed" by class. According to Bourdieu, the pretense of identification is objectively based in the petty bourgeois desire to escape from proletarianization and to subsume culture under the sign of class mobility. Because of this race against the order of time, a process that installs class identification in terms of surplus enjoyment, and because the order of time is marked by the growing gap between the working poor and the wealth of a small number of individuals and mega corporations, the petty bourgeois mode of appropriating culture dominates the so-called creative industries.[29]

	SACRAL ART MIDDLE AGES DYNASTIES	COURTLY CLASSICAL NATION STATES	BOURGEOIS MODERN INTERNATIONAL	NEW PETTY BOURGEOIS GLOBAL
FUNCTION	cult object	representational object	portrayal of individual self-understanding	allodoxia integration life-styling
MODE OF PRODUCTION	collective craft guilds	individual academies	individual studio	networked culture industry
MODE OF CONSUMPTION	collective religious	collective sociable	individual alienated	post-enlightenment enjoyment
STATUS OF THE WORK	magical secret iconic	treasure pageantry alchemical	autonomous avant-garde symbolic	market value activist biopolitical

Among the modalities of petty bourgeois allodoxia, Bourdieu proposed the following processes: structural indeterminacy vis-à-vis the social field; countercultural resentment that verges on nihilism; a taste for the new and a willingness to submit to lifestyle changes (especially among the rising, executant petty bourgeoisie); the creation and selling of new products; new occupations that allow symbolic rehabilitation strategies; occupations that emphasize symbolic production, especially in the areas of communications and new media; the euphemization of seriousness; the fun ethic; relaxation strategies and conviviality; affectation in simplicity; flair combined with bluff; sympathy with discourses that challenge the cultural order; the denunciation of hierarchy; an emphasis on personal health and psychological therapy; an imperative of sexual relation; the offering of one's art of living as an example to others; pragmatic utopianism; a measure of psychic distance from the direct impact of market forces. All of these liberated manners and lifestyle choices, Bourdieu argued, betray an effort to defy the gravity of the social field.[30] The challenge to authority is a particularly telling feature of class structure and is one that figures prominently in relation to the charismatic conception of the artist, a fact that facilitated challenges to bourgeois power as a general condition for the constitution of the field of aesthetic autonomy. Authority boundaries, however, are the most permeable of class boundaries, in comparison with the more static boundaries of skill, knowledge, and property.[31]

One of the features of neoliberalism has been the weakening of the value of skill and knowledge, and with this the corresponding mechanisms of professionalism, in favour of property relations. This was an overt feature of the "neoconservative" years of Thatcher and the downsizing mentality that witnessed the wholesale restructuring of institutions and corporations. In this, petty bourgeois allodoxia plays a crucial role, setting cultural criteria of affect and connectivity above all considera-

tions of necessity. As Thomas Frank argues in his book *The Conquest of Cool*, capitalist values become part and parcel of what appears to be their opposite: counter-cultural resistance to what is construed in idealist terms as traditional and outdated forms of authority and morality. This slight of hand allows for the perpetuation of relations of misrecognition or what Žižek refers as the decline in symbolic efficiency. Notice that today's cultural and educational institutions cavalierly address their constituencies as consumers, as though the real relation inheres in the unquestioned value of culture and knowledge itself, often tacitly held to be homologous to the field of boureois power. However, the field of power is not static, a fact that becomes more visible in times of crisis and discordance. As Mina Möntmann has argued, the "twilight of the welfare state" has resulted in the eclipse of the bourgeoisie as the legitimate peer group for cultural institutions.[32] Because middle-class liberalism by and large continues to function as the stated and unstated ideology of capitalist institutions, the actual sociological entrenchment of the petty bourgeois *habitus* remains largely invisible.[33] As Poulantzas recognized, the ideological and political articulation of the social position of the new petty bourgeoisie is very narrowly defined by the high level of competition and hierarchy in creative fields.[34] While the economic profile of the cultural worker may effectively be middle class, their relationship to culture is, sociologically speaking, petty bourgeois. According to Möntmann, the ideal trait of the flexible person within the new capitalism is the ability to look for the new, to detach oneself from all ties and to abandon habitual behaviour.[35] One of the structuring problems here is the fact that the erosion of the welfare state in the so-called "developed" countries is due to the declining base of full-time, industrial or "Fordist" workers, a result of neoliberal globalization and a basis to the proliferation of nonproductive creative, cognitive and immaterial labour.[36] This tendency, when thought of in terms that ignore class analysis, the intermediary role of the state and the

labour theory of value, contributes to the proliferation of petty bourgeois polarization.

This perception is not entirely new. In the late 1970s, Bourdieu demonstrated how the new petty bourgeois *habitus* was in the process of supplying the economy with the perfect consumer.[37] His conclusions were supported by the postmodern withdrawal from the meta-discourse of class struggle. By the mid-1980s, Hal Foster could refer to the administrative mediation of legitimate forms of art as "arrière-avant-gardism," a fashionable, cyclical mechanism obsessed with marginal forms of art as well as the popular past.[38] Against critical complicity as well as the allegorical concept of redemptive criticism (the return of the old), Foster proposed that the "liberation" from history that was celebrated as postmodern pluralism was irredeemably tied to late capitalism. Almost twenty years later, Foster's position is largely the same: "This 'end of art' is presented as benignly liberal – art is pluralistic, its practice pragmatic, and its field is multicultural – but this position is also not so benignly neoliberal, in the sense that its relativism is what the rule of the market requires."[39] Caught between the promise of a cosmopolitan identity and the pressures of an increasingly administered social context, most postmodernists simply abandoned the language of class analysis as well as its cultural counterpart, critical autonomy.[40] What is the avant garde to do?

From Politics to Fantasy

Rainer Rochlitz has argued that the avant-garde emphasis on political consciousness in twentieth-century art may have been part of an effort to maintain criteria of quality in the absence of a transformation to a singularly aesthetic logic.[41] My argument is that such a transformation of the bourgeois criteria of aesthetic autonomy has not taken place and that petty bourgeois allodoxia plays an uneven and contradictory role. Because of class polarization, however, the major shifts to cultural production that

have marked the late twentieth century often go unrecognized. In the developed countries of the West, the liberal concept of aesthetics has not entirely been displaced. Instead, the cultural features of polarization have gained in symptomatic ascendancy. Inasmuch as the field of culture continues to exploit the reserves of "legitimate" culture, new subjectivities are compelled to engage in the schizoid performativity of individual competition, sometimes translated into activist engagement, subsuming inter-estedness to the contradictions of bourgeois culture, including academia's rarefied post-humanist discourses. As a matter of theory, however, we should not think of aesthetics in positive terms. There is no properly bourgeois, petty bourgeois or prole-tarian aesthetic; there are only works, gestures and images that substitute for a fundamental social antagonism.

In the context of neoliberalism, the reduction of the cultural sphere to a positive signifying economy functions as an attempt to politically and economically manage class differences. Radical practice, instead, strives to create culture that is unconstrained by a privileged social mediation. Thus, whatever operates today as an avant garde, we could say, functions as the supernumerary of aesthetic autonomy; its activity corresponds to the failure of culture to produce social coherence. The goal of avant-garde practitioners is to find a way to enable critical dissatisfaction and to subvert established forms of (dis)identification through a radical subjectivation of politics. In terms of criticism, this implies the diversification of art's audience through the practice of being, as Baudelaire once declared, partial, passionate, and political.

From the outset, what the analysis of class composition suggests for cultural praxis is something along the lines of what Žižek refers to as revolution, the dialectical action of partici-pating and not participating with those institutional arrange-ments that we cannot do without. This *sinthomeopathic activity* is set against three decades or more of complicit reconciliation with

consumer capitalism that has by and large ignored the practical reality and consequences of capital accumulation on a global scale. Lacan's concept of the sinthome is defined as a stage beyond the fundamental fantasy (ideological misrecognition), and which allows for a nonpathological (political) subjectivization (organization) of the symptom (cultural practice). In his *Four Fundamental Concepts of Psychoanalysis*, Lacan presented the dilemma of justified paranoia. In our case, this would mean that to oppose the symbolic order of institutionalized art practice is to risk exclusion; to negotiate with it is to allow one's actions to be determined by it.[42] Since artistic freedom can no longer be thought of in terms of sacrificing oneself to the competitive struggle of aesthetic transgression, one must construct what after Lacan we could call sinthomeopathic solutions: lending oneself to institutional arrangements, the symptoms of contemporary cultural production, while still maintaining the fantasy of critical distance.

Chapter 6

The Subject Supposed to Over-Identify: BAVO and the Fundamental Fantasy of a Cultural Avant Garde

What are the critical issues that inform today's radical anti-capitalist contestation if not those that have caused the most confusion in relation to Marx and Engels' unfinished theory of the socialist transition to communism: the historical role of capitalism in the revolutionization of the forces of production, the democratic potential of state institutions, the role of universal suffrage and education in the coming to consciousness of the working masses, and the appearance of the proletariat as an immanent contradiction of the system that could eventually seize state power. The forces of capitalist accumulation lead inevitably, as Rosa Luxemburg explained, to imperialism and expansionism, turning capitalism into a veritable world system. According to the French philosopher Henri Lefebvre, Luxemburg partly resolved the problem of accumulation by focusing on economic questions, a passage in revolutionary theory that allows us to see that the emphasis on the economic does not solve the problems of capital, but functions as a surrogate for politics.[1]

Far removed from these questions, today's progressive art movements typically avoid issues that are believed to be outdated. A series of taboos crowd the political imaginary: class analysis, dialectics, teleology, the avant garde, the state and the political party organization. Such prohibitions clear the way for neoliberal politics, which justifies itself according to economic growth. Marxism, which upholds class struggle as the answer to the abstract principle of equality, does not justify itself according to economic growth. Marxist theory thus conceives the state as a

bureaucratized system that upholds inequality through the reproduction of existing social relations and modes of production. The problem of the modern state, as Lefebvre argued, is represented by the shift in the twentieth century from questions of social progress to that of ecnmic growth. The most we can say about Marx is that he never proposed an outline of the ideal state. Against pure politics, Marxism-Leninism responded to this absence through the development of the revolutionary party, thereby breaking with any notion of evolutionary historicism – an important lesson to all of those who continue to interpret modernism in terms of a *soi-disant* linear teleology. Slavoj Žižek, following a Freudian line of analysis, suggests that the party should not be encountered as a detested symbol to be destroyed, but as a fetish, a feature of the necessary self-alienation of the people from itself. The fetishism of the market, in contrast, covers the contradictions of rationality – which we could view as the state of international law and trade agreements – and nationality, a metaphysical postulate that allows for the mystification of social processes on a global scale. Consider for example the current economic crisis in Greece in which the state, the EU and the IMF are unable to offer any solutions to intractable broblems other than the extortion of the working class. It is not surprising then that most conceptualizations of radical practice today vary according to postulates concerning the state, from workerist schizo-anarchism to civil society movements, social democracy and communism.

In the context of a renewed anti-capitalist militancy, we can begin to reconceive the role of radical cultural practice and with this make some proposals for a contemporary project of avant-garde contestation.[2] One of the rare voices in this arena is the Brussles and Rotterdam-based collective BAVO. BAVO's members, Gideon Boie and Matthias Pauwels, have produced a significant body of essays and publications dedicated to the radical cultural criticism of neoliberal politics. Drawing on

Jacques Lacan's and Slavoj Žižek's psychoanalytically informed theories of subjectivity and social practice, BAVO has presented an incisive critique of the ways that contemporary cultural practices work to depoliticize the social space by maintaining the privileges of art. The concept of *over-identification* that they have developed in recent writings draws on the widely discredited concept of totality as a path to understanding how it is that the production of surplus value is the necessary condition for efforts on the part of engaged cultural actors to bring about radical social change. The goal of over-identification, as a form of class struggle, serves to render visible the ideological supports of social relations.

Following Žižek's analysis of the cultural strategies that have been used by Neue Slowenische Kunst and the musical group Laibach, BAVO has refined and described practices of social subversion through over-identification as a specific mode of cultural contestation. Over-identification can be conceived as a dialectical mediation of political and cultural practice; it is neither singularly aesthetic nor singularly political. The ultimate failure of the effectiveness of any particular work of over-identification – say the work of the Yes Men, Janez Janša, Janez Janša and Janez Janša, NSK, Andrea Fraser, Thomas Hirschhorn, Christoph Schlingensief, Komar & Melamid, Jakob Boeskov, or the television show *The Colbert Report* – is not equivalent to the failure of a political option. Practice need not lead to immediately recognizable changes to have been effective. Unlike some forms of socially ameliorative art activism, the function of over-identification is not based on the postulate of direct action. It is rather a subversion of the predominant symbolic order, an undermining of the symbolic authority of existing social structures and institutional arrangements. To be clear, in order to be considered avant-garde, a work of over-identification must nevertheless presuppose certain regulatory schema concerning the opposition to dominat relations. In this, it is different in conception from

Stephen Colbert, Colbert Portrait Gallery, 2011.
Courtesy of colbertnation.com

micro-political practices that presuppose an endless constel-
lation of "uncoded" and pre-subjective positions, as argued by
Gilles Deleuze.[3] Against the "communicational stupidities" of
Deleuze's "machinic assemblages," we uphold the Lacanian view
according to which it is possible to break eggs, but it is not

possible to make an *homelette*; one is born a pre-symbolic being, but one does not remain one for an entire lifetime. This emphasis on split subjectivity allows for the minimum of distance necessary to break with the ideological seamlessnes of the capitalist social formation, as well as the moral economy of petty-bourgeois counter-cultural reformism.

A fundamental presupposition of over-identification as an avant-garde tendency is the view that the artistic *transgression* of conventional cultural codes works to reproduce social relations rather than change them. In this sense, BAVO's rejection of the superego injunction to obey social codes resembles the position that Peter Bürger ascribed to the historical avant gardes. The main difference between Bürger's theory and the Žižekian paradigm, however, is the loosening of the laws of historical materialism in terms of the Lacanian paradox of surplus enjoyment, the problem that the desire of avant-garde contestation confronts dissidents as an external demand, mediated by various institutional determinations, including contemporary political injunctions to abandon class struggle in favour of a politics of equivalence or a post-operaist multitude where all of producing labour is by and large equated with the workings of capitalism. In contrast to Bürger's pessimistic view of the position of the postwar neo-avant gardes, Žižek's reading of the revolutionary situation emphasizes the radical contingency of practice and of the historical present.[4]

Žižek's Lacanian understanding of Law, language and norms helps us to understand the crucial difference between the kind of radical practice that BAVO advocates and the proliferation of socially engaged cultural practices that we find in the forms of *connective*, *dialogical*, and *relational* aesthetics, or in Deleuzian forms of *transversal* activism.[5] One of the primary distinctions, we might say, is Žižek's view that Law is constitutively split between the official public letter and its obscene superego supplement. Žižek's work advocates a shift from the obscene supplement –

that which binds social formations by repressing social antag-onism – to that of universal norms – which alone recognize exception (the identity of opposites) as the basis for the emergence of a universal form of politicization. Following Žižek's work, BAVO proposes an *over-identification* with the unstated, obscene demands of capitalist universality as a means of marking the specific ways that liberal democracy organizes the link between the public law (affirmations of the formal space of culture) and its perverse underside (class struggle). In contrast to the Foucauldian view that law produces its self-sustaining forms of transgression, the Lacanian split law points to the possi-bility of social disjuncture, revealing the autonomy of law as a traumatic disturbance.

Through an analysis of Lacan's "four discourses" as well as his concept of the sinthome, it is possible to elaborate BAVO's theory of over-identification as a contemporary avant-garde strategy. In putting forward a theory of avant-garde over-identi-fication, BAVO proposes that we exit the loop of the capitalist demand for activist artworks and enter the space of exception: the objective positing of class struggle as the basis for an ethical critique of consumer capitalism and its management of identity-based conflicts. The psychoanalytic concept of the sinthome is crucial here as the supplement that provides practice with a synthetic sense of consistency and that is able to link subjectivity to a collective socio-historical project. Rather than deny the desire of the Other in the form of the integrative force of the culture industries, we instead take into account drive as an endosomatic internal force, the measure of demand made upon the mind for work and its always inhibited, partial satisfaction.

Culture as Symptom
According to Žižek, "desire thrives in the gaps of a demand – in what is in a demand more than a demand."[6] The Lacanian insight into the desire of the big Other as superego demand, the

constitutive alienation of the subject in the symbolic order, offers a path to a radical political understanding of national-to-transnational cultural politics. Explicit in Žižek's reading of Lacan is the idea than any authentic act that seeks to bring about social change involves, at the subjective level, a shift from desire to drive that subjectively assumes responsibility for a world that does not rely on another's supposed difference from oneself. To give an example, one does not expect foreigners and immigrants to share the same values and social habits as oneself just because they wish to occupy the same territorial region. To do so is to hold the foreigner to a false presupposition of sameness. Whatever social laws all members of society are expected to conform to must be the outcome of explicit rules that reflect all members' aspirations to equality. The level of subjectivity is the level at which these terms of difference are overdetermined. Desire, Žižek argues, is always sustained by some pathological object-cause of desire, by some obscene demand to enjoy that is productive of subjectivity, but that is denied at the level of the unconscious as an impossible contingency. As he argues in *The Puppet and the Dwarf*, the form of surplus value that structures social relations is today the dominant form of enjoyment.[7]

Here we encounter the enigma at the heart of contemporary cultural practice. Inasmuch as *jouissance*, in the form of surplus value, confronts the creative subject with the traumatic core of their being, it becomes impossible for him to separate the network of signifiers that structure his social existence from the fantasmatic enjoyment of its operations. Whereas the free construction of culture requires that we be non-believers, that we assume our own enjoyment of activity without further mediation, the capitalist relations of production reinscribe the subject into his or her own image in the guise of a consumer. The paradox of the artist's relation to what he produces is the commodity (or, to extend the analysis, the cultural service as product), the supplement to the subject's relation to reality. The

commodity is the means by which I, the artist, am included in my own production; it is that which bears witness to my social existence, the Thing whose "metaphysical subtlety" lies precisely in my social interactions with others but which nevertheless leads me to believe in its magical powers. The key point here is that the subject is not the absolute correlate of the commodity. In the context of the depoliticization of cultural production, the first task of the artist is to debunk the symbolic innocence of the globalized culture industry and to reassert the state of alienation. Such a sinthomeopathic act of social antagonism works to reveal the deep solidarity that links the bureaucratic class of arts managers with the creative class and its "underground" reserve army of surplus labour.

Against the tendency of today's art activists and networked relational artists to realize the means of their exploitation by buying back what they produce in a free play of exploitation and resistance, we should attempt to conceive, as Fredric Jameson did in his essay on postmodernism, the dominant cultural logic against which genuine difference can be assessed, and to project, as he wrote, "some conception of a new systematic cultural norm and its reproduction in order to reflect more adequately on the most effective forms of any radical cultural politics today."[8] Rather than naturalize the concept of ideology in terms of social constructionism, we should think of ideology in terms of exception, which, in our age of the progressive disintegration of any unambiguous moral order represents the fantasmatic construction of ideological jouissance through critique, tending toward and necessitating anti-capitalist political organization.

The Pervert's Guide to Avant Garde

While we might wish, along with those who continue to proclaim the disappearance of the distinction between art and life, that the post-politics of actually existing capitalism will eventually undermine its own exploitative workings, the

situation as we find it today increasingly recognizes the function of artistic practice as an exception, "an element which, although part of the system, does not have a proper place within it" and cannot be accounted for on the system's terms.[9] What happens, as Žižek asks, when the system no longer excludes this "part with no part," but directly posits it as a driving force? The most immediate answer is the persistence of wage labour, maintained at poverty levels through unemployment, privatization, enormous wealth differentials and social competition. Perhaps the ultimate aim of art activism should not be to ask what happens when the state comes to realize its murderous function on a global scale, but rather, what happens when democracy itself is shown to be responsible for these conditions. Fantasy of course is what affords the subject a modicum of distance from the obscene reality and the demand for forms of social cooperation and integration on which the ruling order depends.

Gregory Sholette has posed the problem of cultural labour in terms of the proletarianization of artists and the production of what he calls "dark matter." In the context of the deregulation of markets and the encouragement of "creative," flexible work, the productivity of today's engaged artists leads to a détente between artists and neoliberalism. The conditions of competition, however, depend to a great extent on successful artists sharing the same fate as the surplus army of "failed" artists, reproducing the next generation of artists for the market.[10] Adam Arvidsson suggests that the class of urban professionals who work in various sectors of cognitive and cultural production depends for its existence on the appropriation of the work of a relatively autonomous but unsalaried creative proletariat.[11] This "underground" of artists who contribute to arts, design, fashion and music scenes cooperate, he says, in the value added productivity of the creative industries. Underground entrepreneurs typically measure success by negotiating with the business world but without "selling out," preserving one's goodwill toward biopo-

litical circulation and communication and mobilizing one's name and reputation through altruistic provisions of parties, free beer, electronic files and contacts. The autonomy of underground producers, he says, is nevertheless challenged by the precarious economic situation they live in and the privatization of culture. This contradictory situation, where artistic work is praised as a source of value in the new economy and simultaneously subject to redundancy and pauperization, requires the construction of new relations between the specific economy of the sphere of culture and its artistic model of transgression.[12] The "symptomal torsion" in this compromise situation is the link between self-transformation, the delivery one's self and one's social, cultural and political preferences in new cultural forms, submitting oneself to domination, and the suspension of the very artistic, creative or aesthetic priorities that are the specific demand of capitalist institutions, the motor of capitalist self-revolutionizing.

Along these lines, Sholette suggests that dissident collectives and informal cultural cells offer the best potential for using artistic methods to project "an image of power well beyond their actual size" and to "turn institutional power back on itself."[13] What if, however, resistance through small-scale autonomous cells and collectives turns out to be a perverse fantasy, sustaining the notion that we are the instruments of the system, merely projecting the subordinate predicament of the left and its emancipatory struggle? Is this struggle, then, fought within the realm of culture, not the fundamental fantasy or mistaken presupposition of all artists, who, perhaps better than most, know how to derive pleasure from pain?[14] If this were the case, the "biopolitical" aspect of capitalism would render what we produce in all its uncanniness as pathological part-objects, the place where control is relinquished and is supplemented by its regulatory presuppositions. The artist's solitude becomes the cornerstone of the tribe, the source of new ideas.

This solitary activity, however, should not be underestimated.

It should be supplemented with nonpathological subjectivization, allowing for a shift from dis-identification (ignoring the exploitative aspects of the capitalist restructuring and transformation of the arts sector) to over-identification (deciding for ourselves what are the determinant political choices). Art in capitalist society arises as a displacement of class struggle, covered over by non- and anti-institutional practices that tend to refuse the thought of the artwork as a commodity and cultural participation as capitalist social relations.[15] This disavowal of critical thought is combined with the perverted pleasure of resistance, which, paradoxically, creates a self-sabotaging behaviour, a minimum of freedom that is the object of institutional regulation. The assertion of a conditional autonomy, of autonomization, is the gesture of *art*, representing, since the nineteenth century at least, the formal subsumption of cultural production under capital. Autonomization is the elementary form of symbolization that allows reality to be supplied with meaning but whose ultimate function is the circulation of commodities and the reproduction of relations of exploitation.

Reflecting on the contradictions of autonomization at this moment after the "end of history," after the supposed end of alternatives to liberal capitalism, BAVO suggests that cultural producers who remain ambivalent towards the legacy of the avant gardes either accept that there are no alternatives to liberal democracy, or, have a relaxed, fetishistic belief that their progressive cultural work, especially at the level of the representation of social differences, actually counters neoliberal hegemony. In their essay on the "Spectre of the Avant Garde," BAVO rejects the Foucauldian view that resistance is produced strictly by the system, for the system.[16] They draw on the law of uneven development to demonstrate that art is not a direct reflection of social struggle but that, because art is a human product, and not a product of nature, it betrays the belief we may have in the naturalness of existing social relations and in the

determining aspects of economics and technocratic planning. They argue that, as part of hegemonic social regulation, late capitalism commands artists to compulsively engage in forms of cultural and social resistance that then become obstacles to real subversion and means to come to terms with commodification.[17] Only by endorsing a masochistic position inside the system, they argue, can artists represent the kind of critique that cannot be assigned a proper place, and that, as avant-garde work, can lead to cultural change. The official message to the avant garde, they add, is "keep up the perversion, please!"[18] What is valorized in socially engaged art practice, however, is not necessarily what is instituted. This is not due to bad faith on the part of audiences, but to the fact that the art system as we know it, and the way it links up with other aspects of social life – cities, governments, highways, airports, television, music, web sites, cafés – has become second nature and autonomous. Inasmuch as artists are treated as avatars of cultural transgression, as "subjects supposed to subvert," BAVO proposes that the project of the avant garde can be renewed by becoming aware of this adminis-tration of transgression (the failure to offer an alternative to dominant forms of production) and by subverting the position of art in the chain of signifiers.

BAVO recommends to today's artists what we could otherwise call a practice of dialectical negation, a renewal of the realist mediation of naturalism and rationality. The first thing artists should do is make artistic transgression autonomous (internal) by emphasizing the link between perverse subversion and the demands of the cultural market. The next step is to ignore the mechanism of transgression and try to affirm the official line by dirtying one's hands and doing what the left typically doesn't do – even if, they say, it becomes idiotic enter-tainment. Much radicalism, in this instance, may at first pass for conservatism. Lastly, negate the first stage, the awareness of art's link in the chain of equivalence, by abstaining from the demand

to enjoy: remain indifferent to the properly cultural demands of your work. In this way, the demand of the capitalist market for avant-garde subversion encounters the emptiness of its rule, its nothingness, and the link between subversion and demand is momentarily undermined.[19]

BAVO's strategy thus corresponds to Lacan's view that the discourse of psychoanalysis can contribute to social change by revealing the fantasy structure that sustains identification with a given set of master signifiers. The particular set that we are concerned with here is the economy of culture and its interpellation of the aspiring, activist wing of the so-called creative class. The change that BAVO proposes takes into consideration not only the function of jouissance in modes of identification but also the specific laws and policies that anchor jouissance in ideological terms. While radical democrats dispute the historical necessity and the very possibility of imposing new master signifiers, the "end of history" ideology that BAVO is committed to dissolving imposes the need to recognize that forms of ideology and alienation, however these may come about, will be part of any collective effort to alter the existing conditions that structure the desire for social change. From the position of analyst, I argue, BAVO asks artists to reconsider the ideal ego image of themselves as socially disruptive and to consider the coordinates of the ego ideal (the capitalist mode of production), the obvious symbolic reality that either confirms or undermines their fantasies. By working through the fundamental fantasy that cultural activism will contribute to meaningful social change, the activist becomes aware of their means of jouissance.

In a more recent publication, titled *Cultural Activism Today: The Art of Over-Identification*, BAVO elaborates its strategy of over-identification in relation to cultural work designed to propose creative solutions to social problems.[20] In an age in which the idealism of art activism substitutes for radical change at the level of state power and international law, over-identification begins

by rejecting "positive" symbolic experiences and by directly conceding to capitalism's merciless reduction of the social world to economic markets and humans to units of measure. To do otherwise is to play the game of neoliberalism as a "free" subject. In this, BAVO has produced one of the most trenchant critiques of the new paradigm of the artist as community activist. Rather than operate as supplements to the ruling order, BAVO calls on artists to reproduce the contradictions and attack the idea of the artist as the ideal troubleshooter through a positive over-identification that, again, reveals the sadomasochistic contract between Law and its obscene underside.

BAVO's model of over-identification confronts the fundamental fantasy of one's own desire, the fetishistic disavowal of reality in the belief that a happier life is possible. The discourse of immaterial labour, of the creative activity that drives a substantial sector of the economy and that also relies on the surplus value of productive labour, retains its symbolic effectiveness inasmuch as one sustains oneself in a fantasy of resistance. Unlike micro-political practices that resist forms of constituted power (the kind of power that is believed to circulate through inherently corrupt institutional links, media spectacles, vanguard forms of organization and party leadership), over-identification operates through the risky traversal of the Law, exposing the unwritten social codes that double the official identifications of the Law as, today, post-ideological and post-enlightenment enjoyme(a)nt. What's at stake, then, is what Žižek calls the paradox of truth, the obedience to Law as a symbolic prohibition that accepts the excess of political identification as a consequence of the path to social progress.[21] The revolutionary act, supplemented by cultural devices as the mediated form of subjective destitution, seeks to overcome this mediation and its logic of transgression, to lift the prohibition on the prohibition against avant-gardism by articulating its objective structures. More concretely, this implies according a place to the party-state

as a stage in the movement towards a form of governance able to counter the destructive action that free markets impose on working conditions and the public interest.[22] The lifting of bans on prohibitions should never be made the responsibility of an individual, though heroic acts are indeed possible and necessary. In broader terms, leftist solidarity must make room for the political inconsistency of practice in comparison with the lucidity of theory and critique.

The question of over-identification, then, posed by BAVO as a form of *cultural* activism, is appropriately defined as a strategy of over-identification with the worst features of late capitalism, in contrast with the idealistic styles of "NGO art" and "embedded" cultural activisms that propose constructive solutions – precisely what is demanded of the field of art as adjunct to representative democracy.[23] No wonder then that so many artists, caught as they are in a relation of desire with the system, release their aggressivity by devising socially elaborated situations in which social differences are staged symbolically and ideologized as part of a postmodern discourse of pluralistic tolerance.[24] The way in which consciousness disguises itself in the form of a reflection of the other was defined by Hegel as the doctrine of the Beautiful Soul, a complacent sensibility and an attitude towards communion and love that, according to Lefebvre, finds its end in morose delectation. In this regard, much contemporary engaged art naively reproduces the common tropes of the eighteenth-century picturesque. It is, nevertheless, important to recognize the elements of this process – reason, the mimetic faculty, the structure of subjectivity, the world historical situation – and recover realist forms of alienation.

In the introduction and the first chapter of *Cultural Activism Today*, "Always Choose the Worst Option: Artistic Resistance and the Strategy of Over-Identification," BAVO defines today's "blackmail of constructive critique" as the symptom of the impossibility of real critique.[25] The paradox for artists concerned

with change is the fact that today's politically correct tendency art, diplomatic cultural consultancy designed to engage local actors in social empowerment, in the affective production of sociability and the recognition of difference, is viewed primarily from the place of neoliberalism. Capital, as Žižek insists, is the concrete universal of our historical epoch.[26] If engaged art's circulation functions as little more than a means to reproduce the economy of art, BAVO argues, it is because effective social criticism is either not wanted or impossible within existing conditions. Mainstream culture accommodates the activist art sector as a palliative but only inasmuch as it does not dramatically politicize the contexts in which it operates. BAVO suggests that artists should work to expose the demand to offer practical solutions to social problems as symptomatic, as a "pragmatic blinding" to the deep systematic aspects of exploitation. This demand should be refused as a sign of the impotence or unwillingness of the ruling order to do what it can and must do to impose pragmatic solutions to systemic problems.

BAVO proceeds by momentarily suspending Bourdieu's insight that the field of art functions as an inversion of the capitalist economy. Bourdieu, for his part, sought to explain the specific way that cultural capital functions in the reproduction of class distinctions. In asking rhetorically why art should be an exception to the rule, why cultural capital should behave differently from other forms of capital, BAVO suggests that art could instead act as nakedly self-interested. While we might respond that the capitalization of art markets makes this insight somewhat redundant, we should also consider the specific historical situation and institutional constraints in which BAVO calls on artists to "refuse the role of the 'last of the idealists'."[27] Over-identification is not a strategy of critical complicity, the major conceit of institutionalized actors, but a form of dissidence. Needless to say, not all acts of over-identification per se are successful or progressive. It is only to the extent that institu-

tions do not accept artists' revolutionary enthusiasm, to the extent that effective criticism is foreclosed, that BAVO calls upon artists to sabotage art's role of political resistance. In this way, BAVO elaborates Bourdieu's program of demystification by attenuating art's elective distance from necessity, by refusing to act as the dominated activist sector of the dominant transnational class.

Aspects of the art of over-identification can be noticed in the guerrilla performances of the Yes Men, for example, one of the groups mentioned in *Cultural Activism Today*, which also discusses the work of Michael Moore, Christopher Schlingensief, Neue Slowenische Kunst (along with Irwin and Laibach) and Atelier van Lieshout. In their various performances, the Yes Men (fronted by Andy Bichlbaum and Mike Bonanno) stage interactions with audiences in which they ruthlessly apply neoliberal free market ideology more scrupulously than neoliberals do, creating situations in which it becomes difficult to make excuses for the dominant order inasmuch as its repressed ideals are identified and taken seriously. For instance, in May of 2002, and with the assistance of various arts organizations, the Yes Men flew to Sydney in order to make a presentation to the Certified Practicing Accountants Association of Australia. In the guise of WTO representative Kinnithrung Sprat, Bichlbaum announced to the assembled audience that the WTO, having understood how its globalization policies hurt people, would change course by first shutting down its operations and subsequently reorganizing in the form of a new Trade Regulation Organization dedicated to corporate responsibility. The performance included a presentation of shocking statistics concerning the links between social inequality and trade liberalization, an informational surplus designed to relieve the assembled of the burden of having to believe in the system, since, the statistics can believe for them. The contradictory structure of belief was revealed to the extent that the accountants greeted the announcement with approval,

recognizing the need for change and making further suggestions on how to alleviate poverty. As the Yes Men ask on their website,

> Could it be that the violent and irrational consensus gripping the world, what we call corporate globalization, is maintained only through a sustained and strenuous effort of faith? Could it be that almost everyone – even those, like accountants that we are usually inclined to think of as conservative – would immediately embrace a more humane consensus if one were presented by those in positions of authority?[28]

The simple Žižekian answer to this is question, which obviously has not escaped the Yes Men, is yes.[29] However, as Marx emphasized in *Capital*, the conditions of exploitation that inhere in capitalist relations of exchange cannot be accounted for in terms of the moral failings of greedy individuals.

The Yes Men, *End of WTO*, Performance at the Certified Practicing Accountants Association of Australia, 2002. Courtesy of Mike Bonanno and Andy Bichlbaum.

The Yes Men's *End of the WTO* action masks the criteria according

to which social practice can be considered the object of a distinctly cultural consumption.[30] It exposes the impotence of the ruling order not by objecting to the hidden, obscene side to the official letter of the Law, and by charging capitalism with hypocrisy, but by directly identifying with this obscene underside, as do today's systems of cynical power. The limitation of the Yes Men's work is that it tends to dwell in the ambiguities of parody. Consequently, what we have come to expect from the Yes Men is not a challenge to our beliefs but the thrill of culture jamming which maintains subjects within interpassive relations of belief. Criticism is reduced to catching people with their guards down. Inasmuch as this and similar forms of political activism is oriented towards social justice, it is impossible to identify with its interested, politico-aesthetic worldliness without also being made to over-identify with the capitalist class relations through which it is produced. One could therefore respond to the Yes Men's work with the Leninist criticism that what is missing in their aesthetico-political project is the actuality of a revolutionary organization that could lead the capitalist democracies to a new world situation. Class struggle takes place only to the extent that the ruling ideological coordinates are effectively and materially challenged.

Towards a Radical Program of Cultural Dissidence

As a structural factor in over-identificatory practices, we should specify how struggle relates to one of the most enduring aspects of aesthetic discourse: pleasure. How does the creative subject sustain itself in the consistency of an imaginary identification with the institutions of cultural production and what does psychoanalysis offer to the practice of political intervention? How does culture sustain the subject in a condition of non-knowledge?

In an essay that we could relate to the paradox of creativity, Žižek elaborates the subjectivism that can be associated with

aesthetic autonomy.[31] If the artist in today's neoliberal market economy can be defined as the "part with no part," it is because cultural production involves a perversion of synchrony over diachrony, with the genus "art" divided by the species of objective disinterestedness (drive) and subjective interest (desire). And if interest serves as a synonym for dispossession, the paradox is the fact that objective disinterestedness is in some way constitutive of this struggle. The political parallax – the impossible dialectical synthesis, the symptomal torsion – of the economy of avant-garde cultural production is the political situation, divided by an exhaustive disjunction between the agency of consciousness/knowledge, the "what is to be done" of our moment, and the masses themselves, subjectively consti-tuted in everyday experience.

$ = subject, analysand, audience
a = objet petit a, analyst, artist
S1 = master signifier, discourse of psychoanalysis, art discourse
S2 = chain of signifiers (understanding), artworks, screen images

$$\rightarrow \text{ belief (trauma)}$$
$$\text{circulation}$$

overt	addresser	addressee (demand) function of the big other
latent	symptom (hidden truth)	surplus / jouissance function of loss

The missing link in the theory of over-identification can be discovered in Lacan's theorization of the "four discourses," a model that we could translate into art language with the following codifications: $, the split subject, occupies the position of the analysand as well as the audience; a, the *objet petit a*, the

Real that is cathected by knowledge, occupies the position of the analyst and the artist; S1, the master signifier, stands in for psychoanalytic discourse and art theory; S2, the system of knowledge, the chain of signifiers that structure understanding, stands in for screen images and artworks.[32] We should recall as well the moving parts of the quadrature of Lacan's algebraic formula for social structure and his insistence that the subject can never be fully or permanently fixed by a particular system or situation. The top half of the quadrant contains the "overt" exchanges between the addresser (left) and the addressee (right). The relations between them include belief and the impossible, traumatic relations of circulation and reproduction. The place of the addressee involves the network of signifiers. The latent left bottom section is the place of the hidden symptom as the function of truth. This latent truth is a symptom of the addressee. On the bottom right is the place of origin, of jouissance or surplus, the place of the split subject as the place of production and the function of loss. The overall link between the left and right sides is language structured like the unconscious, with desire as the overdetermining element in the structure of fantasy, or the symptom as the overdetermining framework of the sinthome. The Discourse of the Master, which subordinates the laws of subjectivity, suppresses the truth of these fundamental principles. It is, as BAVO argues, a necessary stage in the movement toward the Discourse of the Analyst, which I equate here with the art of over-identification.

Žižek refers to the objective short-circuit that defines the situation of liberal capitalist democracy in Lacanian terms as the Discourse of the University.[33] This short-circuit describes the fetishism of ideological investment and identification as a necessary passage from subjectivity to the authoritarian dimension of political organization. The neutral knowledge of a just ideological organization has the status of the master signifier (S1), the performative exception that incarnates its universality, a

paradoxical point of intersection between the genus and the species that is crucial to understanding the castrative aspect of subjective determination (S2 as the neutral constative of "what is to be done" or "history happens behind the backs of men") and that is disavowed through identification with the political organization (or the artwork) as fetish. As a signifier without a signified, the organization only exists in its movement of sublation, as a consciousness that resists its own ideologization: S2/S1. The bridge between the neutral agency of organization and the possibility of an avant-garde practice is afforded by Lacan in his development of the concept of the sinthome, as decribed in the mid-1970s in his twenty-third seminar. The sinthome describes a nonpathological identification with the symptom, here defined as the political movement. Although BAVO does not directly discuss Lacan's four discourses in their essays, their approach to "the spectre of the avant garde" supports my analysis inasmuch as the Discourse of the Analyst aims at a deliberate subversion of the prevailing Master Discourse.

What characterizes the situation of today's avant garde is the fact that the absence of a privileged place for the working class in the ideological edifice is filled in, by and large, with the lifestyle concerns of consumption, on the one hand, and the politics of difference, especially in academic discourse, on the other. The minimum distance from this particular field of ideological captation is the subject's attachment to the *jouissance* of autonomy, which for our purposes could be considered the trajectory of creative desire (a). Fascination with one's creative work allows for a fantasmatic distance from determination, identification and desire. Lacan relates this kind of surplus enjoyment to surplus value, an excess that sustains the divided subject ($) in a relation of desire. Identification with the capitalist conditions of production, we could say, sustains the subject in a desire for economic and cultural consecration. The predominant

discourse of art activism therefore has the structure of the Discourse of the Hysteric: $\$/a \to S1/S2$. In this form, mass culture is posited as the institutional deadlock, the arbitrary social relation that addresses cultural production in terms of profit, and which denies the productive power of creative labour and affect. The activist addresses populism as the privileged form of political resistance within late capitalism in the position of Hysteric.[34]

Lacan's Four Discourses:

$$
\begin{array}{cccc}
U & M & H & A \\
\dfrac{S_2}{S_1} \to \dfrac{a}{\$} & \dfrac{S_1}{\$} \to \dfrac{S_2}{a} & \dfrac{\$}{a} \to \dfrac{S_1}{S_2} & \dfrac{a}{S_2} \to \dfrac{\$}{S_1}
\end{array}
$$

The purpose of avant-garde practice, in contrast, is to transform the currently existing relations of production (S2) by performatively subjectivizing the "part with no part," which Marx defined as living labour (a) – the creative proletariat that figures as the condition of impossibility of class society (S1). Over-identification attempts to traverse the Discourse of the University, understood as a "hallucinatory mise-en-scène of ideology" in which the commodity itself speaks and represses the truth of the desire for consecration understood in terms of ideological *jouissance*, and which, according to the Lacanian matheme is described as $S2/S1 \to a/\$$. The artist in this scenario is the addressee of the division of labour, with its new conditions of post-Fordist immaterial production. Inasmuch as art discourse functions as the repressed underside of commodification, the subject appears bereft of agency. The paradoxical procedure through which this operation occurs is the fetishistic construal of everyone as creative, thereby subjugating the "part with no part" and denying the subjects of late capitalism the knowledge of historical agency by attributing this power to market relations –

as in the work of Richard Florida and Charles Leadbeater, for instance. Here, the expert managers of the creative economy provide us with facts and statistics, with positivist knowledge about wealth distribution and market indicators, but do not tell us what those facts mean or how we should evaluate them. Artists are treated as objects of technocratic control; their productions are subjugated to arbitrary criteria of economic value that are bereft of higher purpose. These relations of production deny their dependence on the superstructural aspects of the field – the relative autonomy of culture and knowledge, the efficiency of meaning making and symbolic production – and present themselves as neutral, as though the political decisions that affect the artwork's performance in the market has no further bearing on social relations. The community subjects of the creative industries discourse are thus construed, perversely, as the "invisible hand of the market," the laws of supply and demand. In order to hide to themselves their own political performance, technocrats offer "socially relevant" cultural entertainments and charity functions. Moreover, they offer audiences the enjoyment of themselves in terms of identity and identification. Rather than provide for conditions of change, this objectifying process fixes subjects through endless diversification, virtualized through the digitalization and financialization of the social field. However, becoming aware of oneself as the "invisible" "part with no part" opens up possibilities for critical activity.

Avant-garde practice intervenes in the field of cultural production inasmuch as production tends towards a depoliticization of discourse and towards hierarchical forms of social control that do nothing to allow workers a measure of control over the means of production. Practice intervenes, as in the Yes Men example mentioned previously, by confronting the commodification process and by subjecting the autonomy of art to some form of transformation. Through the invocation of

struggle, the avant garde speaks from the position of political organization. By rejecting the desire for consecration, the avant garde artist is the first to submit to a perverse subjective destitution that we can associate with the Discourse of the Analyst: $a/S2 \rightarrow \$/S1$. Against the meritocracy of true believers who deny the determining aspects of cultural production, the avant-garde 'analyst' demonstrates that the art system is unable to totalize itself and instead fulfills the demands of the market as a vehicle for enjoyment. Avant-garde production is therefore directly concerned with enjoyment; however, it fulfills expectations perversely by surrendering to the requirements of social change. Through a contradictory over-identification with the Discourse of the Master, the artist performatively posits the presuppositon of perversion, and makes him/herself over into the "part with no part." Perversion, understood in terms of the Lacanian *père version*, is the presupposition of the Father who fully enjoys. The authority of the artist, in this case, is an outcome of the subject's presupposition that the artist's speech is based in knowledge. Alternately, the subject, in the position of addressee, cannot be sure of this since the speech of the artist, here in the position of master, is ambivalent and contradictory, emerging as it does from the surplus of identification with both art discourse and political organization.

The avant-garde artist responds to the obscene demands of the capitalist market with the dissolution of the mystery of creativity, pleasure and socialized labour itself. This *sinthomeopathic* language of objective necessity clears a path for the dissolution of capitalist expropriation. In this the audience members of avant-garde productions are compelled to give up their fantasmatic identifications as self-positing subjects. The avant garde does not wait for the dissolution of the separation between art and life to be effectuated through capitalist processes. And for this reason too, its strategies and tactics may seem irrational, authoritarian or egalitarian, confronting antagonism with harsh measures, the

point of overlap between revolution and political organization. The struggle becomes all the more violent to the extent that previous (historical) avant gardes have been integrated within official art discourse, and, since the postmodern pluralism of the 1970s at least, have taken on the semblance of productivity proper, signaling an end to class conflict and the formation of new struggles based on the politics of recognition. In the polarized field of this petty bourgeois stage of creative production, the rule of genuinely engaged artists is replaced by the rule of the community artist who construes avant garde artists as the enemies of society.

In this new interregnum, what is the interplay between the Discourse of the Hysteric, the Analyst and the University if not the late capitalist version of the End of History, the belief that the meta-discourse of class struggle is outmoded and that we have reached the post-political stage for which there can be no alternatives to the hegemony of neoliberal capitalism, that, to put it in other words, there is no Master? To return to BAVO's critique of "embedded cultural activism," over-identification is the exhaustive disjunction that distinguishes between the kind of cultural production that represses truth and the kind that suspends, in its own movement of *jouissance*, the repressed truth of the situation.

Whereas artists are perceived as "neutral mediators" whose sublime quality allows them to, according to BAVO, "soften the blow of neoliberal destruction," artists can equally divert attention back to the conflicts that structure not only the divisions of labour of which they are a part as class subjects, but the privileged division that seeks to deny them their social role. In this way, artists can act, effectively, as an avant garde, grasping their inner distance (the fundamental fantasy of art as an inversion of the capitalist economy) from the capitalist game. This involves, as I have argued, a passage through the desire for consecration to that of the objectification of labour. The counter-

parts to petty bourgeois expressions of cultural goodwill towards capitalist hegemony are the reactions to social inequality that we find in all manner of non-politicized discontent. Such outbursts are of course the basis for calls to increase security measures, on the one hand, and politically correct sensitivity training, on the other. The "negative behaviour of the masses" thus forms the background of the liberal politics of tolerance that ignores the class problematic and the fantasmatic *jouissance* that compels people to act against their own best interests.[35] In relation to these problems and countless other side-effects of privatization, business and governments now call on artists to engage community constituencies in a therapeutic process that disarms populist protest and converts subjects through the "moral economy of capitalism."[36] Against the various forms of cultural programming that help to stimulate dissatisfaction through the delivery of politically compromising output, artists are called upon by BAVO to organize planned responses to cultural production that sustain the perversity of revolutionary negativity.

Chapter 7

The Revolution Will (Not) Be Aestheticized

On October 9 and 10, 2010, the New York City-based public art foundation Creative Time hosted the second Creative Time Summit, titled "Revolutions in Public Practice." Founded in 1974, Creative Time commissions and produces artworks in the public realm. It has presented works in vacant storefronts and landmark buildings, through skywriting, on billboards, buses, deli cups, and on the Internet. Self-described as a "vanguard and veteran art presenter," it has partnered with such institutions as the DIA Art Foundation, The Kitchen, the Metropolitan Museum of Art and the Whitney Museum of American Art to present works that have addressed issues like AIDS, domestic violence and racial inequality. The 2010 Summit was the second in a series of conferences that included more than fifty presenters – artists, art collectives, educators, critics and historians – and was organized into six main clusters on the themes of Markets, Food, Schools, Governments, Institutions and Plausible Art Worlds.[1] As the title indicates, the conference was not only concerned with definitions of contemporaneity in art, but the social and political aspects of today's activist forms of art practice.

In his "Curatorial Statement" for the Summit, the Chief Curator of Creative Time, Nato Thompson, addressed the question of art's political efficacy.[2] The idea that the expanded forms of art can have a social effectiveness remains, Thompson suggests, both a truism and a task to be accomplished. He argues that "what constitutes socially engaged art practice remains a mystery that either invokes strong feelings or, strangely enough, a determined ambivalence."[3] At the 2009 Summit it was suggested by someone that political art preaches to the choir.

Who is this choir, Thompson asked one year later, when there is no consensus? As Bret Schnieder has pointed out, when the artist J. Morgan Puett declared at the 2010 Summit that "capitalism is here to stay," the audience booed her outright.[4] The choir, it turned out, was there to be summoned. In comparison, many of the presenters, even if their work constitutes examples of the more politicized practices in the international art circuit, put forward rather timid political views. The overall tenor seemed to confirm Slavoj Žižek's often repeated claim that many progressives, democrats and leftists more or less subscribe to Francis Fukuyama's thesis that liberal democratic capitalism is the least worst of the political systems available to us. The fact that the Summit made use of the word revolution in the title (not to mention the word summit) seemed indeed somewhat ambiguous: social reform, "off the grid alternatives," and activism are not the same as revolution, understood in contemporary terms as anti-capitalist and anti-state class struggle. And

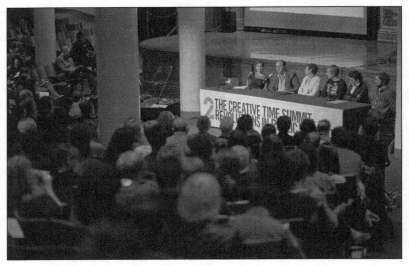

Creative Time Summit: Revolutions in Public Practice, October 9-10, 2010, Cooper Union School of Art. Photo: Sam Horine. Courtesy of Creative Time.

so the question of art's efficacy was easily circumscribed to that of alter-capitalist productivity, a problem that was addressed on numerous occasions. On the whole I am in agreement with Schneider's conclusion that the bad politics that were often demonstrated at the conference doomed the aesthetics, however far afield these projects have taken the artists.

In the following I wish to make some general observations about this moment in contemporary artistic practice. There is no question that the post-structural approaches that predominated in the 1990s, and their accompanying language of simulationism, social constructionism and cultural representation, have shifted decidedly in the direction of a politicization of culture. One is more likely in today's context to frame a discussion in terms of art and politics than in terms of cultural representation. Yet, for all of this newly determined clarity of purpose, there remain some significant differences and contradictions, rough overlaps and incommensurabilities between those informed by postmodern micro-politics and those who have never abandoned materialist dialectics, those working with Proudhonist politics of redistribution and Maussian ideas of gift exchange, and those communists who take Marx and Engels' economic analysis as necessary starting points for a conception of revolutionary praxis, those rhizomatic anarchists who wish to destabilize all constituted forms of centralized power, and those socialists who consider that the state must first be occupied before any communist transition is possible. Despite these differences, we more or less exist within the same social universe of neoliberal market capitalism. In this context, Jodi Dean offers the notion of the "communist horizon" as a way to schematize the importance of an unambiguous political alternative. In the wake of the post-9/11 war on terror, the imperial wars against Iraq and Afghanistan/Pakistan, the 2008 bank bailouts, the economic crises in countries like Ireland, Iceland, Spain and Greece, the revolutionary upheavals in India, Honduras, Iran, Haiti, Libya,

Tunisia and Egypt, and the failed Copenhagen Accord, neoliberal governments continue to press ahead with economic and social models that lead only to greater economic polarization and repressive uses of military and police power. This is the global social context in which culture operates and in relation to which it is possible to articulate an avant-garde model of aesthetic practice. A materialist view of culture does not, from the outset, predict what forms culture will take, or even for that matter, how a correct understanding of political realities should inform aesthetics. It does, on the other hand, require that cultural interpretation take into account as many aspects of life as possible, from art theory to social practices, economics, psychology, technology, popular culture, gender, race and sexuality, geography, urbanism, and historical research. We can, with the collective intellectual means at our disposal, address the ways in which the changing historical contexts of capitalist nation-states inform social and cultural formations. For all of the emphasis on language, mediation, and discourse that post-structuralism has brought to bear on humanism, as well as on the idea of culture as economic epiphenomenon, and for all of the emphasis on art's active role in constructing social relations, the qualifier *revolutionary* requires that art theory take into account the ways in which dominant cultural forms are constrained by hegemonic relations.[5] In response, Alain Badiou asks us to consider whether a militant avant-garde art is possible today. If so, what are its criteria? These he refers to as ground rules for activist art. We should note the distinction here between the rules for academic art theorists, whose degrees of subtlety have no end, and those for students, cultural workers and activists who today are increasingly thinking in terms of cultural revolution, and who demand that knowledge be made accountable for the world in which we live and not merely the preserve of tenured interests or economic blue chip. And so, fittingly, the Creative Time Summit was concerned with revolutions in practice rather than revolu-

tions in theory. The consequence of this, however, is that cultural practice is once again called upon to consider the productive contradictions of revolutionary theory.

Form Becoming Content Becoming Form Again

The Creative Time Summit is an important index of a significant shift in the artworld and in the culture at large from postmodern, micro-political difference politics to macro-political anti-capitalist politics. For reasons that are systemic to the function of the field of cultural production, as Bourdieu defined it, this shift is slow to unfold in the art world in particular. Today's art tends to operate in a way that is analogous to politics, either ignoring the dialectical mediation through social relations, or collapsing culture and politics with the dominant modes of production.[6] Steve Kurtz has recently stated that art can have causal effects in determining how we live and on the structure of society, that struggles in representation are as significant as struggles in factories. In his view, resistant cultural practices "parallel direct actions against the corporate-military state."[7] What I wish to signal here is not so much, as Konrad Becker puts it, that "boutique activism is on the rise," as the manner in which it emerges.[8] As Pierre Bourdieu argued, the development of the sphere of aesthetic autonomy in the nineteenth century was largely due to the development of the commodity status of art. The contemporary neoliberalization of the culture industries could be said to generate engaged political practices in a similar way. Bourdieu did not reduce art to economics, nor did he reduce economics to aesthetics, but suggested that economic class relations help us to understand aesthetics. Today's art in some ways either collapses art into economic social relations and new productive powers, or, avoiding this, attempts to make art analogous to an equally indecipherable politics. Cultural experimentation reveals class struggle to be the form of the social but in ways that, as Bourdieu explained, function in terms of

misrecognition. Culture, however, ceases to be mystifying when it acts in a partisan way. We should therefore not hesitate to comprehend the ways that cultural experiments open up new ways to perceive past avant-garde movements and new ways of understanding the dialectic between contingency and necessity, the contingency of necessity, which retroactively opens up and denaturalizes the circular movement of history.[9] The contingency of the present constitutes artists' actual experience of diminishing access to resources as various national political formations take stock of not only the diminishing prospects of socialism and communism, but of welfare-state democracy. In this context, we are not surprised to discover that the predominant form of contemporary art is that of self-organization. The overwhelming theme of the new public practices, however, is not that of self-organizing as a political principle, but rather, is inscribed in the reflex of survival. In order to survive in a world of double digit unemployment and underemployment, and in which welfare payments hardly make it possible to live an independent existence, one must today extend oneself, make friends, network, collaborate, preferably communally, and with all of the conviction that capitalism has sundered the traditional institutional ties that link us to nature and to one another. Microcredit, alternative currencies, free schools, free software, neighbourhood programmes and soup kitchens, potlucks, consumer participation, market environments, alternative economies, data maps, local skills, platforms of exchange, farmer's markets, victory gardens, Sunday soup dinners – these are many of the frameworks for contemporary art that were presented at the Summit. This is ostensibly what we are expected to understand by the phrase "revolutions in public practice." If we look at the development of materialist art practices since the 1980s, from site-specificity to art in the public sphere, and from community art to socially engaged art, today's self-organized art forms are in fact, relatively novel forms, and this, even if alternative economies

and potluck dinners are hardly new ideas. As collaborative and collective art practices, these forms of art move away from the methods of the studio-based modernist artist dedicated to the transformation of the aesthetic logic of specific media. Instead, these post-institutional practices continue with the demateri-alized practices of the 1960s and 70s by infusing everyday life values into art, and in the process, make the practice of living and surviving, communing and networking, itself into an art form. Rather than a relational artwork that offers refreshments in a lounge space built inside a gallery space, the new practices take this model of living and subtract it from the concerns of both aesthetics and politics. In short, this new way of making a living is presented as a means to reconnect with various social practices that are both generated and undermined by post-Fordist capitalism. In many instances, they refer to antediluvian means of survival and communal living and as such hardly represent a serious challenge to state capitalism.[10]

One is here at a great remove from the question of political organizing and varieties of socialism. There is no discussion of the relation of the workers' parties to that of the state, let alone of being involved with such a party. Art workers, however politi-cized, are as fragmented and disorganized as workers in general. For this reason, the virtuality of the avant-garde past is only hesitatingly acknowledged by the new practices. They are to a large extent, and despite their political orientation, in thrall to what Raoul Vaneigem referred to as a certain "mal de vivre," a "state of survival" that is caught up with hierarchical power and oppressive techniques. A will to power that Gerald Raunig associates with the fictive sovereignty of vandals and teenage gangs, fleeing, he says, "but while fleeing looking for a weapon," substitutes for a federation of such gangs (Vaneigem).[11] Still, they are making history.

The overarching difficulty of the new practices, as I see it, is that for the most part they dispense with serious political

analysis, on the one hand, and aesthetic analysis, on the other. Instead, social relations are associated with the new conditions of (cultural) production: networked sociality, the Internet, affective commons and risk society – bypassing what in older terminology was referred to as the ideological superstructures. In this manner, art reflects rather than challenges the dominant social relations; politics reflects rather than challenges the predominant relations of production. While this is not the case in every instance, and while many of the participants do in fact work toward a critical articulation of political and aesthetic autonomy, what one finds on the whole is a reformist biopolitics in which subjects are incited to move away from isolation and individuality toward collectivity and collaboration. The social function of art within class society is altogether eclipsed by the novelty of the forms of art that proclaim art's irrelevance, "ego-less" artforms, as Agnes Denes put it, that attest to selflessness. Rather than a critique of the ideology of sustainability, one finds the sustainability of ideology, the conviction that aesthetic forms and political forms coincide. Art's effectiveness no longer depends on art just as politics is related to a free-floating idea of power. The artist seems concerned with both and neither at the same time. Although they share an ambient progressivism, these practices do not share a common political language that would allow them to make common cause and form, when needed, a radical bloc for which people would willingly put their bodies on the line in a manner that we could associate with the experiences of the Paris Commune, the Chinese Cultural Revolution, May 68, or the ongoing struggles referred to as the Arab Spring. Thompson's curatorial statement reflects this when he cites Jean-Luc Nancy's idea of "inoperative community." Today's artists would be "a community that is 'ever becoming' as opposed to a community formed out of a nostalgia for a mythic past." Instead, we have the mythic present: free trade, privatization, deregulation, structural adjustment, austerity measures, imperialist wars, bank bailouts,

cap 'n trade.

One of the discrepancies among the participants of the Creative Time Summit was that between developed and developing nations. In his review of the conference, New York-based art critic Gregory Sholette mentions that presentations from Taiwan, Vietnam, Argentina and Guatamala, among others, provided evidence that contemporary artists around the world are engaged in "social and political practices that are seemingly without concern for the lines separating activism from aesthetics."[12] The "centrist" aspect of this realization, however, is apparent when one thinks that the international brokering of contemporary art requires that the new unconventional forms of art become a way to market artists and art collectives, acknowledging the transformations in the geopolitical landscape that are occasioned by globalization, yet smoothing over what Bisi Silva identified as the simple desire of Nigerians to build an art world that profiles high quality respected artists, an impossibility in a society in which military dictatorships target intellectual and cultural communities. One is left with no doubt that extra-institutional socially engaged art has become, for good and bad, the order of the day. Sholette reiterates Thompson's question of whether artists are preaching to the choir and asks: "who is we?" He provides a rather succinct answer. We is those artists who are creating "our own, self-supporting arts organizations, using our own micro-economies, and thus declar[ing] a degree of autonomy from the art world, including both its profit and not-for-profit facets alike." Sholette continues:

Chicago's InCUBATE, and New York's F.E.A.S.T., answered this by describing regional soup and discussion nights in which participants pool pocket cash and later voted to send it back (in bigger chunks of course) to select local artists. Essentially, their sustainable model is an informal, DIY funding mechanism that sidesteps established art-institu-

tional agencies. The online digital platform Kickstarter does much the same thing, though without soup. Or we could use time dollars suggests Anton Vidokle to produce more autonomous space. He is doing just that through e-Flux by setting up an online exchange amongst different owners of cultural capital. I offer this, and take this in return. No grant writing, no administrators, and no taxes.

Sholette asks a few incisive questions about these micro-financing efforts, wondering what organizers plan to do so as to not become micro-financing digital sharks. He closes with a somewhat equivocal note on the politics of social engagement, citing both Chto Delat's suggestion that the spectre of Marx haunts Europe and Claire Pentecost's more anarchistic view that a multitude of worms will chew away at the capitalist bloc like a large-scale, grassroots vermi-composting experiment: "Yo you neoliberals beware."

Art and Political Ideology

Two detailed observations could be related to the new forms of public practice that were showcased at the second Creative Time Summit. One has to do with political theory and the other with artistic practice. The first of these refers to Jodi Dean's talk, "The Communist Horizon," delivered on November 5, 2010, at the Second FORMER WEST Research Congress on Horizons.[13] Dean begins her discussion with the notion of the communist horizon as the "necessary and unavoidable" horizon of our political landscape. Despite its ostensible demise in 1989 and its association with everything that is evil in political terms, American liberals and conservatives are obsessed, she argues, with the threat of communism. For the American right, communism should be a dead political language, yet it persists in various forms: the prospect of national health care, environmentalism, feminism, public education, progressive taxation, paid vacations,

gun control, web 2.0, protests against military aggression, Democratic political leaders, even Barack Obama. While it is obvious enough that Democratic Party politicians are not communists, the right resorts to the language of the Cold War to evoke the spectre of an encroaching communist threat.

Dean takes issue with Žižek's notion of the invisibility of the antagonism that cuts across capitalist societies – an invisibility that makes challenges to the ruling ideology nearly impossible – and argues instead that this antagonism is now visible, undeniable and global. In newspapers, on radio, on television, on blogs, the right wing names this challenge communism. Its point of visibility is gross inequality, which identifies the U.S. among the top three nations with the greatest economic disparity, alongside Mexico and Turkey. The right argues that inequality is the best means to guarantee social benefits for the working poor. If capitalists are certain that they can deliver on its promise, why then are they so concerned with a supposedly inefficient and stagnant social model? Neoliberals and neoconservatives warn against the threat of communism, she argues, because it is a real and possible alternative to neoliberal globalization. Communism is "the name of the end and the alternative to capitalism."

Dean goes on to argue that the left has been unduly mournful of the idea of the collapse of communism. Consequently, the left has betrayed the communist ideal and its language of class struggle. The rejection of communism shapes the fragmentation and splintering of progressive branches into networks of single issue causes. The name for this network of struggles is the struggle for democracy. Dean thus echoes Žižek's argument that the master signifier of today's global capitalist universe is democracy.[14] What does it mean, she asks, for leftists within parliamentary democracies to refer to their goals as struggles for democracy? They have the right to vote and to organize politically, yet they keep their language tuned to democracy as their

"ambient milieu." The reason for this, Dean argues, is that today's left avoids the fundamental antagonism between the top one per cent and the rest. The main imperative is democratic participation, bringing the right and the left closer together in the defense of what Badiou calls capitalo-parliamentarism. We do not see our complicity in despotic financialization. We imagine instead that socialist utopias and primitive forms of capitalist exchange will disabuse us, or at least the purity of our souls, of hegemonic politics. Labour politics is replaced, she says, by flexible work patterns, temporary work, subcontracting and outsourcing. Precarious employment practices, multitasking and contingent personal networks are indeed the reality for what the Dutch collective BAVO refers to as "embedded," NGO-style art activists.[15] The displacement of the class and the collective dimension of work has freed capital from the constraints it once had to contend with. The political consequence, Dean argues, is that the left supports the form of democracy rather than communism. We talk, we complain, we protest, we make Facebook groups, we sign petitions, she says, yet our activity becomes passivity. As BAVO puts it, we become too active to act.[16]

In these terms, one was hard-pressed to hear participants at the Creative Time Summit who used the language of opposition-ality or anti-capitalism in the same breath as calls for socialism or communism. Instead, what was heard was largely the outcome of postmodernist and post-operaist exhortations to abandon this language. Denes, for example, stated that her work has nothing to do with the bourgeoisie, but has to do with using art in the service of humanity. InCUBATE asserted: "we're pragmatists; we need to start somewhere... to create incremental change." Claire Pentecost complained: "all we do is acupuncture." Vidokle, strangely enough, stated that the bourgeois public has vanished and needs to be recreated. Stephen Wright spoke of going beyond objects, authorship and spectatorship but without suggesting

why or how these frameworks are altogether outmoded. Eating in Public spoke of challenging the system of private property, but mostly through anarchist recycling systems and free food practices. Various other modalities were conjured up as tactical tools: chaos and unpredictability (Eyal Weizman), erotics and the grammar of affect and desire (Phil Collins), producing experiences (Surasi Kusolwong), being and sociality as practice (J. Morgan Puett), making things happen and reshaping the world (Pasternak citing Jeremy Deller), amateurism (Claire Pentecost), wonder (Bruce High Quality Foundation), process learning, or "learning learning" (Learning Site), pollination (Amy Franceschini), and of course, participation (InCUBATE, Superflex, Puett). To top off this list, the general amorphousness and democratic capitulation that Dean speaks of can perhaps also be gleaned from Creative Time's self-description. According to their website:

> We are guided by a passionate belief in the power of art to create inspiring personal experiences as well as foster social progress. We are thrilled when art breaks into the public realm in surprising ways, reaching people beyond traditional limitations of class, age, race and education. Above all, we privilege artists' ideas. We get excited about their dreams and respond to them by providing big opportunities to expand their practices and take bold new risks that value process, content and possibilities. We like to make the impossible possible, pushing artists beyond their comfort levels, just as they push us beyond ours. In the process, artists engage in a dynamic conversation between site, audience, and context, offering up new ideas about who an artist is and what can be, pushing culture into fresh new directions. In the process, our artists' temporary interventions into public life promote the democratic use of public space for free and creative expression.[17]

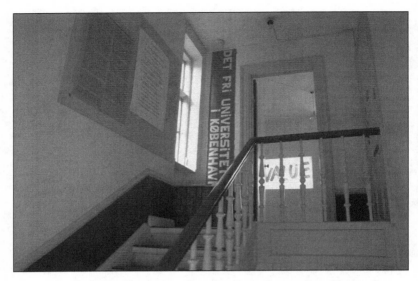

Jakob Jokobsen, The stairwell at the Copenhagen Free University,
2001-2007.

Jakob Jakobsen, Former member of the Situationist International Peter
Laugesen at the Copenhagen Free University, 2003.

One exemplary exception to the political ambivalence to be found among many of the participants was Jakob Jakobsen's presentation of his work with the Copenhagen Free University. Co-founder of the UKK, the Youth Art Workers in Denmark that led protests on migrant workers' rights, Jakobsen described how the self-organized CFU, which was run in an apartment, had as its purpose the production of subjectivity in the context of anti-globalization. The CFU was not a playful, funny alternative art project, Jakobsen insisted, since capital is constantly teaching us how to live our lives and how to shape our innermost emotions, to be skilled in areas in which there is a market. The Free University was dedicated to such themes as art and the economy, radical history, media activism, feminist organizing and refugee subjectivity. Jakobsen eventually dissolved the University insofar as it threatened to become "a nice, interesting theme." He argued that self-organizing need not abandon the task of taking power away from capital. In relation to the attacks on access to education in the U.K., he concluded his talk with the salvo: "All power to the protesting students!"

Jakobsen's work comes closest to my second observation, which has to do with artistic practice. I refer in this case to Alain Badiou's talk, "Does the Notion of Activist Art Still Have a Meaning?," delivered at the Miguel Abreu Gallery on October 13, 2010.[18] In his presentation Badiou takes up the challenge of establishing some rules for a contemporary militant art, which he distinguishes from official art. We could say that insofar as engaged art practices pose no threat to dominant capitalist powers, they have become a kind of official art. Badiou says the same for radical artists in the past, like Brecht and Aragon, cases in which it is difficult to distinguish between an official art and a non-statist militant art since ideology is common to both. Badiou's Maoist politics are evident in this way of framing militant art. With official art, he argues, "ideology is realized in an objective form: the inscription of the work of art in the space

of that sort of objectivity." Objectivity is understood here as an objective apparatus – the party, the state or the party-state. In militant art, in contrast, ideology is a subjective determination; it is an art that has not been completely decided in terms of a victory by power; it is an art of the presentation and not of the re-presentation. Whereas official art uses all means to glorify the result, militant art must create new means to formalize the novelty because the result is not here. It glorifies what does not yet exist. In militant art, Badiou says, we have form and not the glorification of form.

The crux of my interest in Badiou's talk is his next point. Ideology, he says, is the space of the dialectic in which official and militant art interact:

> The difference between the two and the point of exchange between the two is the condition of all art. The condition of art is the existence of a strong ideology. What I mean by strong ideology is an ideology that presents or proposes a completely different vision of history of human beings as such. A strong ideology is something that creates the global idea of an other possibility.

Badiou argues that there is no strong ideology today, no global vision of another possibility for the world. Democracy, he says, is "the clear example of a weak ideology." With democracy there is consensus and equivocation between the revolutionary camp and the reactionary camp. Everyone is a democrat. It is far less possible to affirm that either fifty years ago or even now, everyone is a communist. It is difficult to know what an activist art might be in the context of a weak ideology since the subjective conviction is unclear and there is too much overlap with official art. In such conditions, militant art appears as experimental art and formal novelty. Novelty is not, Badiou asserts, by itself political. The temptation, he says, "is that in every field in which

we create something, we decide that the field is by itself a political one." Artistic autonomy can exist in these conditions without there being a corresponding social and political outcome.

InCUBATE, *Sunday Soup: The Big Crouton*, September 7, 2008.
Photo: Bryce Dwyer.

Badiou proposes four provisional rules for a militant art today. The first is that there be a concrete relationship with local political experiences, a concrete or real proximity. It is necessary, he says, to create common spaces. On this score, many of the practices discussed at the Summit are working in the right direction and represent a sea-change from what was and is predominant in terms of professionalized art practice. The second point is to accept the weakness of the ideology of democracy and attempt to organize progressively the return to a strong ideology, to have a strong intellectuality. On this point the Summit presentations and panels often seemed weak and the

audience (the choir) very often took the opportunity to point out the lack of a strong ideological content. The third point is to substitute forms of presentation for those of re-presentation. It is a paradox of the Summit that those artists who have a strong ideological content in their work are often engaged with representation (Ressler, W.A.G.E., Paglen, Galindo, Collins, Reynolds, Kurgan), whereas those with a weak ideological content were often directly involved with local experiences (Puett, Superflex, Pentecost, Franceschini, Lowe, F.E.A.S.T., PLATFORM). The fourth point is to propose the possibility of a concrete synthesis of the first three points: "a work of art which is really in relation to action – the first point – local transformation, which is intellectually ambitious and which is formally avant-garde in the classical sense of the substitution of presentation for an ornamental vision of representation." Groups like Otabenga Jones & Associates, Chto Delat and The International Errorist provide examples of militant art by weaving a strong praxiological content to their practices, by mounting a composition of these three rules and presaging a new global possibility, which Badiou elsewhere refers to as "the idea of communism."

Politics and Aesthetic Ideology

Dean and Badiou argue against democracy as the only possible form of association and seek to replace it with the idea of communism, an idea that, as Badiou asserts, does not limit itself to state socialism, but links to all emancipatory social events, including those bourgeois revolutions in which the name of the people is upheld as the measure of universal change. In his theory of militant art, however, Badiou in some ways subordinates art to politics, downplaying the fact that both aesthetics and politics have a level of effectivity and independence from one another. I wish therefore to review Badiou's idea of political experience by giving some attention to aesthetic experience. I do so by recalling the writings of Henri Lefebvre, a long-time

member of French Communist Party who also struggled within and outside of the PCF for a non-reductionist view of culture. If critical theory does not attend to matters of aesthetics, it risks ignoring the ways that artists sometimes attempt to resolve social conflicts through the use of artistic representations. In Lefebvre's terms, aesthetic representations are not purely ideological representations.[19] In his autobiography, Lefebvre lamented that fact that Socialist Realism had reduced culture to simple theoretical programmes and neglected individual psychic complexity. What it delivered, he argued in 1959, was

> An extraordinary number of folk ensembles, peasant dancers and singers. A few spectacles and traditional ballets. No plays for the theatre. Some films, some uneven and often mediocre novels, because these people associate themselves with the modern conditions of production. They have spoken to us a great deal about 'socialist realism' and they have force-fed us folklore.[20]

In his understanding of historical materialism, Lefebvre considered that the Marxian reversal of Hegel spread to all of the so-called superstructures, including politics. What this meant was that the understanding of the proletariat as the negation of the existing conditions of capitalism was not an empirically fixed guarantee of revolutionary progress. In the 1940s and 50s, at a time of Communist Party control over intellectual production, Lefebvre sought to disseminate this view through the subterfuge of aesthetic theory as well as the materialist conception of everyday life. In his *Critique of Everyday Life* (1947) he excoriated Surrealism and praised instead Brecht's work for its clarification of contradictions, a task that could be carried out from within conditions of alienation. Art, like knowledge, engages with living thought and with the concrete world and can be helpful in orienting practice. Echoing Marx's critique of *tendenzkunst*,

Lefebvre argued that there can be no Marxist art as such, only a Marxist theory of art. It is therefore wrong to judge art strictly in terms of its ideological content. Political ideas have acted on artists and writers and "folded themselves in with the ideological content of their works of art." "And this," he adds, "without allowing us to define art as the incarnation of ideology, as the conception of the world of a social class, which confuses art with ideology and its history with the history of knowledge."[21] There is no division that can be made therefore between a philosophy of aesthetics and a theory of aesthetic practice, however comforting or motivating that may seem.

These few reflections will suffice to merely suggest that the sites in which artists work should not be held in conformity with the ideological content of artworks, nor their aesthetic or poetic form. In this regard, there is a great deal to be understood about the paradoxical movement of autonomous practices away from official art institutions at the same time that aesthetic discourse attempts to recuperate such an exodus. The Creative Time Summit is just such an example of the means by which critical experiments are transformed into the new forms of experimentation. Practices with a strong ideological content, however, have a social and political effectivity that does not necessarily require the abandonment of the hallowed sites of the culture industry. Their conditions of speech, to use the language of Roland Barthes, correspond to that of "myth on the left." By way of contrast, Barthes defines "myth on the right":

The bourgeoisie wants to keep reality without keeping the appearances: it is therefore the very negativity of bourgeois appearances, infinite like every negativity, which solicits myth infinitely. The oppressed is nothing, he has only one language, that of his emancipation; the oppressor is everything, his language is rich, multiform, supple, with all the possible degrees of dignity at its disposal: he has an exclusive right to

146

meta-language. The oppressed *makes* the world, he has only an active, transitive (political) language; the oppressor conserves it, his language is plenary, instransitive, gestural, theatrical: it is Myth. The language of the former aims at transforming, of the latter eternalizing.[22]

Consider in this regard the words spoken at the Summit by Elizabeth Kabler, patron of the Leonore Annenberg Prize for Art and Social Change, as she presented a $25,000 money award to Rick Lowe, an artist who works with low-income African-American communities in Houston, Texas:

Today I feel like we are supporting an authentic and meaningful artistic practice, an art movement that does not conform itself [sic] to grand gestures or artworld politics, becoming mired in lots of praise but little actual positive outcome... Rick, your work is real. It is authentic and your solutions to very painful and contemporary problems run deep, embedded in the bricks of buildings, roots of trees and veins of people. Your belief that art and the community that it creates can revitalize repressed inner-city neighbourhoods, has continually come to fruition in the fabric of life for people living in Houston's Third Ward... My grandmother, Leonore Annenberg, would have understood your work completely. I feel humbled and quite moved to be able to uphold *her vision* and honor *her memory*.[23] [my emphasis]

Barthes states that myth on the left is a political language. It is operational and transitively linked to its object. The distinction is that between activating the things and activating their names, transforming reality and generating speech that is fully political.

Whereas the revolution announces itself openly, the bourgeoisie hides the fact that it is the bourgeoisie. Revolution becomes myth when one begins to speak of oneself as "the left,"

generating an innocent meta-language. Barthes says that this self-nomination may or may not be tactically necessary but that sooner or later it becomes contrary to revolution, defining its deviations.[24] Myth exists on the left, Barthes concludes, but it is not the same as that of myth on the right. Myth on the left does not reach the entire field of human relationships since everyday life is inaccessible to it – it is alienated. Myth on the left is poverty-stricken, a temporally limited prospect, invented with difficulty. What it lacks, he says, is that of fabulizing.

In *Public Sphere and Experience*, Oskar Negt and Alexander Kluge made a similar observation that the bourgeois public sphere represents a false totality.[25] In contrast to many of their Frankfurt School predecessors, Negt and Kluge did not discount the role of mass culture in the restructuring of subjectivity. What they noticed, rather, was that the idea of the public sphere was exploited by the various institutions of what they defined as the industrialized production public spheres: the press, television, interest groups, political parties, the army, the schools, the universities, the legal system and cultural institutions. Such production spheres aim for a maximum of inclusion, taking people's everyday experiences as the raw material for capitalist profit. Such exploitation does not offer an alternative but is based on "reality," on a vision of society as it exists. Actually existing cultural institutions make use of socially engaged art practices in order to transform the need for meaningful experience into finished products. Negt and Kluge argue that proletarian publicity develops instead in contexts of crisis, war and revolution. Proletarian publicity negates the existing world as a partial power. Short of a revolution, proletarian experience takes place in industrially overlaid contexts of living which require a great deal of imagination and which feed into fantasy as a protective reaction formation. The experiences that are bound up in fantasy, they argue, can be transformed into collective emancipation. As a libidinal counterweight to alienation, fantasy is mere

survival. Fantasy, however, corresponds to a mode of production and to the generation of living labour. What I have sought to argue in this review of the Creative Time Summit is the fact that the motivation of an aesthetic of survival in today's socially engaged art does not so much lead to the problem of not being able to recognize this kind of work as aesthetic but that we may not yet be able to recognize it as politics.

Chapter 8

From Artistic Activism to Geocritique: A Few Questions for Brian Holmes

In his last two publications, *Unleashing the Collective Phantoms* (2008) and *Escape the Overcode* (2009), the Chicago-based cultural theorist Brian Holmes has argued persuasively for forms of confrontational art practice and constructive critique that would challenge contemporary cultural institutions – the museum-gallery-magazine nexus – to move away from their function as economic engines within a neoliberal market and post-welfare state system and towards a decidedly leftist cultural politics that is able to provide solutions to the threats posed by economic instability, social inequality, evironmental catastrophe, and militarism.[1] As a preamble to this interview in which the author is invited to reflect on his work, I would start by asserting my deep affinity with Holmes' radical political commitments and his view that a phase change has occurred in and around the artworld and that this shift in radical cultural practice is linked to the resistance of social movements to the forms of governmental biopower. As a summary of Holmes' position on the latter, I cite a radio interview from March 19, 2010, in which he outlines the following four-point doctrine: 1) transnational corporations have outstripped the capacity of nation states to control them; 2) the financialization of capitalism allows speculators to disrupt economies and enforce market prices; 3) the essence of neoliberal governance is that people govern themselves based on calcula-tions of profit and loss – each is his or her own entrepreneur seeking self-empowerment by nurturing their potential as creative beings; 4) critical spaces within this form of "risk society" and "security state" can be opened up through creative

interventions, especially those that are guided by doctrine against the excesses of resistance.[2]

Marc James Léger: To begin with, I would like to address one of the essays in *Unleashing the Collective Phantoms*: "Signals, Statistics & Social Experiments." This essay is particularly interesting to me because it addresses a work of over-identification – Jakob Boeskov's 2004 project *The ID Sniper*, a proposal for a rifle that would allow security forces to tag protesters with electronic tracking devices that are in actuality marketed as "Veri Chips" and that are commonly used to tag pet animals. What interests me in your discussion is that although you are familiar with Žižek's analysis of over-identification in the work of Neue Slowenenische Kunst, which you discuss in a previous chapter, you relate over-identification in this case to Gilles Deleuze's idea that "resistance is primary" – as opposed to the Lacanian idea of the subject "castrated" by language – and that social control is managed through "apparatuses of capture" which you also describe as the feedback process of governmentality, a concept derived from the work of Michel Foucault. So, if I may start with a very theoretical question, how is it that you propose that the "collective phantoms" can perform a conscious withdrawal from today's institutions by "playing the governance game"? In contrast, I would ask a fairly unambiguous question. President Hugo Chavez has recently called on radical political parties and social movements around the world to form a fifth international, a global solidarity project to oppose imperialism and capitalism simultaneously. Do you think that an artist could or should contribute to this latter kind of radical cause?

Brian Holmes: The theory of over-identification claims that certain artistic performances can make the spectator uncomfortably conscious of the ob-scene (literally: offstage, unrepresented) pleasure they take in their unconscious identification with social norms. There's something to that, for sure, but as an

activist I'm more interested in taking the viewpoint of people who actually do such interventions, in which I engage myself from time to time. From that viewpoint, the main thing is the confrontation with members of the transnational capitalist class and the cognitive gains that come with trying to understand how they think and what kind of *habitus* they have – how it feels to be in their skin.

In the case of Jakob Boeskov's intervention it was first of all a matter of going to this insane sort of arms fair, "China Police 2002," a massive display of so-called less-lethal weapons, and some more lethal ones. This, of course, is just everyday business under the conditions of really existing neoliberal globalization. The artistic fiction that Boeskov was promoting at the fair had to do with a rifle called the "ID Sniper," which would shoot a GPS tracking chip under a protester's skin and allow him or her to be followed anywhere, from a distance. So he was asking us to imagine what happens when the police get under your skin, in very pragmatic and invasive ways. Consider such a performance, identify with it. What would it be like to try to sell such a thing? How would the legitimate participants react to such an extreme proposal? Most pressingly, what would happen if they bought it and if *you* got hit with that dart some day down the line? The last question isn't in vain, because since that time, we have seen the widespread use of GPS-equipped mobile phones to track pretty much whoever the police are interested in. And the subcutaneous chips, alas, are on the way. What I was trying to ask was who's going to govern this kind of society, with this sort of technology. How are the rest of us going to react to the imposition of new procedures for the production of the truth, about your location, your citizenship status, your intentions, etc?

This kind of work has to do with government and also with governmentality, both of which are relations that we are involved in, serious "games" that we can and do play. Now, you ask about Chavez's call for artists to join the revolution. Out of curiosity, I

went to Venezuela twice. One of the things I learned was that the Bolivarian process could only get seriously underway after several waves of strikes in the national oil company, in the course of which they gradually pushed out some of the people who had been running that vital industry. Yet they still depend on expertise from the American oil majors. If the left would like to see a change in the way the developed countries are run, we would have to confront the members of the transnational capitalist class and push some of them out of their positions. Most crucially, we would have to replace them at their jobs, which, of course, would also have to be gradually and deeply transformed. Frankly I would like to see that happen. I think that the kind of critical work I am doing is a small but real contribution to a social process that could head in that direction, if only more people decided that they would like to come to grips with the way that society functions, and work on the ways that it could be different.

MJL: The transitions from pre-socialist societies to state socialism and now to neoliberal capitalism with a resurgence of extreme right-wing politics should at least alert us the need for some emphasis on ideology. This is something that the workers' communes in Venezuela and the experiments of factory self-management fully recognize. Of course this is one of the difficulties of the Autonomist Marxist framework, which is to emphasize the tension between modes and relations of production without an adequate emphasis on the relation to superstructures or to the problem of political representation.

To make a bridge between your two books I would say that two essays in particular, "Extradisciplinary Investigations: Toward a New Critique of Institutions," from *Escape the Overcode*, and "Unleashing the Collective Phantoms: Flexible Personality, Networked Resistance," from *Unleashing the Collective Phantoms*, represent a fairly concise articulation of your analysis of what you call the "gallery-magazine-museum" circuit and how to

escape or challenge it. The anarchistic solution that you propose, self-organization from the outside, is premised, you say, on lessons learned from the generation of '68: the lesson to flee from the "dialectical" return of the same through the clash of seeming opposites. This is most fully fleshed out in *Escape the Overcode* with its analysis of how to become mobile within maps of constituted power and extradisciplinary autonomous experimentation in areas separate from art that can bypass the processes of overcoding through practices of resistance, invention and deviance.

I want to ask you, how is it for you that art can figure as class struggle if you want to operate with an anti-dialectics that leads you, intevitably, to what I would consider a kind of subjectivization that is premised on the communicative and affective production of immaterial labour which itself is premised on an imperialist process of global proletarianization? Capitalism, as we know, feeds off of counter-cultural expression and trans-subjective communications, looking to it for new forms of life and cultural expression. How would you respond to the assertion that on some level what you are proposing in your books and from a schizo-anarchist position – though perhaps less so in what you have said so far – is the indestructibility of capitalism and the negation of politics? Is the phrase "post-politics" one that you accept?

BH: Do we know what's gonna destroy capitalism? I have to begin by observing that Marx, the greatest materialist philosopher, has been completely wrong on that score. Capitalism definitely survived the industrial worker, first through the formation of a redistributive Keynesian state, then through the creation of a middle-manager class by mass education and most recently through the neoliberal orchestration of productive relations into fractured spaces and times where people are rarely together long enough to conspire – which means to breathe the same air, if you take words literally. So I'd

say the dialectic had better evolve a little.

All the revolutions that happened in the twentieth century involved disaffected members of a rising "new class" of engineers and managers, collaborating with industrial workers but crucially with peasants too. Now global free trade is producing not just proletarianization and displaced peasants but imperialist wars, environmental disasters, tremendous flows of highly individualized migration and dramatically increasing poverty amidst the very boom of the luxury economy. What we need is a concept and a practice of transnational, cross-class collaboration way beyond the old "intellectuals and workers" model, but manifestly, no one has it. In that respect, ideology and social hierarchy are inseparable. On the one hand, most people with an old left or even a new left orientation have gained niches in the social and cultural institutions – guaranteed jobs which are evaporating in the current crisis. On the other, the younger generations have been fascinated by the possibilities and caught in the traps of the global communications system – whose limits are finally beginning to show, also due to the financial meltdown. We are about to see huge disaffection among the middle classes, but is there a way for these disaffected people to engage in new collaborations and solidarities? Can they break through the existing ideology of liberal freedoms and specu-lation on one's own human capital? Is there a political alternative to religious nationalism? These are the key questions of political philosophy and of engaged artistic practice, and I've been very clear about them since the turning point of 2004, when the American people went out and willingly elected Bush for a second term.

My own work is not about positions but pathways. That's why I always mix the social sciences with art, in order to put analysis to the test of experimentation. It's also why there is a continuous development of the ideas presented in my essays and books. I began in Paris in the mid-1990s, demonstrating with

graphic artists and unemployed people while analyzing finan-
cialization. When the counter-globalization movements showed
the way toward broader and more effective mobilizations,
obviously I began to participate. The Italian Autonomists and the
French journal *Multitudes* had the most to contribute to the self-
organization of the movements. Of course I joined them. We took
strong inspiration from people actually building a productive
technology, the free software hackers, some of whom reached
across class divides to collaborate with movements in Latin
America or India. All that gave rise to what I call a "political
generation" that is defined by a common set of problems and
possibilities. It was a chance to breathe a little, to conspire, to ask
real questions. Now, I don't think people choose their subjec-
tivity, but they do work with it and maybe even through it. What
you call "schizo-anarchism" was the experience of hundreds of
thousands of people trying to change their world and trans-
forming themselves in the process. Among the turmoil it was not
easy to find artistic expressions that could fit into the established
frames of art, but I wrote about them whenever I could. More
importantly, I tried to theorize the experiments themselves, using
avant-garde references and drawing on art practice to expand life
instead of the usual reverse. There was a lot of concern about co-
optation, particularly during the later phases of the real-estate
boom. Check out my text called "Reverse Imagineering," which
is about resisting exactly that. But you know, the real problem is
that the movements remain relatively small, and the control
capacity of the contemporary state is tremendous. Ten or fifteen
million people marching against the Iraq war on February 15,
2003, is considered peanuts in world society!

Today I have moved back from Europe to the United States,
where the social system is under tremendous stress. It's not an
easy moment but I do want to be part of the next political gener-
ation. In an essay from my recent book called "Recapturing
Subversion" I analyze the limits of the Autonomist position,

which risks becoming dogmatic at exactly the moment when we need new assessments of a very different economic and political situation. The focus on production in Autonomous Marxism is liberating, but I agree with you, it also has blind spots. In the last section of *Escape the Overcode* I work through the archaeology of the control society, which is crucially involved with the computerization of the military-industrial complex and with the development of contemporary finance. When I speak of "escaping the overcode" it's about denormalizing yourself and breaking the *habitus* built up by these institutions, which is a precondition for any kind of political engagement. Beyond that, what I call extradisciplinary practice is about coming consciously to grips with the technical processes that turn ideology into commodities and infrastructure – processes that employ huge amounts of people and continuously occupy their minds and emotions. People read my texts for detailed critical descriptions of the world they live and work in, but also for the "outside" perspectives, for reflections on the creation of value that can help them to orient their lives away from the dominant functions. The texts are clearly not just about art. The strategies they present cannot be reduced to pre-cut notions of class struggle and the whole thing has less and less to do with the gallery-magazine-museum system. I'm looking for cultural and political use-values that have to be developed by individuals and small groups before they can change the mainstream institutions.

MJL: Just by the way, Keynesianism has never been practiced in its most radical sense. Throughout the "golden age" of Western capitalism, Keynesianism was held as the refutation of Marx's economic thinking. But it was never used, and instead an arms-based economy and imperialist competition during the Cold War were associated with booming economies. Since the 1970s and 80s, however, both Keynesianism and state-directed socialist economics – which was also capitalist and became the model for transnational capitalism – proved unable to overcome

the main contradictions of accumulation, which Marx identified long ago. Needless to say, this was used by neoliberal capitalists to assert that there is no alternative, and for Schumpeterians to say that economic crises and capitalist mayhem in general may be even a good thing, stimulating new rounds of productivity. Meanwhile, and despite the claims of sociologists that we now live in a post-industrial word, proletarianization proceeds unabated, especially in developing countries, but without the kinds of revolutionary parties, solidarity networks and unions it once could claim. Further, international capital relies as much as ever on state provisions and protections to strengthen its grip on democratic institutions.

My last question then comes back to institutions and what you've said already about the art system. Based on your writings, and I'm thinking here of your contribution to the Chto Delat panel on artistic avant-gardes, it could be fair to say that you are ambivalent about the role of today's institutions.[3] Should institutions evolve, as you say about the dialectic, or should we learn to live without them?

BH: One of the thinkers to whom I often return is Cornelius Castoriadis, the philosopher, anthropologist and psychoanalyst who wrote about the "imaginary institution of society." His use of the word "imaginary" corresponds to what's often described as the symbolic order. However, he conceives it somewhat differently, as the magma of culturally shared ideas and images out of which concrete institutions are shaped. His concern is to institute a condition of individual and collective autonomy – i.e. democracy. But of course he recognizes the heteronomy (or "alien law") that capitalism comes to exercise over us. How can we not recognize this in our own era, when financial capital runs rampant and the industries of war constantly take over the state? In a text called "The Speculative Performance," I quote Castoriadis' ideas in order to describe the process whereby the capitalist imaginary has overcome democratic institutions and

reshaped contemporary subjectivity. I also describe some performative experiments that attempt to institute another way of living in society.

In fact, the period of Keynesian economic governance has been of great interest to me. Mind you, I don't naively celebrate it and I'm very aware of what, in the U.S., was called "the welfare-warfare state." But in texts like "The Flexible Personality" or in the essay on "Invisible States" in *Escape the Overcode*, I recall the ways that a partial socialization of the economy acted to free up time from the pressures of the market: the time of child-rearing, education, health care, leisure, retirement, and of course, the time of publicly supported cultural production, in which non-monetary and non-productivist values could be explored and given form. It seems to me that much of the experimental culture that flourished in the 1960s and 70s resulted from a subversion of welfare-state educational and cultural institutions, that is, from an attempt to radicalize their potentials and to exceed their limits. Even today, the extradisciplinary art practices that interest me tend to not come out of commercial art practice nor even out of underground subcultures, but out of public universities – which are under attack right now, all over the world.

So to answer your question, yes, I do find today's neoliberal institutions unbearably superficial, existing almost entirely in the electronic fluctuations of the present, articulated only to the staccato rhythms and the visual fascination of information flickering on screens. This type of financialized culture has become the very basis of the state, justifying its relentless destruction of the formerly public institutions and continually unleashing violent outbursts whenever its shaky claim to "risk management" breaks down in moments of crisis. Obviously I believe these institutions need to be relentlessly criticized, through the kinds of analysis that I develop in my texts and also through the social movements and artistic subversions with

which I'm engaged. But the point can only be to found new institutions, through which we are better able to recognize each other's autonomy and its limits, to care for each other, to educate and transmit knowledge, to overcome inequalities and to begin undoing the tremendous damage that the industrial system has done to the ecology. This cannot be achieved through the rash destruction of what exists. But the paradox is, evolving toward bearable and viable institutions requires some kind of break in our current understandings of what life in society is good for. It can't just happen in the realm of ideas, it also has to enter the world of the senses. The important risk is there. Art in its expanded forms can be a site of rupture. That's the role that Castoriadis assigned to the radical imagination.

Notes

Introduction: The Avant Garde Hypothesis

1. Brian Holmes, "Extradisciplinary Investigations: Towards a New Critique of Institutions," *Transversal* (January 2007), available at http://eipcp.net/transversal/0106/holmes.en.

2. Alain Badiou, *The Century*, trans. Alberto Toscano (Cambridge, UK: Polity Press, 2007) 131.

3. Alain Badiou, *The Communist Hypothesis*, trans. David Macey and Steve Corcoran (London: Verso, [2008] 2010). In his preamble, Badiou states: "Because is had ended in failure all over the world, the communist hypothesis is [thought of as] a criminal utopia that must give way to a culture of 'human rights', which combines the cult of freedom... and a representation in which Good is a victim. Good is never anything more than the struggle against Evil, which is tantamount to saying that we must care only for those who present themselves, or who are exhibited, as the victims of Evil." He adds that against the capitalo-parliamentarian form of democracy, our times is the era of the reformulation of the communist hypothesis. Badiou, *The Communist Hypothesis*, 2 and 66. See also Badiou, *The Meaning of Sarkozy*, trans. David Fernabch (London: Verso, [2007] 2008).

4. Johanne Lamoureux, "Avant-Garde: A Historiography of a Critical Concept," in Amelia Jones, ed. *A Contemporary Companion to Art: Since 1945* (Oxford: Blackwell, 2006) 207.

5. See Jacques Rancière, *On the Shores of Politics*, trans. Liz Heron (London: Verso, [1992] 2007) 56. For workerist themes in contemporary art criticism, see for example, Sonja Lavaert and Pascal Gielen, "The Dismeasure of Art: An Interview with Paolo Virno," *Open* #17 (2009), available at http://www.skor.nl/article-4178-en.html; and Gerald Raunig, *Art and Revolution: Transversal Activism in the Long Twentieth*

Century, trans. Aileen Derieg (Los Angeles: Semiotext(e), [2005] 2007).

6. For a brief review of this shift from the avant garde quest to occupy the institutions of power to the post-1968 disabling of institutions and specialized activity, see Gerald Raunig, "On the Breach," *Artforum* (May 2008) 341-3.

7. Slavoj Žižek, *In Defense of Lost Causes* (London: Verso, 2008) 183.

8. Brian Holmes, "Extradisciplinary Investigations."

9. Peter Bürger, *Theory of the Avant-Garde*, trans. Michael Shaw (Minneapolis: University of Minnesota Press, [1974] 1984); Hal Foster, "What's Neo about the Neo-Avant-Garde?" *October* #70 (Fall 1994) 5-32; Benjamin H.D. Buchloh, *Neo-Avantgarde and Culture Industry: Essays on European and American Art from 1955 to 1975* (Cambridge: The MIT Press, 2000); Norman Bryson, "The Post-Ideological Avant-Garde," in Gao Minglu, ed. *New Chinese Art* (Berkeley: University of California Press, 1998) 51-58; and Sianne Ngai, "The Cuteness of the Avant-Garde," *Critical Inquiry* #31 (Summer 2005) 811-47. A key text in the lead up to the postmodern critique of the notion of an avant garde is of course Rosalind E. Krauss, *The Originality of the Avant Garde and Other Modernist Myths* (Cambridge: The MIT Press, 1985).

10. Martin Jay, *Marxism and Totality: The Adventures of a Concept from Lukàcs to Habermas* (Berkeley: University of California Press, 1984) 10.

11. Andrea Fraser, response to the questionnaire "How has art changed?" *Frieze* #94 (October 2005), available at http://www.frieze.com/issue/article/how_has_art_changed/.

12. Badiou, *The Meaning of Sarkozy*, 97-8.

13. See Linda Hutcheon, *The Politics of Postmodernism* (London: Routledge, 1989).

14. See Slavoj Žižek, *Looking Awry: An Introduction to Jacques Lacan through Popular Culture* (Cambridge: The MIT Press,

1991).

15. Alexei Monroe, *Interrogation Machine: Laibach and NSK* (Cambridge: The MIT Press, 2005) 247.

16. Pierre Bourdieu, *Distinction: A Social Critique of the Judgement of Taste*, trans. Richard Nice (Cambridge: Harvard University Press, [1979] 1984).

1. Andrea Fraser and the Subjectivization of Institutional Critique

1. Andrea Fraser, "In and Out of Place," *Art in America* #73 (June 1985) 122-8.

2. Andrea Fraser, "Museum Highlights: A Gallery Talk," *October* #57 (Summer 1991) 104-22.

3. These essays include: "How to Provide an Artistic Service: An Introduction," available at http://adaweb.walkerart.org; "Services: A Working-Group Exhibition," Beatrice von Bismarck, Diether Stoller and Ulf Wuggenig, eds., *Games, Fights, Collaborations: The Game of Boundary and Transgression; Art and Cultural Studies in the 90ies* (Stuttgart: Cantz, 1996) 210-213; "What's Intangible, Transitory, Mediating, Participatory, and Rendered in the Public Sphere?" *October* #80 (Spring 1997) 111-16; "Services: Working-Group Discussions," *October* #80 (Spring 1997) 117-48. Additional critical writings include "Notes on the Museum's Publicity," initially published in *Lusitania* in 1990 and reprinted in Kynaston McShine, ed. *The Museum as Muse: Artists Reflect* (New York: The Museum of Modern Art, 1999) 238-9; "A 'Sensation' Chronicle," *Social Text* #67 (Summer 2001) 127-56; "'A museum is not a business. It is run in a businesslike fashion'," in Melanie Townsend, ed. *Beyond the Box: Diverging Curatorial Practices* (Banff: Walter Phillips Gallery, 2003) 109-22. Most of these are available in the recent collection of writings, Andrea Fraser, *Museum Highlights: The Writings of Andrea Fraser* (Cambridge: The MIT Press, 2005).

4. Pierre Bourdieu, *Distinction: A Social Critique of the Judgement of Taste*, trans. Richard Nice (Cambridge: Harvard University Press, [1979] 1984).

5. Andrea Fraser, ""To quote," say the Kabyles, "is to bring back to life"'," *October* #101 (Summer 2002) 9. Bourdieu's well-know expression of this is that artists and intellectuals form a dominated sector of the dominant (bourgeois) class of society. The opposite of this scholastic group is that of socialites who replace the prudence of an awareness of limits with the rightness of self-assurance and arrogant bluff.

6. Fraser, ""To quote,"'," 10. Reflexivity involves a critique of the tools of analysis. "To be able to use theory, even against cultural legitimacy, requires a degree of competence. However, the exercise of that competence itself tends to reproduce the very legitimacy one might use it to critique." Fraser cited in Yilmaz Dziewior, "Interview with Andrea Fraser," in Dziewior, ed. *Andrea Fraser: Works: 1984 to 2003* (Köln: DuMont, 2003) 93.

7. This specific role is described by Fraser in "From the Critique of Institutions to an Institution of Critique," *Artforum* 44:1 (September 2005) 278-83, 332.

8. Fraser, "From the Critique of Institutions," 283.

9. Bourdieu, *Distinction*, 466.

10. Bourdieu, *Distinction*, 172.

11. For an analysis of Fraser's conflation of creatitvity and exploitation, see my essay concerning her project *Untitled* (2003): Marc James Léger, "What's Neo about Neo-Feminism?," *Etc* #84 (Dec 2008-Jan/Feb 2009) 20-2.

12. It should be stated that this need not be the case and is not always so. The New Museum in New York City, for example, is recognized for its development of alternative approaches to museum education and security.

13. Fraser, ""To quote,"'," 9.

14. Bourdieu, 321-323. Bourdieu distinguishes between false

popularizations of legitimate culture from legitimate, pedagogical popularizations that acknowledge the effort involved in the mode of acquisition.

15. See Andrea Fraser, "Dear Stephan," available online at www.societyofcontrol.com/akademie/fraser.htm.

16. The proper name of Louise Lawler can therefore be said to mark a difference of gender within a male genealogy of institutional critique. On this subject, Miwon Kwon has emphasized how the maintenance performance works of Mierle Laderman Ukeles complicated the gendered division of labour within the museum and also within critical art practice. See Kwon, *One Place After Another: Site-Specific Art and Locational Identity* (Cambridge: The MIT Press, 2002) 18-19.

17. Andrea Fraser, "Museum Highlights," 107.

18. Fraser, 107-8. The artist can actually find further grounds of identification with the leisured disposition of Castleton inasmuch as the field itself extracts from her the surplus of her activity.

19. Jean Laplanche, "To Situate Sublimation," *October* #28 (1984) 7.

20. "One of the primary impulses behind my first gallery talk-performance was to try to integrate institutional critique and what could be called a psychoanalytic feminist critique of subjectivity. What I came up with – and am still working with – is something like a psychoanalytic notion of site-specificity that's informed by the concept of transference." Joshua Decter, "Interview with Andrea Fraser," *Flash Art* #155 (Nov/Dec 1990) 138.

21. See George Baker, "Fraser's Form," in Dziewior, ed. *Andrea Fraser: Works: 1984 to 2003*, 57-8.

22. Fraser, "Museum Highlights," 112. These conflicting interests are elaborated by the script of *Museum Highlights* and are based in an archaeology of the Philadelphia

Museum of Art's history as an institution of early twentieth-century bourgeois reform and charity.

23. Andrea Fraser in "Feminism & Art: 9 Views," *Artforum* (October 2003) 142.

24. Cited in Decter, 138. Along these lines, Fraser's contribution to the 1993 Whitney Bienniale was based on the separation between the heterogeneity of public desires and the assumptions of the museum's professional staff. See Jennifer Fisher, "Speeches of Display," *Parachute* #94 (April/May/June 1999) 25-31.

25. The view that transnational global capital functions according to the dominant cultural tendencies of the international petty bourgeoisie is put forward by Bill Readings in *The University in Ruins* (Cambridge: Harvard University Press, 1996). On this, see also Andrew Ross, *No Collar: The Humane Workplace and Its Hidden Costs* (New York: Basic Books, 2003) and Ross, *Nice Work if You Can Get It: Life and Labour in Precarious Times* (New York: New York University Press, 2009).

26. See Oscar Negt and Alexander Kluge, *Public Sphere and Experience: Toward an Analysis of the Bourgeois and Proletarian Public Sphere*, trans. Peter Labanyi, et al. (Minneapolis: University of Minnesota Press, [1972] 1994).

27. Inasmuch as within capitalist class relations, cultural dispossession justifies economic dispossession, an acknowledgement of transformations within the field of cultural production should entail a corresponding shift in the knowledge sector of this same field.

28. *Services* took place at the Kunstraum de Universität Lüneburg between January 29 and February 20, 1994. The exhibition traveled to Stuttgart, Munich, Vienna, Geneva and Hasselt, Belgium. See Luk Lambrecht, *Services* (Haaselt: Provincial Museum, 1995) and Beatrice von Bismarck et al., eds. *Games, Fights, Collaborations: The Game of Boundary and*

Transgression: Art and Cultural Studies (Stuttgart: Cantz, 1996).

29. As stated by the organizers: "While curators are increasingly interested in asking artists to produce work in response to specific existing or constructed situations, the labour necessary to respond to those demands is often not recognized or adequately compensated. Conversely, many curators committed to project development are frustrated by finding themselves in the role of producers for commercial galleries, or a 'service department' for artists they find uninterested in dialogue." Helmut Draxler/Andrea Fraser, "Services: A proposal for an exhibition and a topic of discussion," in *Games, Fights, Collaborations*, 196. Among the participants were the artists and curators Judith Barry, Ute-Meta Bauer, Ulrich Bischoff, Iwona Blazwick, Buro Bert, Susan Cahan, Clegg & Guttman, Stefan Dillemuth, Helmut Draxler, Andrea Fraser, Reneé Green, Christian Phillipp Muller, Fritz Rahmann and Fred Wilson.

30. Deskilling needs to be understood here not only in terms of technical skill and 'dematerialized' products, but also in relation to forms of status-based discrimination and social control.

31. See Andrea Fraser, "Services: A working-group exhibition," in *Games, Fights, Collaborations*, 210. The institutionalization and academicization of site specificity is discussed in "Unhinging of Site Specificity," in Miwon Kwon's *One Place After Another*, 33-55.

32. On this topic, see BAVO, ed. *Cultural Activism Today: The Art of Over-Identification* (Rotterdam: Episode Publishers, 2007).

33. See in particular, Fraser, "'A museum is not a business. It is run in a businesslike fashion.'"

34. Andrea Fraser, "How to Provide an Artistic Service: An Introduction," (1994), available online at http://adaweb. walkerart.org, 3.

35. Fraser, "What Intangible," 115-16.
36. Slavoj Žižek, *Looking Awry: An Introduction to Jacques Lacan through Popular Culture* (Cambridge: The MIT Press, 1991) 64-66. In the language and tactics of labour unions, *Services* has the function and dimensions of a strike, that is, to not only sell one's labour, but to call into question the unethical grounds of this exchange.
37. See the contributions of Green and Dillemuth in *Games, Fights, Collaborations*, 215-220. Art critic Jean-Baptiste Bosshard went so far as to credit Fraser with an "abuse of power" and an arrogation to herself and co-organizer Draxler of the benefits of signature. The only defense for Fraser in this instance would be to justify her work by reference to earlier works, thereby not only making use of the mechanisms of art critical and historical retrospection, but simultaneously faulting the same system for providing her with critical allowance in the first place. Understood in these terms, Bosshard's position is unredeemably idealistic.

2. Community Subjects

1. See Michael Hardt and Antonio Negri, *Empire* (Cambridge: Harvard University Press, 2000).
2. Nicolas Bourriaud, *Relational Aesthetics*, trans. Simon Pleasance et al. (Dijon: Les presses du réel, [1998] 2002).
3. Most prominent is Claire Bishop's "Antagonism and Relational Aesthetics," *October* #110 (2004) 51-79.
4. See Slavoj Žižek, "The Good Men from Porto Davos" in *Violence: Six Sideways Reflections* (New York: Picador, 2008) 15-24.
5. Grant Kester, *Conversation Pieces: Community + Communication in Modern Art* (Berkeley: University of California Press, 2004).
6. Miwon Kwon, *One Place After Another: Site-Specific Art and Locational Identity* (Cambridge: MIT Press, 2002).

7. See Jean-Luc Nancy, *The Inoperative Community* (Minneapolis: University of Minnesota Press, 1991).

8. See Grant Kester, "Rhetorical Questions: The Alternative Arts Sector and the Imaginary Public," in Kester, ed. *Art, Activism & Oppositionality: Essays from* Afterimage (Durham: Duke University Press, 1998) 103-35.

9. Slavoj Žižek, "Multiculturalism, or, the Cultural Logic of Multinational Capitalism," in Zizek, *The Universal Exception: Selected Writings, Volume Two.* edited by Rex Butler and Scott Stephens (London: Continuum, 2006) 151-82.

3. In a Way We Are All Hokies: Polylogue on the Socio-Symbolic Frameworks of Community Art

1. Patrick Fitzsimons, "Neoliberalism and 'Social Capital': Reinventing Community," (2000), available at http://www. amat.org.nz/Neoliberalism.pdf.

2. Pierre Bourdieu, *Acts of Resistance: Against the New Myths of Our Time* (Cambridge: Polity Press, 1998).

3. Fitzsimons, "Neoliberalism and 'Social Capital': Reinventing Community."

4. Jacques Rancière, *The Politics of Aesthetics: The Distribution of the Sensible*, trans. Gabriel Rockhill (London: Continuum, 2004) 90.

5. Nina Möntmann, "Community Service," *Frieze* 102 (October 2006), available at http://www.frieze.com/issue/article/community_service/.

6. The contours of an operative community art practice have been described by Bruce Barber in numerous essays, including "Cultural Interventions in the Public Sphere," in *Performance, [Performance] and Performers, Volume 2: Essays*, ed. Marc James Léger (Toronto: YYZ BOOKS, 2007) 145-55.

7. For the sake of exposition, I am making use of Grant Kester, "Dialogical Aesthetics: A Critical Framework for Littoral Art," *Variant* 2:9 (Winter 2000), available at http://www.

variant.randomstate.org/ 9texts/KesterSupplement.html. See Grant Kester, *Conversation Pieces: Community + Communication in Modern Art* (Berkeley: University of California Press, 2004).

8. Kester's *Conversation Pieces* and related interviews are informed by arguments he made in previous writings. See for example, Grant Kester, "Aesthetic Evangelists: Conversion and Empowerment in Contemporary Community Art," *Afterimage* (January 1995) 5-11; and Grant Kester, "Rhetorical Questions: The Alternative Arts Sector and the Imaginary Public," in *Art, Activism, & Oppositionality: Essays from Afterimage*, ed. Grant Kester (Durham: Duke University Press, 1998) 103-135. On the whole, I consider these earlier essays to be far more satisfactory than the mix of leftism, liberalism and populism that he works with in *Conversation Pieces* as an effort to avoid being associated with anything that seems like orthodox Marxism. Along these lines, *Conversation Pieces* is followed by his essay "Crowds and Connoisseurs: Art and the Public Sphere in America" in *A Companion to Contemporary Art Since 1945*, ed. Amelia Jones (London: Blackwell, 2006) 249-68.

9. On this score, Kester's criticism comes to resemble the rather confused writing of Nicolas Bourriaud in his 1998 text on relational aesthetics. This book, based on essays written in the early 1990s, is almost entirely dependent in its critique on the socialism of the historical avant gardes. At the same time, this political identification is negated and the theory of social connectivity is limited to a growth model for art production. Art activity is a game, we are told, in which aesthetic judgement plays no part. Nor does newness and the Baudelairean idea of the modern act as criteria. Instead, contemporary practices are about types of behaviour, often irrational and spontaneous, that are opposed to authoritarian forces. The ideologies of progress that fueled the imagina-

tions of the avant gardes, Bourriaud argues, are now bankrupted by the history of totalitarianism. Today's avant garde is reformed on the basis of different cultural and philosophical presuppositions. Erring on the side of caution, Bourriaud tells us that today's participatory avant garde comes up with models by mixing and borrowing equally and indiscriminately from Marx and Proudhon, the Dadaists and Mondrian. There is no presumed historical evolution, no models for a better future. Instead, contemporary art offers us possible universes and better ways of living and getting along. Bourriaud's idea of the avant garde thus completely dispenses with Marxist theorization. Although marked by real academic qualification, his writing is in the end an eclectic theoretical pastiche that disregards the incompatibility of the historical references and theories that he cites. Bourriaud fails to distinguish economics from art, which would then allow us to consider some of the determinations of his politics. He acts as an *intellectuel désengagé*, offering the artworld a foreclosure of radical politics through interpassive relations, managed disconnection and gated interactions. See Nicolas Bourriaud, *Relational Aesthetics*, trans. Simon Pleasance et al. (Paris: Les presses du réel, [1998] 2002) and *Postproduction. Culture as Screenplay: How Art Reprograms the World*, trans. Jeanine Herman (New York: Lukas & Sternberg, 2002).

10. Claire Bishop, "Antagonism and Relational Aesthetics," *October* #110 (Fall 2004) 51-79.

11. Bishop, 65.

12. Bishop, 71.

13. Claire Bishop, "The Social Turn: Collaboration and Its Discontents," *Artforum* 44:6 (February 2006) 178-83.

14. Bishop, "The Social Turn," 179.

15. Grant Kester, "Another Turn," *Artforum* 44:9 (May 2006) 22.

16. This perception has been reiterated more than once. I myself

have weighed in on this debate with a book review of Bishop's 2006 anthology *Participation* (MIT Press) in the pages of *Afterimage* (September/October 2007) and in an online discussion on the subject of "Queer Relational" on the *empyre* list-serve in July of 2009. The editors of the *Journal of Aesthetics and Protest* also single out Bishop in the their 2009 issue for comments she made in "Public Opinion: Scene and Herd," *Artforum* (October 2009), in which she presents socially engaged art as a genre and argues for its continuity with 70s artistic gestures. Bishop here reiterates her most questionable position – the problematization of public practice as a direction in contemporary *art*. Available at http://artforum.com/diary/id=24062.

17. Mick Wilson, "Autonomy, Agonism, and Activist Art: An Interview with Grant Kester," *Art Journal* (Fall 2007) 106-18.

18. Giorgio Agamben, *Homo Sacer: Sovereign Power and Bare Life*, trans. Daniel Heller-Roazen (Stanford: Stanford University Press, 1998) 25.

19. The thematics for this analysis were first proposed in Andrew Wernick's essay "Bataille's Columbine: The Sacred Space of Hate," *C Theory* (1999), available at http://www.ctheory.com.

20. Georges Bataille, "Propositions sur le fascisme," *Acéphale* (January 21, 1937), available at http://i.am.free.fr/.

21. See Maurice Blanchot, *The Unavowable Community*, trans. Pierre Joris (Barrytown: Station Hill Press, 1988).

22. Blanchot, 33.

23. Blanchot, 50.

24. Jean-Luc Nancy, *The Inoperative Community*, trans. Peter Connor et al. (Minneapolis: University of Minnesota Press, 1991) 3.

25. Nancy, 15.

26. Nancy, 26.

27. Jean-Luc Nancy, "The Inoperative Community," in Claire

Bishop, ed. *Participation* (London/Cambridge: Whitechapel/ MIT Press, 2006) 55.

28. Nancy, 56.

29. Nancy, 62-3.

30. Nancy, 62.

31. Nancy, 65.

32. "The artist is, to use Lacan's phrase, 'the subject presumed to know,' bringing the viewer into compliance with a properly de-essentialized mode of being through some sort of revelatory encounter. The purism comes through quite clearly; the viewers must be punished for their reliance on forms of identification or collectivity that don't pass theoretical muster; they must be made to feel 'discomfort,' and so on. Of course this sort of S & M co-dependence between the artist and the viewer has a venerable history, extending back at least to Courbet's slap-in-the-face with *The Stonebreakers*. Provocation can easily enough slide over into titillation and one might argue that, at this late stage, art audiences expect, even anticipate, the shock, dislocation, and discomfort that avant-garde art delivers." Kester cited in Wilson, 116.

33. Slavoj Žižek, *The Sublime Object of Ideology* (London: Verso, 1989) 76.

34. Slavoj Žižek, *Welcome to the Desert of the Real* (London: Verso, 2002) 142.

35. Alain Badiou, "Philosophy and the 'Death of Communism'," in Badiou, *Infinite Thought: Truth and the Return to Philosophy*, trans. Oliver Feltham and Justin Clemens (London: Continuum, 2006) 95.

36. Badiou, 96.

37. Badiou, 97.

38. Badiou, 97.

39. Badiou, 98-9.

40. Jacques Rancière, "On Art and Work," in *The Politics of*

Aesthetics, 42-5.

41. See the glossary of terms in Rancière, 81.

42. Rancière, 44.

43. Rancière, 45.

4. A Brief Excursus on Avant Garde and Community Art

1. Krzysztof Wodiczko, "For the De-Incapacitation of the Avant-Garde," *Parallelogramme* 9:4 (1984) 22-5.

2. Hal Foster, "Against Pluralism," *Recodings: Art, Spectacle, Cultural Politics* (Seattle: Bay Press, 1985) 23. See also Hal Foster, "The Funeral is for the Wrong Corpse," in *Design and Crime (and Other Diatribes)* (London: Verso, 2002) 125.

3. Wodiczko, 25.

4. In numerous publications, BAVO have decried the role of community art and cultural activism in the context of the neoliberal dismantling of progressive social policy. Embedded, or NGO art, as they call it, limits the scope of cultural agency to "softening the 'collateral damage' caused by [capitalist] restructuring and inventing humanitarian, compensatory measures or 'ways of dealing with', as opposed to radically contesting the neoliberal and neoconservative measures as such." Cited in BAVO, "Neoliberalism with Dutch Characteristics: The Big Fix-Up of the Netherlands and the Practice of Embedded Cultural Activism," in Rosi Braidotti, Charles Esche and Maria Hlavajova, eds. *Citizens and Subjects: The Netherlands, for Example* (Zürich: JRP/Ringier, 2007) 61. See also, BAVO, ed. *Cultural Activism Today: The Art of Over-Identification* (Rotterdam: Episode Publishers, 2007).

5. Nina Möntmann, "Community Service," *Frieze* #102 (October 2006), available at http://www.frieze.com/issue /article/community_service/.

6. See Oliver Ressler, ed. *Alternative Economics, Alternative Societies* (Gdansk: Wyspa Institute of Art, 2007).

7. See for instance, Isabell Lorey, "Governmentality and Self-Precarization: On the Normalization of Cultural Producers," *Transversal* (January 2006), available at http://www.eipcp.net/transversal/0106/lorey.en.

8. As Žižek himself puts it: "Politics proper thus always involves the tension between the structured social body, where each part has its place, and the part of no-part, which unsettles this order on account of the empty principle of universality... Politics proper thus always involves a kind of short-circuit between the universal and the particular; it involves the paradox of a singular that appears as a stand-in for the universal, destabilizing the 'natural' functional order of relations in the social body. This *singulier universel* is a group that, although without any fixed place in the social edifice (or, at best, occupying a subordinate place), not only demands to be heard on equal footing with the ruling oligarchy... but, even more, presents itself as the immediate embodiment of *society as such*, in its universality, against the particular power interests of aristocracy or oligarchy." Cited in Slavoj Žižek, "A Leftist Plea for 'Eurocentrism'," in *The Universal Exception: Selected Writings, Volume Two*, eds. Rex Butler and Scott Stephens (New York: Continuum, 2006) 183-4.

9. See Gerald Raunig, "Anti-Precariousness, Activism and May Day Parades," *Republicart* (2004) available at http://eipcp.net/transversal/0604. For more information see http://www.euromayday.org. See also Adrienne Goehler, "Basic Income Grant – The Cultural Impulse Needed Now!" in Free/Slow University, *Culture, Not Profit: Readings for Artworkers* (2009), available at http://wuw2009.pl/czytankid.php?lang=eng.

10. Angela Mitropoulos, "Precari-Us?" *Republicart* (2005), available at http://eipcp.net/transversal/0305.

11. Gregory Sholette, "Dark Matter: Activist Art and the

Counter-Public Sphere," *Journal of Aesthetics and Protest* 1:3 (August 2003), available at http://www.journalofaesthetic-sandprotest.org/3/sholette.htm. See also Gregory Sholette, *Dark Matter: Art and Politics in the Age of Enterprise Culture* (London: Pluto Press, 2011).

12. Sholette, "Dark Matter."

13. On the culturalization of politics, see Slavoj Žižek, "Tolerance as an Ideological Category," *Critical Inquiry* #34 (Summer 2008) 660-82.

14. Hal Foster, "Chat Rooms," in Claire Bishop, ed. *Participation* (Cambridge/London: MIT Press/Whitechapel, 2006) 194.

15. On this subject, see Pierre Bourdieu's landmark study of the field of cultural production, *Distinction: A Social Critique of the Judgement of Taste*, trans. Richard Nice (Cambridge: Harvard University Press, 1984).

16. Peter Bürger, *Theory of the Avant-Garde*, trans. Michael Shaw (Minneapolis: University of Minnesota Press, 1984).

17. For an analysis of community art's participation in the moral economy of capitalism, see Grant Kester's "Aesthetic Evangelists," *Artforum* (January 1995) 5-11.

18. See Nicolas Bourriaud, *Relational Aesthetics*, trans. Simon Pleasance (Dijon: Les presses du réel, 2002) and Grant Kester, *Conversation Pieces: Community + Communication in Modern Art* (Berkeley: University of California Press, 2004).

19. See Mary Jane Jacob, Michael Brenson, and Eva M. Olson, *Culture in Action: A Public Art Program of Sculpture Chicago curated by Mary Jane Jacob* (Seattle: Bay Press, 1995).

20. See Komar & Melamid, *When Elephants Paint: The Quest of Two Russian Artists to Save the Elephants of Thailand* (New York: Perrenial, 2000).

21. Slavoj Žižek, "Why Are Laibach and *Neue Slowenische Kunst* Not Fascists?" in *The Universal Exception*, 64.

5. Welcome to the Cultural Goodwill Revolution: On Class Composition in the Age of Classless Struggle

1. Theodor Adorno, "Commitment" in Terry Eagleton and Andrew Milne, eds. *Marxist Literary Theory* (London: Blackwell, 1996) 187. Adorno's opening salvo from 1962 finds its dark echo in one of Žižek's latest books, *In Defense of Lost Causes*, which he concludes with the question: "Does, then, the ecological challenge not offer a unique chance to reinvent the 'eternal Idea' of egalitarian terror?" See Slavoj Žižek, *In Defense of Lost Causes* (London: Verso, 2008) 461.

2. Henri Lefebvre, *De L'État, Tome I: L'état dans le monde moderne* (Paris: 10/18, 1976) 143-51.

3. Lefebvre, 151.

4. Pierre Bourdieu, *Distinction: A Social Critique of the Judgement of Taste*, trans. Richard Nice (Cambridge: Harvard University Press, [1979], 1984).

5. Bourdieu, 48.

6. Peter Bürger distinguishes the nineteenth-century "bohemian" avant gardes (Impressionists, Post-Impressionists, Symbolists, Fauves) from the critical, utopian and future-oriented twentieth-century "historical" avant gardes (Expressionists, Cubists, Futurists, Constructivists, Dadaists, Surrealists and Situationists) and from the postwar "neo" avant gardes (Neo-Dada, Neo Realism, Pop Art, Minimalism, Conceptualism) that recovered the strategies of the former (collage, montage, readymade, monochrome, construction) despite institutionally imposed ignorance of critical precedents. It is often held that seventies pluralism and postmodernism mark the end of avant-garde praxis. See Peter Bürger, *Theory of the Avant-Garde*, trans. Michael Shaw (Minneapolis: University of Minnesota Press, [1974], 1984).

7. See Walter Benjamin, "The Author as Producer," in *Reflections: Essays, Aphorisms, Autobiographical Writings* (New

York: Schocken Books, 1978) 220-38.

8. Bürger, xxviii. See Oskar Negt and Alexander Kluge, *Public Sphere and Experience: Toward an Analysis of the Bourgeois and Proletarian Public Sphere*, trans. Peter Labanyi et al. (Minneapolis: University of Minnesota Press, 1993).

9. In one of the more well-known critiques of Bürger's thesis, Hal Foster argues that the neo-avant gardes can be better understood through the concept of deferred action. Foster's work develops from some of the practices that may not and could not, for historical reasons, have been known to Bürger, beginning with the institutional critical work of Marcel Broodthaers, Daniel Buren and Michael Asher through to the discourse analysis of Fred Wilson, Andrea Fraser and Renée Green and the abject art of David Hammons and Robert Gober. However, in relation to more recent practices, Foster remains silent on the question of how class operates in relation to the chain of signifiers: class, race, gender and sexuality. See Foster, "What's Neo about the Neo-Avant-Garde?" *October* #70 (Fall 1994) 5-32.

10. Gerald Raunig, "On the Breach," *Artforum* (May 2008) 342. See also Raunig's *Art and Revolution: Transversal Activism in the Long Twentieth Century*, trans. Aileen Derieg (Los Angeles: Semiotext(e), 2007).

11. See Robert Paul Resch, *Althusser and the Renewal of Marxist Social Theory* (Berkeley: University of California Press, 1992).

12. Nicos Poulantzas, *Les classes sociales dans le capitalisme aujour-d'hui* (Paris: Éditions du Seuil, 1974) 195-207.

13. For example, see the very uneven treatment of these issues in Volume 1 (2009) of the Journal of the Free / Slow University: *Culture, Not Profit: Readings for Artworkers*, available at http://wuw2009.pl/czytankid.php?lang=eng; see also the special issue on the "Bologna process" of standardized university education in the e-flux journal *Journal* (2010) edited by Irit Rogoff, available at http://e-

flux.com/journal/issue/14. For more rigorous analysis, see the Institute of Network Cultures' 2007 publication, edited by Geert Loving and Ned Rossiter: *My Creativity Reader*, available at http://www.networkcultures.org/_uploads /32.pdf; and finally, see also the special issue "University, Failed" of the journal *Ephemera* (August 2008) edited by Armin Beverungen et al., available at http://ephemera web.org/journal/8-3/8-3index.htm.

14. C. Wright Mills, *White Collar: The American Middle Class* (New York: Oxford University Press, 1953) 71. Twenty years before Mills, Kracauer, following the insights of Emil Lederer, suggested that office life had become the new space of social domination and that the struggle for better working conditions had been replaced by the rationalization of play and the construal of public life as culture. See Siegfried Kracauer, *The Salaried Masses: Duty and Distraction in Weimar Germany*, trans. Quintin Hoare (London: Verso, [1930] 1998) 32. For an interesting follow-up to *The Salaried Masses*, see Kracauer, *From Caligary to Hitler: A Psychological History of the German Film*, ed. Leonardo Quaresima (Princeton: Princeton University Press, [1947] 2004).

15. I have in mind here Nina Möntmann's assertion that "the challenge for art is to create a temporary model situation of community – one that can be experimental, provisional, informal and maybe prototypical, even Utopian." Nina Möntmann, "Community Service," *Frieze* #102 (October 2006), available at http://www.frieze.com/issue/article/ community_ service/.

16. Bill Readings, *The University in Ruins*. (Cambridge: Harvard University Press, 1996).

17. Readings, 49. See Giorgio Agamben, *The Coming Community*, trans. Michael Hardt (Minneapolis: University of Minnesota Press, [1990], 2007).

18. Agamben cited in Readings, 50.

19. Readings' analysis of a symbolic, managerial class is supported by numerous studies, including: Alain Touraine, *The Post Industrial Society* (New York: Random House, 1971); Barbara and John Ehrenreich, "The Professional-Managerial Class," in Pat Walker, ed. *Between Labour and Capital* (Boston: South End Press, 1979) 5-45; Robert Reich, *The Work of Nations: Preparing Ourselves for 21st Century Capitalism* (New York: Knopf, 1991); Fredric Jameson, *Postmodernism, or, the Cultural Logic of Late Capitalism* (Durham: Duke University Press, 1991).

20. Strictly speaking, the contemporary petty bourgeoisie is unlike the middle class in that it does not own the means of production and numbers among salaried professionals and white-collar "post-industrial" workers – referred to by Andrew Ross as "no-collar" workers. Post-industrial theory assumes that such workers require more autonomy and decision-making power. Psychologically, the new de-proletarianized petty bourgeois class wishes to be distinguished from the working poor and from the proletariat. This reflects the fact that they are less proletarianized and have more technical training and access to knowledge production than the industrial proletariat. The relation of the petty bourgeoisie towards the middle class is similar to that of the small and medium size business owner vis-à-vis the large capitalist enterprise. In contrast to the view that class conflict implies a direct relation between the working class (socialism) and the middle class (capitalism), Marx argued that in modern societies, a petty bourgeois class is created, which fluctuates between the two but renews itself as *a supplementary part of bourgeois society*. Another term used by Marx and Engels is that of a bourgeois proletariat, alienated from its revolutionary role by industrial capitalism. We can also speak of a "petty bourgeois complex," a fantasy of capitalistic affluence that has become a permanent feature of

late capitalism, which includes post-Keynesian palliatives, structural unemployment or chronic underemployment, third world debt, war expenditure, commodity fetishism and sales promotion, inflation, and environmental catastrophe. See Asok Sen, "Marxism and the Petty-Bourgeois Default," in P.C. Josji, ed. *Homage to Karl Marx: A Symposium* (New Delhi: People's Publishing House, 1969) 158-62. See also Erik Olin Wright, *Class Counts: Comparative Studies in Class Analysis* (Cambridge: Cambridge University Press, 1997).

In some respects, it could simplify matters to understand today's petty bourgeoisie as simply the middle class: it is not the ruling capitalist class, able to devalue both labour and professionalism, and it is not the working class, against which the middle class resentfully guards its symbolic capital against demands for equal opportunity. Resch argues that the "middle" class of professional petty bourgeois workers is divided between a liberal humanist fraction that is based in the public sector, the media and universities, and a Darwinist fraction based in the private sector and corporations. This class as a whole is unable to understand and resist the restructuring of global capitalism inasmuch as it refuses to consider the analysis of economic determination as class struggle. The more blatant the recent effects of economic determination and class exploitation, he argues, the more the ideological response of this class is to blame its failures on the concessions it once gave to Marxism, whether at the level of the welfare state, state socialism, or at the level of social theory. See Resch, 11.

21. According to Brian Holmes, in his introductory lecture for the Continental Drift conference at New York City's 16 Beaver Group, neoconservatism acts as the protective reaction to neoliberal market capitalism. Holmes mentions in this regard the current interest in the work of Karl Polanyi

and his 1944 publication *The Great Transformation.* According to Yahya Madra, Polanyi argued that society would develop protective responses to market capitalism and warned that nothing could guarantee that such reflexes would be democratic. Madra argues that in addition to regulation, the market needs to be socially embedded. See Yahya M. Madra, "Karl Polanyi: Freedom in a Complex Society," *Center for Popular Economics* (May 19, 2004): www.fguide.org/?=127; and Brian Holmes, "Articulating the Cracks in the World of Power," (2005), available at http://71.18.85.184/drift/ 091505_brian-intro.mov.

22. Sen cites Gramsci's view that the main task of progressives in the capitalist West is to win in the area of civil society and culture. Today, however, authoritarian governments have learned to recoup the humanitarian efforts of citizens' movements. Another aspect of this, on a broader scale, is the rise of a symbiotic relation between civil society groups, NGOs and micro-political groups, on one side, and capitalist institutions. The virtue made by anticapitalist forces in the form of the post-Marxist multitude and micro-political struggles that abandon "class essentialism" is that they are non-linear, that they can assemble and disperse at will, put pressure on state organizations and intervene tactically and anonymously. However, this tendency to make a virtue out of a weakness is only the moral aspect of the fact that the existence of the movement can be only verified as a virtuality. For a Marxist critique of Gramsci's "anarchist" emphasis on civil society, see Henri Lefebvre, *De L'État, Tome II: De Hegel à Mao par Staline* (Paris: 10/18, 1976).

23. Holm was also a participant in the demonstrations against the World Economic Summit in Heiligendamm in June of 2007. See Richard Sennett and Saskia Sassen, "Guantánamo in Germany," *The Guardian* (August 21, 2007), available at http://www.education/guardian.co.uk/higher/

comment/story/.

24. See David Akin, "Conservatives cancel $4.7M arts travel program," *The Ottawa Citizen* (August 8, 2008).

25. Gregory Sholette, "Disciplining the Avant-Garde: The United States versus The Critical Art Ensemble," *Circa* #112 (Summer 2005) 52.

26. Bourdieu, 323.

27. In Lacanian terms, we could draw some simple correspondences between the petty bourgeois mode of late capitalist production and the "discourse of the University." We could further supplement Lacan's discourse of the University with his discourse of the Capitalist: $/S1 \rightarrow S2/a$. In this scenario, the rhetoric of stakeholders, the idea of students as clients, quantitatively measured public opinion, and market-driven curriculum determine what constitutes knowledge through a fantasmatic identification with the prevailing capitalist discourse.

28. The opposite of allodoxic overidentification would be the critical over-identifications strategies of artists, as described in BAVO, ed. *Cultural Activism Today: The Art of Over-Identification* (Rotterdam: Episode Publishers, 2007).

29. Holloway argues that the starting point for theoretical reflection should be an awareness of social realities like the fact that in 1998, the assets of the 358 richest people were worth more than the combined wealth of 45 per cent of the world's population – more than 2 billion people. John Holloway, *Change the World Without Taking Power* (London: Pluto Press, 2002) 1.

30. Bourdieu 318-371. One possible objection that should be addressed is the view that Bourdieu's work prevents forms of analysis that are not based in class analysis. In the section on "Social Space and Its Transformations," Bourdieu argues against the concept of class as a container or property. Instead, he states that social class is defined by a "structure

of relations" that must also take into account "secondary characteristics" and determinants. Specific agents cannot be defined by one set of characteristics only, and in the context of struggle, secondary principles of division can become primary principles and therefore no determinants are necessarily and always primary. See Bourdieu, 99-107. Secondary determinants, like the unconscious, should not be viewed as truths revealed, but as indices of the structure of subjectivity. In this, we should insist that subjects are incomplete, created and self-created in conditions not of their making. Within capitalist society, class operates in terms of ideology, as a fantasy that attaches us to a particular social formation. As a mode of enjoyment, this ideology, as Jodi Dean writes in relation to Žižek's interpretation of Lacan, structures "the practices in which we persist even as we know better." Ideology creates a distance that relieves us of responsibility for what we do, and, moreover from the belief that I act as an individual. As long as I believe that others act in ways that are class specific, I can continue believing that my actions are individual and autonomous. In this, I can act collectively; I can participate in anti-capitalist organizing. That is why, at this moment of disintegration of the belief in individualism, liberals argue, *allodoxically*, that economic and political inequality can be resisted by "rebuilding" either the middle class or civil society, which amounts to the same thing. According to Žižek, this false presupposition leads in the direction of a greater distance between capitalism and democracy. See Jodi Dean, *Žižek's Politics* (New York: Routledge, 2006).

31. Wright, 199.
32. Mina Möntmann, "Art and its Institutions," in Mina Möntmann, ed. *Art and its Institutions: Current Conflicts, Critique and Collaborations* (London: Black Dog Publishing, 2006) 8.

33. It could be argued that this shift is only apparent and that behind the petty-bourgeois displacement of national representation lies an unbroken alliance between bourgeoisie and petty bourgeoisie, as Roland Barthes argued in his 1957 text, *Mythologies*. What I am suggesting here is the logical progression of the bourgeoisie's "ex-nomination," its passing into an undifferentiated nature that is not perceived as directly political.

34. Poulantzas, 277.

35. Möntmann borrows these ideas from Richard Sennett and his book, *The Culture of the New Capitalism*. See Möntmann, 9. These same traits are sometimes treated as departure points for new forms of individuation and networked resistance to corporate capitalism. See also, Brian Holmes, "Unleashing the Collective Phantoms: Flexible Personality, Networked Resistance," in *Re/Public* (January 2002), available at http://www.republicart.net.

36. On this, see Max Henning, "Money for Nothing?" in *Turbulence* #1 (June 2007), available at http://turbulence.org.uk/turbulence-1/.

37. Bourdieu, 371.

38. Hal Foster, "Against Pluralism," in *Recodings: Art, Spectacle, Cultural Politics* (Seattle: Bay Press, 1985) 23. Foster's previous book, *The Anti-Aesthetic* (1983), made an important distinction between a postmodernism of reaction and a postmodernism of resistance. The tenuousness of this distinction, however, became more apparent as the field of visual studies enlarged the problematic of (psychological) identification and as the editors of the journal *October*, among them Foster and Rosalind Krauss, argued that advanced culture, including visual studies, is helping to "produce subjects for the next stage of globalized capitalism." The latter phraseology, derived from the "Visual Culture Questionnaire" is markedly different from

Krauss' phraseology in "Welcome to the Cultural Revolution" (both of these from the Summer 1996 issue of *October*) where she states: "advanced culture – far from being contestatory or resistant – is continually preparing *its subjects* to inhabit indeed, the next, more demanding stage in the development of capital." (84; my emphasis) In this phrasing, the Lacanian insights she presents in her essay are skewed in favour a more Heideggerian reading. If capitalism can operate here as the pre-ontological dimension, we should bear in mind that we are nevertheless talking about subjects, who, as Žižek argues in Hegelian terms, always exist in a way that is "out of joint" with regard to their circumstances. On this see Slavoj Žižek, "The Night of the World," in *The Ticklish Subject: The Absent Centre of Political Ontology* (London: Verso, 1999) 9-69.

39. Hal Foster, "The Funeral is for the Wrong Corpse," in *Design and Crime (and Other Diatribes)* (London: Verso, 2002) 125. The relativism that attends culture understood in terms of art and formal culture of course extends to the idea of multiculturalism and ethnicity and is part of this same process of neoliberal engineering. For instance, the 2008 European Year of Intercultural Dialogue, proposed by the European Commission, was focused on the way that cultural diversity, identity politics and transnationalism contribute to economic prosperity.

40. See for example Johanne Lamoureux, "Avant Garde: A Historiography of a Critical Concept" in Amelia Jones, ed. *A Companion to Contemporary Art Since 1945* (Oxford: Blackwell, 2006) 191-211.

41. Rochlitz, *Subversion et subvention: Art contemporain et argumentation esthétique* (Paris: Gallimard, 1994).

42. Donald Callen, "The Difficult Middle," *rhizome* #10 (Spring 2005), available at http://www.rhizome.net/ issue10/callen .htm.

6. The Subject Supposed to Over-Identify: BAVO and the Fundamental Fantasy of a Cultural Avant Garde

1. Henri Lefebvre, *De L'État, Tome II: De Hegel à Mao par Staline (La théorie "marxiste" de l'état)* (Paris: 10:18, 1976) 298.

2. It is agreed that whatever new forms of revolutionary struggle are practiced, they will never again be those that characterized the twentieth century. Alain Badiou attempts to account for this with his idea of the "communist hypothesis." Revoutionary egalitarianism, he argues, begins with the French Revolution and runs through to the Paris Commune. This sequence represents the popular seizure of power. The next sequence runs from the Soviet experience through to the Chinese Cultural Revolution. Its purpose was to organize a new state and to make it last against its enemies. In this sequence the problem of working-class power is absorbed by the party, which has proven unable to make the dialectical transition towards the withering of the state. The second sequenc comes to an end around the time of May 68 and organizes collective action as a new space of politics that is not reducible to a centralized bureaucracy. Badiou argues that we cannot restore the second sequence. What we will have instead will involve "a new relationship between the real political movement and ideology." It will be neither the Trotskyist and Maoist party apparatus, nor an alter-globalist multitude, yet it will be supported by the Idea of communism as a philosophical task and a "revolution-izing of the mind." See Alain Badiou, "The History of the Communist Hypothesis and Its Present Moment," in *The Meaning of Sarkozy*, trans. David Fernbach (London: Verso, [2007] 2008). See also Alain Badiou, *The Communist Hypothesis*, trans. David Macey and Steve Corcoran (London: Verso, [2008] 2010).

3. For a critique of Deleuzian thematics in contemporary theory, see Slavoj Žižek, *Organs Without Bodies: On Deleuze*

and Consequences (New York: Rouledge, 2004) and Alain Badiou, *Theoretical Writings*, edited and trans. Ray Brassier and Alberto Toscano (London: Continuum, 2006).

4. See Peter Bürger, *Theory of the Avant-Garde*, trans. Michael Shaw (Minneapolis: University of Minnesota Press, [1974] 1984).

5. For a treatment of transversal activism, see Gerald Raunig, *Art and Revolution: Transversal Activism in the New Century*, trans. Aileen Derieg (Los Angeles: Semiotext(e),[2005] 2007).

6. Slavoj Žižek, *The Parallax View* (Cambridge: The MIT Press, 2006) 296.

7. See Slavoj Žižek, *The Puppet and the Dwarf: The Perverse Core of Christianity* (Cambridge: The MIT Press, 2003). On this, Žižek argues that there is an analogy between the Marxist theory of surplus-value and Lacan's theory of surplus enjoyment (*jouissance* as the correlate of the *plus de jouir*). In contrast to the view that capitalism blocks the relational field of affect and that this same relationality challenges capitalist homogenization, Žižek argues that surplus value is what propels affective productivity, and further, that we should renounce this activity inasmuch as it operates as the support of revolutionary activity.

8. Fredric Jameson, *Postmodernism, or, The Cultural Logic of Late Capitalism* (Durham: Duke University Press, 1991) 6.

9. Žižek, *The Parallax View*, 318. For an example of the theory that the "disappearance" of the distinction between art and life will and can take place by prolonging existing post-ideological conditions, see Grant Kester, "Crowds and Connoisseurs: Art and the Public Sphere in America," in Amelia Jones, ed. *A Companion to Contemporary Art, Since 1945* (London: Blackwell, 2006) 249-267. One of the consequences of the art of over-identification would thus be the resumption of avant-garde challenge.

10. Gregory Sholette, "Untitled Draft for Re:(Image)ining

Resistance," unpublished manuscript, 2008; see also Sholette, "Dark Matter: Activist Art and the Counter-Public Sphere," in Andrew Hemingway et al., eds. *As Radical as Reality Itself* (Oxford: Peter Lang, 2007) 429-57.

11. Adam Arvidsson, "Creative Class or Administrative Class? On Advertising and the 'Underground'," *Ephemera: Theory and Politics in Organization* 7:1 (February 2007), available at http://ephemeraweb.org/journal/7-1/7-1arvidsson.pdf.

12. Pierre Bourdieu's insight into the economy of culture is that it lacks official criteria of selection. Art succeeds by imitating the effects of exclusivity, a striving that is constrained in its relation to larger assemblages like institutional canons and collections, and more immediate obstacles like taste cultures or art movements. The administration of the cultural economy operates through executive, technocratic gatekeepers who seek to win the acquiescence of the excluded and impose norms of enlightened conservatism. See Bourdieu, *Distinction: A Social Critique of the Judgement of Taste*, trans. Richard Nice (Cambridge: Harvard University Press, [1979] 1984).

13. Sholette, "Untitled Draft for Re:(Image)ining Resistance." Some of the artists' collectives mentioned are The Yes Men, Center for Tactical Magic, Yomango, Howling Mob Society, Reverend Billy, Critical Art Ensemble, Gran Fury, Knit for Peace, ATSA, CSpace, NeMe, AREA, Change You Want to See, City Beautification Ensemble, WochenKlausur, *Les panthères roses*, Temporary Services, N55 and the Biotic Baking Brigade.

14. No wonder then that arts administrators routinely insist on the utopian nature of cultural production, detached from all determinations and necessities, and more to the point, detached from an open acknowledgement of the class deter-minations of cultural production. Indeed, the fundamental fantasy of the cultural producer is the impossible subjec-

tivization of class, caught as it is in the dialectic of desire. Here we encounter the hidden logic of what we might consider a utopian realism: there is no proper proletarian aesthetic. For this reason, we should knowingly assert that the avant-garde artist is the artist "doomed to castration." See Lacan's Séminaire XIV, "La logique du fantasme," available at www.lacan.com/seminars1c.htm.

15. This is one of the reasons why much of today's museum art and biennial fodder is a symptom of the way the art field operates as an adjunct to state and capitalist demands, even and especially where it is allowed to experiment.

16. BAVO, "The Spectre of the Avant-Garde: Contemporary Reassertions of the Programme of Subversion in Cultural Production," *Andere Sinema* #176 (2006) 27-8.

17. BAVO, "The Spectre of the Avant-Garde," 31-2.

18. BAVO, "The Spectre of the Avant-Garde," 35.

19. BAVO, "The Spectre of the Avant-Garde," 37-9.

20. BAVO, *Cultural Activism Today: The Art of Over-Identification* (Rotterdam: Episode Publishers, 2007).

21. What is at stake here, according to Žižek, is nothing less than the rehabilitation of dialectical materialism. The idea of an *excess* of identification serves to explain the social nature of the process of politicization and cultural production. On this, see Žižek's *The Parallax View* (Cambridge: The MIT Press, 2006).

22. Pierre Bourdieu, *Contre-feux: Propos pour servir à la résistance contre l'invasion néo-libérale* (Paris: Éditions RAISONS D'AGIR, 1998) 119.

23. On this see BAVO, "Neoliberalism with Dutch Characteristics: The Big Fix-Up of the Netherlands and the Practice of Embedded Cultural Activism," in Rosi Braidotti, Charles Esche and Maria Hlavajova, eds. *Citizens and Subjects: The Netherlands, for Example* (Zürich: JRP Ringier, 2007) 51-63.

24. See Žižek, "Tolerance as an Ideological Category," *Critical Inquiry* #34 (Summer 2008) 660-82.

25. BAVO, *Cultural Activism Today*, 19.

26. Class struggle is the concrete universal that overrides cultural difference and the series of antagonisms that structure today's social processes. However, Žižek argues, that "does not mean that class struggle is the ultimate referent and horizon of meaning of all other struggles; it means that class struggle is the structuring principle which allows us to account for the very 'inconsistent' plurality of ways in which other antagonisms can be articulated into 'chains of equivalences' [as argued by Laclau and Mouffe]." In Žižek, *The Parallax View*, 361-2. See also, Žižek, "Class Struggle or Postmodernism? Yes, Please!" in Judith Butler, Ernesto Laclau and Slavoj Žižek, *Contingency, Hegemony, Universality: Contemporary Dialogues on the Left* (Cambridge: MIT Press, 2000) 90-135.

27. BAVO, *Cultural Activism Today*, 7.

28. The Yes Men, "End of the WTO," available at www.theyesmen.org/hijinks/sydney.

29. See Slavoj Žižek, *On Belief* (London: Routledge, 2001).

30. Thanks to Aras Ozgun for pointing out to me the fact that the Yes Men do not consider their work to be art. My response is that a distinctly cultural or aesthetic approach to avant-gardism avoids the issue concerning whether or not the objective conditions are appropriate for radical art to be effective. As BAVO recognizes, cultural activism may, in the end, and if the social structure endures, remain merely cultural. The avant garde wager, in the absence of a situation where the exercise of power is held by the working masses, is that the organization of political activity nevertheless can take place. The radical artist becomes, as Debord once stated, a party unto themselves. Thanks too to BAVO for clarifying that they hold to this view as well.

31. Slavoj Žižek, "The Fetish of the Party," in Žižek, *The Universal Exception: Selected Writings, Volume Two*, edited by Rex Butler and Scott Stephens (London: Continuum, 2006) 67-93.

32. Mark Bracher makes an interesting argument for Lacan's Discourse of the Analyst as an effective mode of cultural criticism. One key distinction between his and Žižek's approach is Žižek's development of a theory of practice, which he refers to as an "authentic act" that supplants the "way of the superego." See Mark Bracher, *Lacan, Discourse and Social Change: A Psychoanalytic Cultural Criticism* (Ithaca: Cornell University Press, 1993).

33. In addition to Žižek's "The Fetish of the Party," my thoughts on the relation of Lacan's Four Discourses to avant-garde practice has been greatly influenced by chapter 2, "Fascism and Stalinism" in Jodi Dean's *Žižek's Politics* (New York: Routledge, 2006) 47-93.

34. On this topic, see Thomas Frank, *What's the Matter with Kansas: How Conservatives Won the Heart of America* (New York: Henry Holt and Company, 2005). See also Slavoj Žižek, "Why Populism Is (Sometimes) Good Enough in Practice, but Not in Theory," *In Defense of Lost Causes* (London: Verso, 2008) 264-333.

35. See Slavoj Žižek, "Some Politically Incorrect Reflections on Urban Violence in Paris and New Orleans and Related Matters," in BAVO, eds. *Urban Politics Now* (Rotterdam: NAi Publishers, 2007) 12-29.

36. On this, see Grant Kester's "Aesthetic Evangelists: Conversion and Empowerment in Contemporary Community Art," *Afterimage* (January 1995) 5-11.

7. The Revolution Will (Not) Be Aestheticized

1. The discussion group Markets included Anton Vidokle, J. Morgan Puett, Surasi Kusolwong, Superflex, and Julia Bryan-Wilson; Food included Amy Franceschini, Agnes Denes,

InCUBATE, F.E.A.S.T and Claire Pentecost; Schools involved Jakob Jakobsen, The Bruce High Quality Foundation, Learning Site, and Saskia Bos; Governments included Laura Kurgan, Chen Chien-Jen, Oliver Ressler, PLATFORM and Aaron Levy; Institutions was comprised of Thomas Keenan, Danielle Abrams, Otabenga Jones & Associates, W.A.G.E. and Andrea Fraser; Plausible Art Worlds included Chto Delat, Eating in Public, The International Errorist, Scott Rigby and Stephen Wright. This conference also include presentations by Anne Pasternak, Gridthiya Gaweewong, Sofia Hernández Chong Cuy, Rick Lowe, Trevor Paglen, Shaun Gladwell, Dinh Q. Lê, Regina Tosé Galindo, Phil Collins, Eyal Weizman, Laurie Jo Reynolds, Chris Martinez, Claire Doherty, Bisi Silva, Kickstarter, Basekamp, Stephen Wright, Tidad Zolghadr, and keynote speaker Wendell Pierce. The majority of these 8 to 15 and 20 minute presentations are available online at: http://creativetime.org/programs/archive/2010/summit/swf.h tml.

2. Nato Thompson, "Curatorial Statement: Preaching to the Choir that Has Yet to Exist," 2010 Creative Time Summit; available at: http://creativetime.org/programs/archive/2010/summit/WP/curatorial-statement/.

3. This theme of ambivalence and indeterminacy is a hallmark of difference politics. In many respects it has less to do with an "uncertainty principle" as a constituent of knowledge than a political pluralism. Consider for example Chantal Mouffe's essay "Artistic Activism and Agonistic Spaces," *Art & Research* 1:2 (Summer 2007), available at http://www.artandresearch.org.uk/v1n2/mouffe.html. For a critique of postmodern political relativism, see Slavoj Žižek, "Postmodernism or Class Struggle? Yes Please!" in Judith Butler, Ernesto Laclau and Slavoj Žižek, *Contingency, Hegemony, Universality: Contemporary Dialogues on the Left* (London: Verso, 2000) 90-135.

4. Bret Schneider, "Petrified Unrest: A Review of the Creative Time Summit," *Platypus Review* #29 (November 2010): available at: http://platypus1917.org/2010/11/06/petrified-unrest-a-review-of-the-creative-time-summit. Thanks to Marc Herbst for bringing this review to my attention.

5. In their introduction to a well-known reader in Marxist cultural theory, Grossberg and Nelson write: "Yet this dismissal [of economism] is itself overly reductive, for the theoretical orientation did yield powerful insights and did place the political and social significance of cultural production on the agenda of interpretive theory, successfully challenging the unthinking idealization of high art. Moreover, even the most notoriously reductive elements of traditional Marxism are difficult to dismiss easily. In fact, one might argue that reflection theories, however qualified and problematized, play a necessary and constitutive role, not only for all later and more sophisticated Marxisms, but also in all historically and politically grounded interpretation. Finally, the established canon of Marxist criticism provided the tradition against which an alternative tradition of Marxist cultural theorizing could be defined – not only, however, by way of correction, amplification, revision, or outright rejection, but also by way of an uneasy relation or derivation, potential return, and perhaps even occasional nostalgia for the security of its political interpretations. 'Vulgar Marxism,' that overdetermined and mythically hypostatized category, remains the anxiously regarded double of contemporary Marxist writing." Cited in Lawrence Grossberg and Cary Nelson, "Introduction: The Territory of Marxism," in Cary Nelson and Lawrence Grossberg, eds. *Marxism and the Interpretation of Culture* (Urbana: University of Illinois Press, 1988) 3.

6. See Alain Badiou, *The Communist Hypothesis*, trans. David Macey and Steve Corcoran (London: Verso, 2010) 242-5.

7. See Steve Kurtz in Konrad Becker and Jim Fleming, eds.

Critical Strategies: Perspectives on New Cultural Practices (Brooklyn: Autonomedia, 2010) 25-6.

8. Conrad Becker cited in Becker and Fleming, 168-9.

9. On this, see Slavoj Žižek, "The Return to Hegel," Lecture presented at the European Graduate School, March 1, 2010; available at: http://www.youtube.com/watch?v=aR3vfHu 0W38.

10. In his presentation of an anti-capitalist political program, David Harvey agues for the necessity of a dialectical unfolding of seven moments within the body politic of capitalism. These are: 1) technological and organizational forms of production, exchange and consumption, 2) relations to nature, 3) social relations, 4) mental conceptions of the world, culture and beliefs, 5) labour processes, services and affects, 6) institutional, legal and governmental arrangements, 7) the conduct of daily life. A serious activist art should perhaps in some ways be able to account for all of these moments. See David Harvey, "Organizing for the Anti-Capitalist Transition," Lecture presented at the World Social Forum, 2010, available at http://davidharvey.org/2009/12/organizing-for-the-anti-capitalist-transition/#more-376.

11. See Gerald Raunig, *A Thousand Machines: A Concise Philosophy of the Machine as Social Movement* (Los Angeles: Semiotext(e), 2010) 57.

12. Gregory Sholette, "Art as Social Practice: The Good, the Bad, and the Yet to be Born," (October 10, 2010); available at http://www.facebook.com/topic.php?uid=35516651321&topic=13782.

13. Jodi Dean, "The Communist Horizon," Lecture delivered at the Second FORMER WEST Research Congress on Horizons: "Art and Political Imagination," November 5, 2010; available at: http://www.formerwest.org/VideoRecordings. FORMER WEST describes itself as "a long-term international research, education, publishing, and exhibition project (2008-2014),

which from within the field of contemporary art and theory: (1) reflects upon the changes introduced to the world by the political, cultural, artistic and economic events of 1989; (2) engages in rethinking the global histories of the last two decades in dialogue with post-communist and postcolonial thought; and (3) speculates about a "post-bloc" future that recognizes differences yet evolves through the political imperative of equality and the notion of "one world."

14. See Slavoj Žižek, *Revolution at the Gates: Žižek on Lenin, the 1917 Writings* (London: Verso, 2002) 273.

15. See BAVO, "Neoliberalism with Dutch Characteristics: The Big Fix-Up of the Netherlands and the Practice of Embedded Cultural Activism," in Rosi Braidotti, Charles Esche and Maria Hlavajova, eds. *Citizens and Subjects: The Netherlands, for example* (Zurich: JRP Ringier, 2007) 51-63.

16. BAVO, "How Much Politics Can Art Take?" (2009); available at: http://www.bavo.biz/texts/view/210.

17. "About Creative Time" available at: http://creativetime.org /about/index.html.

18. Alain Badiou, "Does the Notion of Activist Art Still Have Meaning?" Lecture delivered at the Miguel Abreu Gallery, New York City, October 13, 2010, in collaboration with *Lacanian Ink*; available at: http://himanshudamle. blogspot.com/2010/11/alain-badiou-does-notion-of...

19. Henri Lefebvre, *Alfred de Musset: Dramaturge* (Paris: L'Arche, 1955) 37. See Marc James Léger, "Henri Lefebvre and the Moment of the Aesthetic," in Andrew Hemingway, ed. *Marxist Art History: From William Morris to the New Left* (London: Pluto Press, 2006) 143-60.

20. Henri Lefebvre, *La Somme et le reste*, vol.2 (Paris: Editions NEF, 1959) 68.

21. Henri Lefebvre, *Contribution à l'esthétique* (Paris: Éditions Sociales, 1953) 34.

22. Roland Barthes, *Mythologies*, trans. Annette Lavers (New

York: The Noonday Press, [1957] 1972) 149.

23. Lowe tried to take some distance from the prize by empha-
 sizing social justice rather than social change. Regardless of
 the merits of his ongoing Project Row Houses, his language
 of "social sculpture" tended to avoid any suggestion of how
 labour and wealth is distributed in the U.S. The emphasis
 was rather on dignity, participation, education and creativity
 – a rather innocent, even if socially minded, notion of social
 improvement.

24. Barthes, 146-7.

25. Oskar Negt and Alexander Kluge, *Public Sphere and
 Experience: Toward an Analysis of the Bourgeois and Proletarian
 Public Sphere*, trans. Peter Labanyi et al. (Minneapolis:
 University of Minnesota Press, [1972] 1993).

8. From Activism to Geocritique: A Few Questions for Brian Holmes

1. Brian Holmes, *Unleashing the Collective Phantoms: Essays in
 Reverse Imagineering* (Brooklyn: Autonomedia, 2008);
 Holmes, *Escape the Overcode: Activist Art in the Control
 Society* (Zagreb and Eindhoven: WHW/Van Abbemuseum,
 2009).

2. Alan Minsky, "Radio Interview with Brian Holmes,"
 on *Beneath the Surface*, KPFK radio, March 19, 2010, available
 on the *Occupy Everything* website, available at
 http://occupyeverything.com/news/brian-holmes-on-kpfk.
 The interview was conducted in the context of Holmes'
 involvement with student protests at the University of
 California on March 4, 2010.

3. See Brian Holmes, "Risk of the New Vanguards?," Issue #17
 of Chto Delat, *Debates on the Avant-Garde*, available at
 http://www.chtodelat.org/images/pdfs/17_vanguard.pdf.

Contemporary culture has eliminated both the concept of the public and the figure of the intellectual. Former public spaces – both physical and cultural – are now either derelict or colonized by advertising. A cretinous anti-intellectualism presides, cheerled by expensively educated hacks in the pay of multinational corporations who reassure their bored readers that there is no need to rouse themselves from their interpassive stupor. The informal censorship internalized and propagated by the cultural workers of late capitalism generates a banal conformity that the propaganda chiefs of Stalinism could only ever have dreamt of imposing. Zer0 Books knows that another kind of discourse – intellectual without being academic, popular without being populist – is not only possible: it is already flourishing, in the regions beyond the striplit malls of so-called mass media and the neurotically bureaucratic halls of the academy. Zer0 is committed to the idea of publishing as a making public of the intellectual. It is convinced that in the unthinking, blandly consensual culture in which we live, critical and engaged theoretical reflection is more important than ever before.